THE BIG BEND COOKBOOK

RECIPES AND STORIES FROM THE HEART OF WEST TEXAS

TIFFANY HARELIK | Foreword *by* GRADY SPEARS

AMERICAN PALATE

Published by American Palate
A Division of The History Press
Charleston, SC 29403
www.historypress.net

Copyright © 2014 by Tiffany Harelik
All rights reserved

Front cover, top: Lesley Brown; bottom left: Lesley Brown; bottom right: Cochineal.
Back cover, top left and bottom: Lesley Brown.
Unless otherwise noted, all images are by the author.

First published 2014

Manufactured in the United States

ISBN 978.1.62619.722.0

Library of Congress CIP data applied for.

*This book is dedicated to the resilient people of the Big Bend.
May this work honor your communities and reflect their true beauty.*

CONTENTS

FOREWORD

I am so proud to see where the Trans-Pecos food movement has come from and where it is going. If you had told me there would be a food or a culinary movement back in the early '90s out in Far West Texas, I would have thought you were crazy. In the early '90s, it was sheer survival just trying to run a restaurant in the Big Bend area. It wasn't like you could go right down to the local market and get whatever supplies you needed or hire the best cooks you could find; they were nonexistent. People didn't come out to this area back then to further their cooking careers; they either came to be cowboys or were running from the law. I'll never forget that feeling or what I saw as long as I live! I was on a train heading west from Houston to Alpine, Texas, in 1991 on my way to the Gage Hotel. It was about eight o'clock in the morning, and I had just woken up from a restless night cramped against a train window. I looked out and could not believe what I saw—the desert and the mountains and just the sheer vastness of where I was was life changing! I had no idea how really life changing it would be until about ten years later. After a week in Marathon, I took on the task of running the restaurant at the Gage Hotel.

I arrived in Marathon around March 1991 and began my cooking career there out of sheer mishap. I had come to the Gage to be a restaurant manager, but the chef and the dishwasher both walked out on me one night with close to one hundred people waiting to eat, so I was forced to step behind the stove and figure it out. Up to that point, I could barely boil water, so this was a huge task in a new, desolate environment. I learned to be self-sustainable and to rely on local products far before it was a trendy thing to do. I utilized the local cowboys and chuck wagon cooks to help me cook meats and breads; I even had a local Marathon resident who grew all my vegetables and made my goat cheese. It was at this point I learned to respect food and the process that goes into creating it. After settling into my new role, I was starting to

see just how much this vast beautiful place had to offer. It was people like Shirley Rooney, Guy Lee, Biddy Martin and Tom Glasscock who I really owe for showing me all they knew about this West Texas style of cooking.

After spending five years at the Gage, I went on to open the first Reata restaurant in Alpine, Texas. Sticking with what I knew by drawing off the influences of the border and crossing that with ranch-style comfort food was natural. With the national attention from people like Martha Stewart and Rosie O'Donnell, the Reata had become a pretty well-known name in Texas. I also published my first cookbook, *A Cowboy in the Kitchen*, which was based on cooking from the Trans-Pecos region, about this time. One of my favorite food memories was hosting a Texas-sized barbecue with Martha Stewart at the Chianti Foundation. It was four days of mariachis, margaritas and barbecue. It was during this time I also learned to love the vastness and purity of the Trans-Pecos. As harsh as it could be on some people, it turned out to be an oasis for me.

Flash-forward to today, and seeing the forward thinking and movement on the food front is not only exciting but infectious. From Marathon down to the border over to Marfa and Valentine and then up to Fort Davis, you don't have to look hard to see what I'm talking about. The region now has its own namesake music festival and food festival, an incredible feat for this part of the state. I also believe the future looks bright for this area. As the art movement keeps growing and as people continue to come visit and live in this area, food will always have its place. My partner at Reata used to call this area a gastronomic wasteland in the '90s—not anymore! As you will come to see in the following pages, there is much to celebrate out in West Texas, from the people and their culture to the food and the land!

—Grady Spears

Frito Pie with Venison Chili, Fancy Cheeses and Texas Pico

Courtesy of Grady Spears

This is one of our all-time favorite Texan treats. We've dressed up this version with venison or quail chili, but you can use beef too. The caciotta (or Monterey jack) and goat cheeses add sophistication to the flavor, and the Texas Pico makes a colorful finish with the rich topping of crème fraîche.
—From The Texas Cowboy Kitchen *by Grady Spears with June Naylor (Andrews McMeel Publishing)*
Makes 6–8 servings

Venison or Quail Chili:

4 tablespoons vegetable oil
1 red onion, chopped
1 tablespoon minced garlic
2 pounds coarsely ground venison or diced boneless quail meat
1 cup Red Chile Sauce
1 tablespoon pure chili powder (ancho or New Mexico is good)
2 teaspoons dried oregano
2 teaspoons ground cumin
2 tomatoes, coarsely chopped
3 cups chicken stock
kosher salt

To Assemble:

1 large (16-ounce) bag Fritos
Texas Pico (see page 13)
2 cups shredded caciotta or Monterey jack cheese
1 cup crumbled goat cheese
2 cups crème fraîche or sour cream

° Prepare the chili by heating the oil in a stew pot or Dutch oven over medium heat. Add the onion and garlic and sauté until soft. Add the venison and cook until starting to brown, stirring as necessary. Add the Red Chile Sauce, chili powder, oregano, cumin and tomatoes. Stir well to combine. Cook for 5 minutes; then lower the heat to a simmer and add the stock. Simmer the chili, uncovered, for 45 minutes to 1 hour. Stir occasionally to prevent sticking. Season with salt to taste. Remove from heat and set aside until ready to assemble the Frito pie. If preparing ahead of time, place chili in an airtight container and refrigerate until ready to use.
° Assemble Frito pies by piling the Fritos into serving bowls. Top with hot chili, pico and cheeses. Drizzle with crème fraîche.

Red Chile Sauce
(makes 4½ cups):

When you let your imagination fly, you'll find that Red Chile Sauce can be as versatile as tomato sauce. We use it in tamale fillings, venison chili and enchilada sauces, but you'll find your own ways to incorporate it into recipes for meatloaf and hearty casseroles.

16 dried ancho chili peppers, about
 ½ pound
6 cups water
⅓ cup white wine
½ white onion, peeled and diced
5 cloves garlic, minced
5 teaspoons packed light brown
 sugar
2 tablespoons ground cumin
2 tablespoons honey
kosher salt and freshly ground
 pepper to taste

° Rinse the chilies to remove any dirt. Slit each chili with a sharp knife and remove and discard the seeds and stem. Wash hands very well after this, as the peppers are hot. Wear gloves if you have sensitive skin. Place the peppers in a large saucepan and cover with water by 1 inch. Bring to a boil over high heat; then reduce the heat and simmer for about 15 minutes. The peppers should be soft and have absorbed some liquid. When cooked, remove the pan from the heat and set aside without draining.

° While the peppers are cooking, combine the wine, onion, garlic, brown sugar, cumin and honey in a small saucepan. Set this mixture over medium heat and simmer for about 10 minutes, or until the onions are soft. Remove from the heat and set aside.

° Using tongs, transfer the cooled anchos to the container of a blender. Add about 2 cups of the ancho liquid and all of the onion broth. Cover the blender container and start blending at low speed, increasing to high speed as the purée becomes combined. The result will be a thick, dark red sauce. Adjust seasonings with salt, pepper and more honey if desired. Use the sauce as is in a recipe or place in a clean glass container and refrigerate. Use the sauce within a week or freeze for later use.

Texas Pico (makes 2 cups):

Our version of pico de gallo is an indispensable condiment. It's a key ingredient in our Frito Pie, but you'll find that it's perfect on tacos, fish and baked potatoes, too. Dress it up with diced avocado to add a little richness.

6 jalapeños, sliced
1 red onion, diced
6 green onions, thinly sliced
2 tomatoes, diced
2 bunches cilantro leaves, stems
 removed and minced
juice of 2 limes
kosher salt

° Toss the jalapeños, onions, tomatoes and cilantro in a bowl. Drizzle with lime juice, top with salt and toss again to combine. Let sit for about 15 minutes before serving.

Lesley Brown

ACKNOWLEDGEMENTS

During the year I spent writing this cookbook, I met many wonderful people living in Big Bend country. In this work, I did not exclude anyone intentionally and would have loved to feature many more of the restaurants and people in the area if time were permitting. There are so many interesting people, histories and recipes from Alpine to Valentine. If you are journeying in West Texas, I encourage you to eat, explore and meet people who can tell you firsthand their involvement with the history of the area and their roots in the communities.

Thank you to the beautiful May Leal for introducing our mutual friend Stewart Ramser to her hometown of Alpine and to them for including me in producing the first few years of the Viva Big Bend music festival and Viva Big Bend food festival. We have some good memories laying out at the Gage pool recapping the first Viva with Maurine over sandwiches and beers from the French Grocer and, of course, burying the whiskey bottle by the tracks. Through those festivals, I grew to know and love several people in the communities and ultimately decided to move out to the area on December 31, 2013. Thank you, May May, for your sisterhood and introducing me to a beautiful part of Texas.

To those who helped make Marathon home for me and all the colorful characters in town, thanks from the bottom of my heart.

To my "Fort Davis family" (Susie, Randy and Aaron Liddell, Becky and Worth Puckett): thank you for the arrowhead hunts, the family dinners and Catan nights, for introducing me to so many people in the community and for all the laughs. Thank you also for your special contributions to the cookbook through your recipes and art.

To the Stovalls for letting me ride in their roundup on the GSR (May 2014), the Drawes for showing me the Petan Ranch (April 2014), Phil for taking

me on a cull hunt at Maravillas (January 2014) and for all the memories at the White Buffalo Bar, Kimball for the helicopter ride where I saw my first aoudad herd (May 2014), the Sibleys for including me in their Thanksgiving at the Montessori school in Alpine (November 2013), Mercer for letting me sit in at the Marfa Writer's Club (ongoing)—you all have given me memories that will last a lifetime that were pertinent in understanding the area in the research of this book.

Thanks to Wilma Schindeler for making a handshake deal several hundred miles apart over the phone to rent her beautiful home for the duration of this project. I woke up grateful every day I spent in the casita bordered by ranchland and mountain ranges.

To my friend Maurine Winkley: thank you for exploring the area with me from Chinati Hot Springs to Independence Springs and several hikes in Big Bend National Park and thank you for your contribution to the cookbook through your knowledge of foraging and cooking.

To Callie and Brighton, I hope you'll one day have the opportunity to explore this part of the country and make discoveries of your own. To my parents and family, thank you for always believing in my projects.

To Christen Thompson, my commissioning editor on this project, and to all the committed History Press staff involved: thank you for sharing your genuine enthusiasm, expertise and supportive vision of *The Big Bend Cookbook*.

Last but not least, thank you to Aunt Tootie for your strong editorial support and for always wanting to get the very first copy of my books.

TUMBLEWEEDS AND TARANTULAS

Driving into Big Bend country, tumbleweeds roll slowly across the highway while tarantulas pick their way across the desert floor. Turkey vultures line the barbed-wire fences, warming their wings as they try to spot the latest kill. If you get out to stretch or hike, catclaw tugs at your sleeves and prickly pear cactus pokes into your shoes. This is rough country. But it's majestic country, and the soul searchers of the world are unexplainably drawn to this desert and these mountains.

Brewster County is the largest county in Texas and home to Big Bend National Park. Bordered to the west by Presidio County and to the northwest by Jeff Davis County, the tri-county region is known for its vast desert skies, beautiful mountain ranges and eclectic western lifestyles. The wide-open landscape of the Chihuahan Desert area is home to mule deer, elk, javalina, mountain lions and black bears. It offers hearty succulents in all shapes and sizes. Big Bend country has allured stargazers, bird watchers, archaeologists, hunters, hikers and naturalists for years. It is a land of endurance and one that also offers reprieve.

"The real distinction between north county and south county is summer climate, as demonstrated by the difference between Alpine and the Terlingua/Lajitas area," shares Marathon resident Russ Tidwell. "In north county, we are at elevations around 4,000 to 5,000 feet, which means we enjoy a high desert climate. The summer days do not usually get super hot, and with low humidity, it is comfortable in the shade of a porch. At night it cools down, often to the low sixties. In south county, it gets much hotter in the day because the elevation is, *mas o menos*, 2,300 feet. The river valley seems to hold in the heat. They do, however, have warmer winters."

Hundreds of miles separate neighbors and communities. The otherwise barren land of the Trans-Pecos region is peppered with several mountain

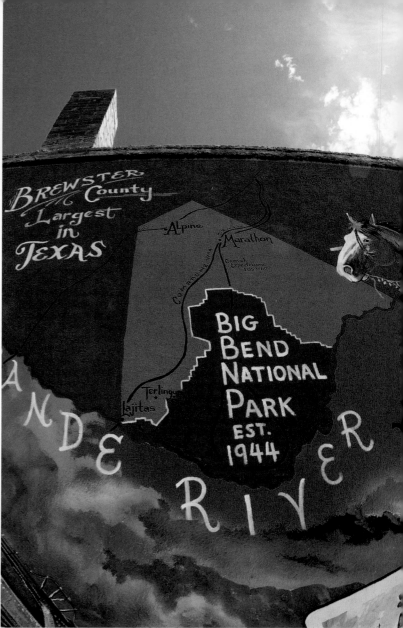

Top left: Creative Commons Attribution 4International. Patrick Denker via Corey Leopold; right: Creative Commons Attribution 4International. David Fulmer via Flickr.

ranges: the Dead Horse Mountains, the Glass Mountains, Elephant Mountain, Television Mountain and more. There are long stretches of road with no cellphone reception, so you'll want to take extra care to watch out for animals, bikers and other cars. If you run into trouble, it could be a long time before someone else drives by to help. Toward that end, you will want to fill your gas tank up every chance you get along the way—especially if the gas station happens to be open.

Now that I've painted a picture of the area for you, you're wondering, *What's a girl from Austin doing out here writing cookbooks?* The first cookbook I attempted to write was for a family heirloom project in 2007. I was inspired by a close friend who had gifted me with one of her family cookbooks she had put together. It was also during a period when the older generation in our family was passing, and I wanted to preserve some family histories through recipes. I reached out to everyone on both sides of my family to send me some of their favorite recipes and any stories about the recipes. Then I went through all of my mom's cookbooks and started typing up some of our go-tos plus any that sparked my attention. The project became massive and remained on my laptop for several years. I eventually went back through it for editing and ended up with an heirloom family cookbook that was printed just for our family. At that point, I realized I had a formula down for writing cookbooks and that I really enjoyed the process.

My next seven cookbooks focused on the niche market of food trucks and food trailers. Published through the American Palate division of The History Press, the Trailer Food Diaries cookbook series covered recipes and histories from entrepreneurs in the food cart world. We covered Austin, Dallas and Houston, Texas, as well as Portland, Oregon, in this project. Beyond that, I helped curate multiple food truck events and food festivals and began getting offers from TV producers and restaurant owners to consult on turn-around projects.

The first time I came to Far West Texas was on a trip with my Girl Scout troop (#447). We rode horses at the Prude ranch, hit up historical hikes in Fort Davis and stayed at the Indian Lodge, swam in Balmorhea, went to a star party at the McDonald Observatory, visited historic spots in Presidio and, generally speaking, did the "grand tour" of the area. Looking back, I don't know how our troop leader managed all of us, but I'm glad she did because it planted a seed for me to want to come back.

Several years later, in July 2012, I was hired to help produce Viva Big Bend music festival through my friend Stewart Ramser of *Texas Music Magazine*. We had about seventy bands covering the cities of Marfa, Alpine and Marathon. Since then, the festival has expanded to include venues in Lajitas and Fort Davis. It was a great excuse for people to make the drive to explore the area while getting to hear some great music. It was during these concerts that I fell in love with the region and decided to make Big Bend my home.

I moved from Austin to Marathon on New Year's Eve of 2013 to begin the New Year (2014) in a new terrain. I was often asked, "Why did you move here?" with a strong emphasis on the why. I gave people my most authentic and honest answer: because I love it here. But because that wasn't good

enough for most folks, I asked them why they were here. What I learned through these little conversations was that we couldn't necessarily put our fingers on what had lured us out of our former lives and into this place. The magnet of West Texas had a deep pull on my heart, and I knew I was going to stay a while.

During one of my initial trips out West, I found a house I wanted to live in. It wasn't available for rental, but I called and spoke with the owner anyway to make an offer. Half an hour later, we had a deal that we both could live with, and I found myself moving into what I considered a very sacred space. I remember tearing up because I was so grateful when I opened the door for the first time; it was better than I had remembered.

At my new home in Marathon, I began writing a few different novels. My day would start with yoga and a bike ride to the post followed by a protein shake and shower, and then I would hunker down to write until happy hour.

Some days I would go hiking in the park, others I would drive out to Marfa or Fort Davis to visit friends who would introduce me to more people in their hometowns. I practiced shooting, toured in helicopters and rode horses. I went to goat ropings, livestock shows and ranch rodeos and enjoyed the slow pace that was similar to my years spent in Buffalo Gap and Cross Plains. Eventually, I realized I wanted to use my background in cookbook writing to honor the histories and recipes of the communities I was growing to love. After The History Press accepted my book proposal, I paused on the novels to give my full energy to the *Big Bend Cookbook* project.

In my initial research, I found a few community or personal cookbooks from locals, but they were all out of print. There were some really strong cookbooks authored by local chefs but nothing that reflected the broader communities or the area. This fueled my interest in providing a bird's-eye narrative of the culinary culture of Far West Texas.

I began to draft and outline the cookbook, filling it in as I interviewed my way across the Trans-Pecos area. This cookbook is the result of many dinners, hikes, hunts and sunsets shared with the people of the Big Bend country. It has been my honor to write their stories and share their recipes so that future generations might know the people and tables that came before.

FOOD OF THE BIG BEND: RESTAURANT GUIDE

THIS IS NOT A comprehensive list, and is subject to change, but here is an at-a-glance look at locally owned area restaurants you can put on your Big Bend bucket list.

Marathon

Eve's Garden Bed-and-Breakfast
Johnny B's
Marathon Coffee Shop
12 Gage Restaurant & White Buffalo Bar at the Gage Hotel

South County (Terlingua and Lajitas)

Bad Rabbit Café at the Terlingua Ranch
The Boathouse Bar and Grill
Bobby's Blues & BBQ
Candelilla Café at Lajitas Golf Resort and Spa
Chilli Pepper
Longdraw Saloon and Pizza
Ten Bits Ranch

Marfa

Bozy 2 Men food truck
Cochineal
Fat Lyle's food truck
Food Shark food truck
Frama
Future Shark
Jett's at the Paisano Hotel
Maiya's
Mando's
Museum of Electronic Wonders and Grilled Cheese Parlour

Padre's
Pizza Foundation
Planet Marfa
Rib Krib food truck
The Squeeze

Fort Davis

The Black Bear Restaurant at Indian Lodge
Blue Mountain Bistro at the Limpia Hotel
Cueva de Leon
Fort Davis Drug Store
Fort Davis Nut Company
Herbert's Caboose Ice Cream Shop
Lupita's
Mary Lou's
Mountain Trails Lodge/Come and Take It BBQ
Murphy's Pizzeria
Poco Mexico
Stone Village Market
Veranda Inn

Alpine

Alicia's
Century Club inside the Holland Hotel
Cow Dog food trailer
El Patio
Guzzi Up Pizza
Judy's Bread & Breakfast
La Casita
La Trattoria
Los Jalapeños
Magoo's
Plaine
Reata
Saddle Club

MEXICAN FOOD SEMANTICS

ARE THEY BOTANAS OR nachos or campechanos? What's the difference between a chalupa and a tostada? Aren't chimichangas and burritos the same thing? So close to the border between Texas and Mexico, there is a heavy Mexican influence on the flavors in Big Bend country. Asados, fideos, enchiladas, flautas, quesadillas, gorditas, guadalajaras and even tacos all come with multiple names here in Far West Texas. A dish with the same name is often prepared differently from restaurant to restaurant and household to household.

These aren't the most concrete definitions, but there are a variety of names for ways to serve meat, beans and cheese on top of a corn tortilla. It's not "wrong" to call a nacho a botana, per se, it's just a regional dialect that differs depending on how one was introduced to the food. Regionally, each dish has a back story. I have attempted to provide a literal translation, a "most likely" area of origin and a description of the food.

ASADO
Literal translation: roasted; barbecued
Most likely origin: Argentina
Description: Usually this dish is barbecued beef but can also refer to roasted pork.

BOTANA
Literal translation: snack; appetizer
Most likely origin: Guatemala
Description: The base is a chip the size of half of a fried tortilla, spread with beans and cheese and baked in the oven, then topped with an assortment of things to taste: lettuce, onions, tomato, meat, more cheese, etc. (some people call them nachos).

BURRITO
Literal translation: little donkey
Most likely origin: Guanajuato
Description: A soft tortilla wrapped around fillings to taste (beans, meat, cheese, etc.). Burritos are completely enclosed, wrapped similar to swaddling a baby,

whereas tacos are just a tortilla folded in half. They are not crispy-fried (like taquitos and flautas). Rather, they are often served soft.

CAMPECHANO
Literal translation: friendly, hearty
Most likely origin: unclear
Description: Fried tortillas quartered into chips as the base, which are spread with beans and cheese melted on top. The entire dish of individual nachos is then covered in desired toppings: lettuce, diced onions, diced tomatoes, meat, guacamole, sour cream, salsa, etc. (some people call them nachos).

CHALUPA
Literal translation: small rowboat
Most likely origin: Oaxaca and central Mexico
Description: A whole round fried tortilla is the base, topped with desired toppings: beans, cheese, meat, lettuce, onions, tomatoes, sour cream, guacamole, salsa, etc. (some people call it a tostada).

CHIMICHANGA
Literal translation: trinket or trifle
Most likely origin: Mexican states of Sinaloa and Sonora
Description: Deep-fried burritos (see description of burritos above).

ENCHI-BURRITO
Literal translation: combination of *enchilada* and *burrito*
Most likely origin: Tex-Mex
Description: A burrito using a flour tortilla covered in sauce.

ENCHILADA
Literal translation: rolled corn tortilla
Most likely origin: Mexico in Mayan times
Description: There are two main styles of enchiladas: rolled and stacked. The stacked enchiladas are similar to a burrito but filled with various ingredients and covered in sauce. Examples: cheese enchiladas with red chili sauce, chicken enchiladas covered with salsa verde, beef enchiladas with chili sauce. If the stack is topped with a fried egg, it's called enchiladas montadas.

FIDEOS
Literal translation: noodles
Most likely origin: Spain
Description: Although there are several varieties of this dish, most often fideos refers to noodles cooked with Mexican meat and broth. It is typically served with tortillas, rice and beans.

FLAUTA
Literal translation: flute
Most likely origin: Mexico
Description: Whole round tortilla, filled with desired ingredients (meat, cheese, sauce, etc.) then crispy-fried (some people call them taquitos).

GORDITA
Literal translation: little fat one
Most likely origin: Mexico, Colombia, Venezuela
Description: Small, thick round pastry made of masa harina and stuffed with desired fillings such as beans, cheese, meat, lettuce, tomato and onion (similar to a Venezuelan arepa).

NACHO
Literal translation: flat-nosed
Most likely origin: Coahuila, Mexico
Description: The chip is a quarter of a whole tortilla, fried and layered with desired toppings such as beans, cheese, meat, lettuce, tomato and onion (some people use the term botanas or campechanos to describe nachos as well).

QUESADILLA
Literal translation: derived from the Spanish words for cheese (queso) and tortilla
Most likely origin: Mexico
Description: A flour or corn tortilla either filled with cheese and desired ingredients and folded in half or two tortillas with the filling in between. Typically served cut up in small wedges.

TACO
Literal translation: plug, wad
Most likely origin: Mexico

Description: Soft tacos are made with either flour or corn tortillas and filled with desired toppings; crispy tacos use corn tortillas that are fried to form a boat shape and stuffed with desired fillings.

TAQUITO
Literal translation: small taco
Most likely origin: New Mexico, Southern California
Description: A whole round tortilla filled with desired ingredients (meat, cheese, sauce, etc.) and then crispy-fried (some people call them flautas).

TOSTADA
Literal translation: toasted
Most likely origin: Colombia, Mexico
Description: A whole round fried tortilla is the base, layered with desired toppings: beans, cheese, meat, lettuce, onions, tomatoes, sour cream, guacamole, salsa, etc. (some people call them chalupas).

RISE AND SHINE!
BREAKFAST IN THE BIG BEND

Adele's Ranch Biscuits

Courtesy of Michelle West, Rancho Escondido

The Mitchell women from the Rancho Escondido have all been great cooks. Aurie, her daughters and nieces use recipes that have been handed down for generations. Adele's Ranch Biscuits, I believe, is the best biscuit recipe ever.
—Michelle West

1 package active dry yeast
½ cup warm water
5 cups flour
½ cup sugar
2 cups buttermilk
1 teaspoon salt
½ teaspoon baking soda
½ cup butter

º Preheat oven to 400 degrees.
º Mix together 1 package of active dry yeast in a bowl with ½ cup of warm water until dissolved.
º Mix together in one bowl flour, sugar, buttermilk, salt and baking soda.
º Add dissolved yeast mixture and combine. Do not overwork the dough. Roll out or press out dough on floured surface and cut.
º Melt ½ cup of butter and pour into the bottom of a 9x12 baking dish. Place biscuits close together and bake for 15 to 20 minutes until brown.

Baked Almond French Toast

Courtesy of Mountain Trails Lodge B&B

This delectable French toast is based on a recipe given to me by my office assistant. Her husband remembers his Aunt Jean baking French toast, and now he won't eat it any other way! I added my own special touches. Growing up on a farm, we used heavy cream, butter and real eggs, which make everything taste better!

—Jenny Turner

Serves 6–8

12 large eggs
¼ cup heavy cream
2 tablespoons sugar
pinch salt
2 tablespoons real almond extract
1 loaf day-old French or Vienna
 bread, sliced into about 12 pieces
powdered sugar
butter
fresh strawberries, sliced
maple syrup

º Preheat oven to 375 degrees. Treat your baking tray liberally with baking spray and preheat the treated baking tray in the oven.

º Whip eggs, heavy cream, sugar, salt and almond extract until well blended. Soak slices of French bread in the batter. Arrange soaked slices on the hot baking tray and bake for 8 to 10 minutes. Flip toast with a sturdy spatula and bake another 5 to 6 minutes until golden brown.

º Sprinkle warm French toast with powdered sugar. Serve with real butter, sliced fresh strawberries and real maple syrup.

º Tip: The amount of egg and heavy cream you need will depend on how soft and absorbent the bread is. The softer the bread, the more egg batter you will need.

Blueberry Oat Waffles

Courtesy of Mountain Trails Lodge B&B

This recipe uses my mom's trick of substituting applesauce or yogurt for part of the oil and substituting part whole wheat flour and oats to make the waffles heartier and healthier.
—Jenny Turner
Serves 4–5

Dry Ingredients:
$\frac{2}{3}$ cup all-purpose flour
$\frac{2}{3}$ cup whole wheat flour
1 cup quick-cooking oats
2 tablespoons brown sugar
2 teaspoons baking powder
pinch salt
½ teaspoon cinnamon

Liquid Ingredients:
1$\frac{1}{3}$ cups milk
2 eggs
½ cup vegetable oil
¼ cup applesauce
1 teaspoon lemon juice

¾ cup fresh or frozen blueberries
¾ cup toasted pecans, chopped
butter
maple syrup

° In a mixing bowl, combine the dry ingredients. In a separate bowl, combine the liquid ingredients.
° Preheat a waffle iron, spraying liberally with baking spray.
° While the waffle iron is heating, stir the liquid ingredients into the dry ingredients and mix well. Fold in blueberries. Let stand for 5 minutes.
° Bake in preheated waffle iron according to manufacturer's directions until golden brown.
° To toast pecans, spread pecans on a lightly greased baking tray and bake at 325 degrees for 8 to 10 minutes.
° Top warm waffles with real butter, toasted pecans and real maple syrup.

House Breakfast

Courtesy of Marfa Table

This is a moderately healthy breakfast made of things one finds in the refrigerator on any given morning. Vegan chorizo will allow vegetarians to enjoy the same breakfast; use a splash of olive oil in place of animal fat.
—*Bridget Weiss*
Serves 4

12 ounces bacon, sausage or
 chorizo
4 market tomatoes, thickly sliced
 or halved
8 mushrooms, thickly sliced or
 halved
2 large jalapeños, seeded and
 quartered
4 cups greens (kale, mustard,
 collard, field greens or
 romaine), coarsely chopped
8 corn tortillas
8 yard eggs
2 mangoes, peeled and sliced
2 oranges, quartered with skins on
salsa or chili sauce for serving

° Cook breakfast meat in skillet and set to drain on cloth towel. Keep warm.
° Reserve 4 tablespoons of meat fat or use olive oil.
° In succession, cook vegetable groups one at a time in grease or oil until just browned and al dente. Set aside and keep warm.
° Cook tortillas in greased pan until soft, 30 seconds or less on each side. Wrap in a cloth and sandwich between two small plates to keep warm and pliable.
° Fry eggs in remaining grease or oil. Poached eggs are also beautiful with this breakfast.
° To serve: Arrange tomatoes, mushrooms and jalapeños in a semicircle around a mound of cooked greens. Place fruit to the other side of the greens.
° Top greens with cooked eggs and serve with tortillas and chili sauce.

Ranch Biscuits

Courtesy of Marilyn Shackelford

> *Everyone needs a go-to recipe for biscuits; this is Marilyn's.*

1 package dry yeast
½ cup warm water
2 cups buttermilk (or sour milk)
½ cup salad oil
½ cup sugar
¼ teaspoon soda
1 teaspoon salt
3 teaspoons baking powder
4½ cups flour

° Dissolve yeast in a large bowl in ½ cup of warm water. Add buttermilk and oil. Stir well. Add sugar, soda, salt and baking powder. Add flour. Knead well on floured board. Place in greased bowl and cover. Refrigerate. Pinch off desired number of biscuits and bake in 425-degree oven approximately 15 minutes or until done.

Veranda Apple-Cinnamon Oat Pancakes

Courtesy of the Veranda Historic Inn

> *Built in 1883, the Veranda is one of the oldest hotels in West Texas.*
> *This recipe yields 14–15 five-inch pancakes.*

1 cup whole wheat flour
1 cup oatmeal (quick or regular)
2 tablespoons sugar
2½ teaspoons baking powder
1 teaspoon cinnamon
1 teaspoon salt
2 large eggs
²/₃ cup milk
²/₃ cup buttermilk

1 cup applesauce
¼ cup canola oil
¾ cup chopped walnuts

° Stir together dry ingredients.
° Beat eggs in separate bowl. Stir in milk, buttermilk, applesauce and oil.
° Add liquid mixture to dry ingredients. Stir just until well blended. Fold in walnuts.
° Pour batter onto lightly greased 350-degree griddle, measuring out ¼ cup for each pancake. Cook until bubbles form and edge begins to firm, approximately 30 seconds to 1 minute. Flip and brown other side. Serve with butter and warm maple syrup.

MARATHON

Above: Creative Commons Attribution 4International. Robert Hensley via Flickr.

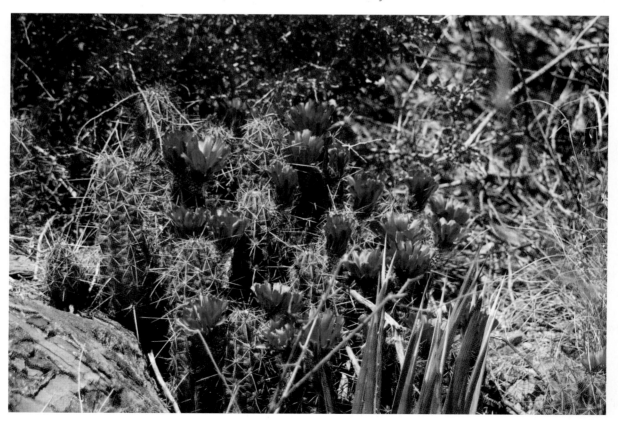

GEOLOGY 101: THE MARATHON BASIN

BY RUSS TIDWELL

There's a great book called *The Roadside Geology of Texas*, by Darwin Spearing, and all throughout it has major segments of Texas highways listing prominent geological features. In the beginning of that book, it goes through the terms that are going to be used to describe the various geological periods. The Marathon Basin is mentioned in virtually every period because it has the oldest exposed rock in Texas and most of the younger ones. The Marathon Basin sits on the old Ouachita Mountain range. It has lots of 350-million-year-old rock. This ancient mountain range underlies much of Central Texas, but this is the only place it is exposed. So within the basin we have exposed rock of virtually every other geologic period on the record.

The Marathon Basin is tied with a few places, such as the Franklin Mountains in El Paso and Enchanted Rock in the Llano uplift, for having the oldest exposed rock in Texas.

The Glass Mountains are to the north. They are partly an ancient reef structure; the Capitan reef is about 130 to 165 million years old. It is a gigantic horseshoe-shaped reef structure. One end is exposed above ground north of Marathon where you can see it in the Glass Mountains, but most of it is underground to the east, where it is an aquifer. The other end of the horseshoe comes above ground in the Guadalupe Mountains to form the highest peak in Texas—El Capitan in the Guadalupe Mountains National Park—so the horseshoe is hundreds of miles long.

The mountains you see to the west are the Del Nortes, and they are sedimentary and igneous. You can generally describe them as formed by the same process that formed the Rocky Mountains. They are a collision of the North American plate with the Pacific plate.

South of Marathon, about ten miles, is the only place on the North American continent where the Rocky Mountain range meets one of the older East Coast ranges. The more ancient Ouachita Belt collides with the Rockies there.

BRIEF HISTORY OF MARATHON

Established in the late 1800s as a railroad town, Marathon is considered the gateway to the Big Bend region. The main products shipped from Marathon on the railroad included livestock, wool and large game. The mining, wax and rubber industries were also served from Marathon as a central shipping point on the Union Pacific Railway.

Captain Albion E. Shepard is credited with naming the town. The former sea captain and railroad surveyor who established Iron Mountain Ranch is reported to have said that the landscape reminded him of Marathon, Greece.

A post office was built in 1883, and the first school was established five years later. A windmill in the center of town once served as the town's first jail, where offenders were chained to its base.

Today, Main Street is a collection of galleries and small businesses on a stretch of U.S. Highway 90 where traffic is slowed to twenty miles per hour. The historic Gage hotel still stands as a central pillar of the community and is flanked by locally owned restaurants and shops.

Boasting of itself as the "town where there's nothing to do," the community offers a quaint getaway spot with only the basics for travelers. Marathon sets itself apart as having some the darkest night skies in the region. The current population is around four hundred.

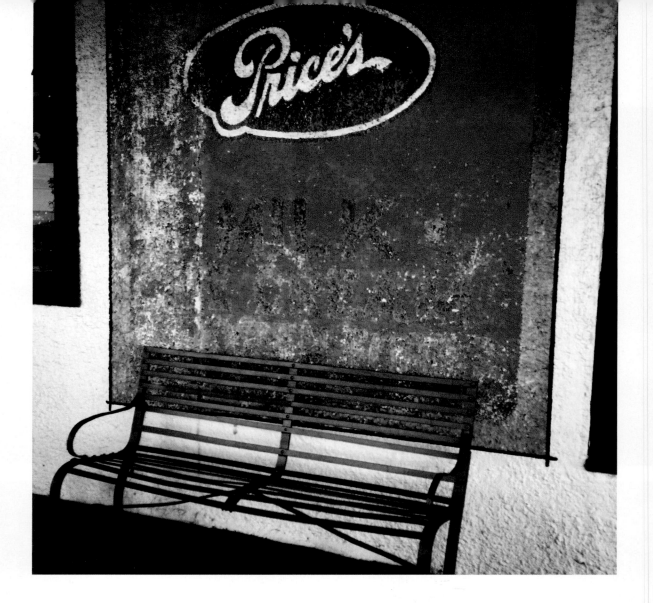

Big Bend Bucket List: Marathon

- Ride your bike on the Post Road to Post Park
- Check out the art galleries and stores on Main Street
- Attend the West Fest Cabrito Cook-off
- Run or volunteer in the Marathon 2 Marathon

Adams Famous Goat Meat

Courtesy of Brandy Rainey-Amstel

This is one my family has served to family and friends for generations on the ranch while working cows and celebrating the joys of life.
—Brandy Rainey-Amstel
Serves 4 people

1½ pounds goat meat (can substitute with beef, pork or deer) from shoulder, ham and backstrap
1 beer
2 cups flour (for healthier option, use coconut flour)
1 teaspoon salt
1 teaspoon pepper
oil, for cooking

° Cut up goat meat into small bites and put into a bowl. Pour 1 beer over meat, making sure that pieces are submerged. Put in refrigerator and let sit overnight.
° In a bowl, add flour, salt and pepper. Douse meat in flour mixture to coat evenly.
° In a frying pan, add oil about ¾ inch deep. Add enough meat to fill pan without the pieces touching one another. Cook approximately 4 minutes on first side or until blood boils out. Flip with a fork and let cook another 3 minutes on other side.
° Remove from skillet onto a plate with paper towel to soak up the excess grease.

Buffalo Chili

Courtesy of Harold Cook

2 pounds beef or bison
1 8-ounce can tomato sauce
1 14.4-ounce can diced tomatoes
1 diced tomato can full of water
6 tablespoons chili powder
2 teaspoons paprika
2 teaspoons cumin
1 tablespoon onion powder
1½ tablespoons garlic powder
1 teaspoon salt
1 teaspoon oregano
1 teaspoon cayenne pepper
1 teaspoon black pepper
2 tablespoons masa flour
Fritos, to serve
chopped onions, for garnish
shredded cheddar, for garnish

° Brown the meat in a large pot. Be warned that if you opt for the ground buffalo, you'll wonder why it smells so weird while it's browning. Don't worry—it'll come out fine in the end. Drain the fat after the meat browns.

° Add the tomato sauce, diced tomatoes, water, chili powder, paprika, cumin, onion powder, garlic powder, salt, oregano, cayenne pepper and black pepper. Cover, lower the heat and let that simmer for at least 30 minutes if you're using ground meat. If you're using chili or stew meat, let it simmer until the meat is falling-apart tender, which will be an hour or longer. Stir it up every once in a while. Don't get in a hurry on this part; this is when all the flavors mix and mingle. Consider it a singles bar

If you try to make chili in any other way than "season to taste," you don't get the point and you've already lost the war. That said, most people need to know the ballpark ground rules for making a great pot of chili. But honestly—don't expect exact quantities on ingredients, because at the end of the process, what you really want is for it to taste great to you.

Here's what I start with for a pot of chili. Think of the quantities as friendly suggestions rather than rules. It's the only real way to get into the true spirit of making chili anyway.

Use 2 pounds of beef or bison. It can be ground beef or half ground beef and half stew meat or all stew meat. My personal favorite: a couple of pounds of ground bison—ground buffalo meat to the uninitiated. Not only does it taste great, but you can brag to your guests that they're eating buffalo chili, which sounds much more exotic than it actually is."

—Harold Cook
Serves approximately 6–8

for tasty ingredients—they need to meet and get to know one another. Don't go for the speed date.

° In a small bowl stir the masa flour into a small amount of warm water until it becomes a paste, then stir that into the pot. Cover and let that simmer another 20 minutes.

° Now's when the rubber meets the road: re-seasoning to taste. I almost always have to add more salt. I always always always have to add more garlic powder because garlic is the nectar of the gods, and if you disagree, get the hell out of my kitchen. Depending on the crowd I'm feeding, I often add more cayenne because I like a pretty big bite on my chili. If the chili doesn't taste chili-like enough to suit you, add more cumin. If the chili's too thin, add a bit more of the masa mixture, and if it's too thick, add a little more water. Whatever you add, give it a few more minutes of simmering time before serving.

° My favorite way to serve it is Frito pie–style—pour the chili over a mound of corn chips in a bowl, then top with chopped onions and/or grated cheddar cheese.

° Where are the beans, you ask? There are no beans in chili. This is not debatable.

Cabrito

Courtesy of Russ Tidwell

The same recipe can be applied to brisket or Cabrito. Depending on amount of meat used, this recipe serves approximately 6–8

quartered goat
preferred dry rub, to taste
onions, quartered
chipotle peppers (canned)
oregano, dried
jalapeños, deseeded or whole
black pepper
can anchovies

° Put your preferred dry rub on the quartered goat and smoke on a regular BBQ smoker with mesquite wood for 2 to 2½ hours at 250 degrees. Then, chop the meat and place in roasting pans that can be easily sealed.

° Add quartered onions, chipotle peppers (drained from the can), oregano, deseeded or whole jalapeños, black pepper and anchovies, all to taste.

° Put the top on the roasting pan, cover it with foil and put it in an underground, preheated pit with hardwood (mesquite or oak) for 6 to 8 hours. The idea is to bury the sealed container underground and smother it with fire. After 6 to 8 hours, dig up the container. The meat will be fall-off-the-bone tender, and all those flavors will be infused.

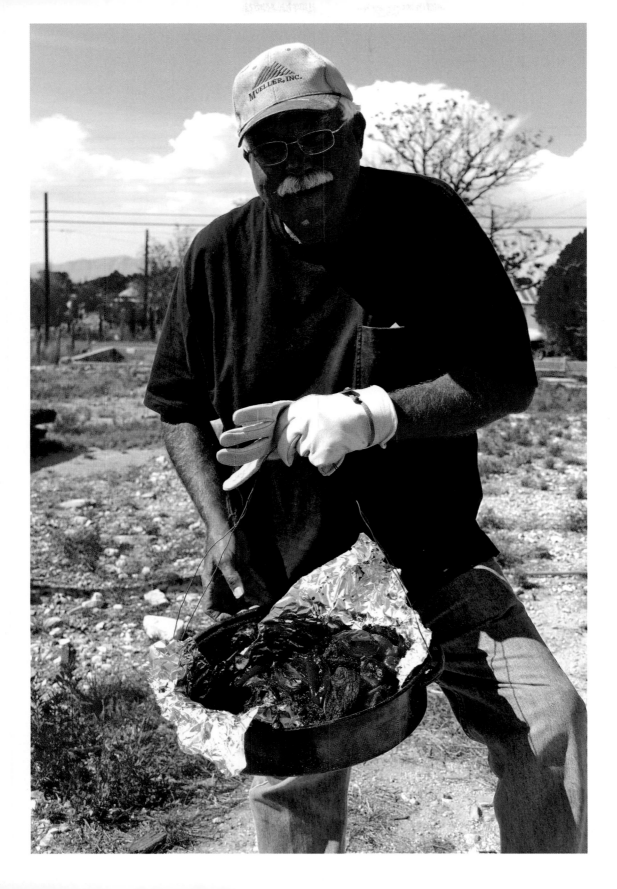

Chicken Corn Chowder

Courtesy of Linda Trumbower

1 tablespoon butter
1 8-ounce package fresh
 mushrooms, sliced
1 medium yellow "Texas Sweet"
 onion, chopped
2 14½-ounce cans chicken broth
1 16-ounce package frozen
 shoepeg white corn
2 cups cubed cooked chicken
 breast
1 10¾-ounce can cream of chicken
 soup
½ cup uncooked orzo
½ teaspoon dried basil
1 tablespoon sugar
½ teaspoon pepper
½ teaspoon rosemary or thyme
½ teaspoon salt
1 cup milk
2 tablespoons all-purpose flour

"This is my mother's recipe."
—Linda Trumbower

° Melt butter in large Dutch oven over medium-high heat. Add mushrooms and onion and sauté for 5 minutes or until tender.
° Add chicken broth and next nine ingredients. Simmer 10 minutes or until orzo is tender.
° Stir together milk and flour in a small bowl. Gradually stir into chowder and simmer 5 minutes.

Cotulla Ranch Fish Fry

Courtesy of Kimball Martin

Serves 2–4

1 New Orleans–style fish fry
 breading mix (10-ounce bag)
$1/8$ cup Tony Chachere's Creole
 seasoning
$1/16$ cup lemon pepper
1 tablespoon black pepper
$1/16$ cup powdered garlic
3 eggs
¼ gallon milk
3–4 pounds red fish or your choice
 of fish
oil for frying, your choice
lemon juice, to taste

○ Mix all dry ingredients in a large bowl. Mix eggs and milk in a separate bowl. Dip raw fish in the wet mixture, then in the dry batter mixture and fry in oil at 350 degrees for 5 to 10 minutes or until golden brown and cooked through. Add lemon juice on top of cooked fish to taste.

Harold's Halibut with Cilantro Sauce

Courtesy of Harold Cook

> *"So...as with any great meal preparation plan, the very first step is to lure somebody into your kitchen who you actually like hanging out with. Step two is to open the first, but not last, bottle of wine of the evening, in this case a chardonnay or pinot grigio. Don't even think about starting to cook until you're at least a glass into it."*
>
> *—Harold Cook*
>
> *Serves 2*

2 halibut fillets
1 stick butter (Yes, I mean butter. If you can't take it, go back to your wussy little tofu miserable life.)
2 medium tomatoes, finely diced
4–5 cloves garlic, finely chopped (At least. To start. Don't wanna scare ya.)
white wine
capers (I dunno, maybe a medium handful tops, I never measure anything)
pinch fresh cilantro, for the sauce and to garnish

° Preheat oven to 325 degrees.
° On the stove, preheat a large skillet until hot, then add a little butter or oil or Pam or other oil-like substance that isn't vaseline. Sear fillets on both sides (even if the skin is still on, which I recommend). Don't overdo it—you don't want to overcook the fish, you just want some color on the top and bottom and start 'em out right. Carefully remove the fish from the pan, put it in something oven safe and pop it in the oven to finish cooking.
° Refill your wine glasses. You're falling behind on that by now.
° Remove the pan from heat for a minute or two to let it cool somewhat, then put it back on low heat and add a little bit of the butter, the tomatoes and some of the garlic (you can add more garlic until it seems like the mosquitoes will leave you alone for a while, or to taste). You really don't want to stop stirring at this point, except for brief wine breaks. As the tomatoes get really red, add some of the wine from your glass and let that simmer for a minute or two, then add the

rest of the butter and the capers plus a pinch of fresh cilantro. Stir it around on low heat until the butter melts, plus another couple of minutes.

° By now, in the time since the fish disappeared into the oven, you've probably killed about 10 to 15 minutes BS'ing with your partner and preparing the sauce, and that's more than enough time for the fish. Remove them from the oven, carefully transfer each fillet to a plate, drizzle the sauce over the fish, sprinkle a few leaves of the cilantro to garnish, refill the wine and eat up. If you end up with food poisoning, don't come cryin' to me, but that's how I've done it a hundred times and I'm still taking up space on the planet.

° Graham Kerr would be proud because you drank a lot of wine. Julia Child would be proud because you spared no garlic or butter. Really, the only victims here are the halibut, and the hell with 'em. Have fun.

° See more at www.lettersfromtexas.com.

The Gage's Mexican Seafood Cocktail

Courtesy of 12-Gage Restaurant and White Buffalo Bar, Gage Hotel

Serves 6–8

½ cup fresh lime juice
½ cup Heinz chili sauce
¼ cup olive oil
½ cup tomato juice or Clamato juice
¼ cup fresh cilantro, chopped
¼ cup green olives, chopped
¼ cup yellow onion, diced
½ cup seeded roma tomatoes (about 2), diced

½ cup chopped green chili (2 4-ounce cans, drained)
¼ cup jalapeño (about 1, seeded and deveined), diced
1 pound chopped shrimp or lump crabmeat
1 avocado, diced
kosher salt to taste

° Combine the first ten ingredients in a large bowl; gently fold in seafood and avocado and adjust seasoning. Serve with tortilla chips.

Tarragon Chicken Salad

Courtesy of Linda Trumbower

Serves 2

¼ cup mayonnaise
1 tablespoon fresh tarragon, chopped
1 teaspoon lemon juice
2 cups cooked chicken, diced in ½-inch cubes
¼ cup dried cranberries, finely chopped
1 stalk celery, finely chopped
1 tablespoon red onion, finely chopped

○ In a small bowl, create the dressing by combining mayo, tarragon and lemon juice. Mix well.
○ In a medium bowl, add the chicken, cranberries, celery and onion and lightly toss to mix. Add dressing and mix well. Chill 6 to 8 hours before serving.

The French Company Grocer's Egg Salad

Courtesy of Marci Roberts

"This is a great booster to get you through the day. I need to eat something often, and I find if I have some eggs that I am good to go for a while. I was in Dallas eating at my favorite restaurant, Local. The owner, Tracy Miller, is a friend of my companion, and that evening she came out to talk to us. She found out I was from Marathon and said, 'They have the greatest little grocery store there with the most fabulous egg salad.' I was thrilled!"

—Marci Roberts
Serves approximately 6–8

1 dozen eggs, boiled and peeled
1½ tablespoons Miracle Whip (can also use fat-free)
1 teaspoon mustard
½ teaspoon salt
5 shakes pepper

° Remove 6 yolks and give them to the kitties.*
° Chop the remaining eggs in large chunks and combine with the remaining ingredients.
° Shake a little pepper on top of each serving.

*In Marathon, we have several feral cats; the yolks go only to the kitties we have fixed. Currently, we have thirteen "cared-for" kitties.

Coleslaw

Courtesy of Brandy Rainey-Amstel

6 cups green cabbage, chopped
½ cup red onion, chopped
½ cup pickled jalapeño or serrano
 peppers, chopped
¼ cup juice from pepper jar
1 cup Marzetti Original Slaw
 Dressing
½ teaspoon black pepper

"Let's spice it up! This is my take on an oldie but a goodie."
—Brandy Rainey-Amstel
Serves 4

° Cut end off of a head of green cabbage and then cut it in half. Now cut small slivers approximately ¼ inch thick. Place chopped cabbage into a large bowl. Chop red onion and pickled peppers and add to bowl. Next add pepper juice, Marzetti Original Slaw Dressing and black pepper. Mix thoroughly.
° Can be served immediately. Best if put in refrigerator to set for about an hour.

Brandy Rainey-Amstel

Mozzarella and Tomato Salad

Courtesy of Z Bar Farm

Serves approximately 3–4

4 ounces mozzarella
4 spring onions
4 sprigs sweet basil
½ pound tomatoes, thinly sliced
salt and pepper, to taste

° Cut cheese into cubes. Chop onions and basil. Arrange tomatoes, mozzarella, onions and basil in a bowl. Add salt and freshly ground pepper to taste. Cover and chill in the refrigerator before serving.

Variation—French Dressing:
6 tablespoons olive oil
3 tablespoons wine vinegar
pinch sugar
½ teaspoon French mustard
salt and freshly ground pepper

° Mix all ingredients in a glass jar and shake well. Pour over the tomatoes and mozzarella.

Potato Salad

Courtesy of Brandy Rainey-Amstel

"This is my grandma's famous recipe that we had every Easter and Mother's Day and any other day that she felt like making it. This recipe serves 4–6 people."
—Brandy Rainey-Amstel

6 medium-large potatoes
4 medium sour pickles, diced
¾ teaspoon salt
¾ teaspoon black pepper
¼ cup juice from sour pickle jar
⅔ cup mayonnaise

° Preheat oven to 350 degrees. Wash potatoes, then take a fork and poke into the middle of each, about halfway in. Set straight on baking rack. Bake for 1.5 to 2 hours until skin is crisp. Remove from oven and let set for about 10 minutes to cool.
° In a bowl, add chopped sour pickles. Now cut potato in half longwise, then cut each half into half again. Next chop into ¾-inch bite sizes. Add potatoes to the bowl with pickles. Add salt, pepper, sour pickle juice and mayonnaise and stir together until mixed. Be careful not to over mix.
° Best served warm.

Brandy Rainey-Amstel

Sunny Broccoli Salad

Courtesy of Patsy Ruth Cavness

"I got this recipe from a friend and it's really good."
—Patsy Ruth Cavness
Serves approximately 6–8

3 cups broccoli, diced into small florets
¼ cup white onion, diced
½ cup peanuts
2 cups cheddar cheese, grated

⅓ cup raisins
½ cup mayonnaise
2 tablespoons sugar
2 teaspoons lemon juice
bacon bits, to taste

° Mix broccoli, onions, peanuts, cheese and raisins. In a separate bowl, mix mayo, sugar and lemon. Mix all together. Just before serving, add bacon bits.

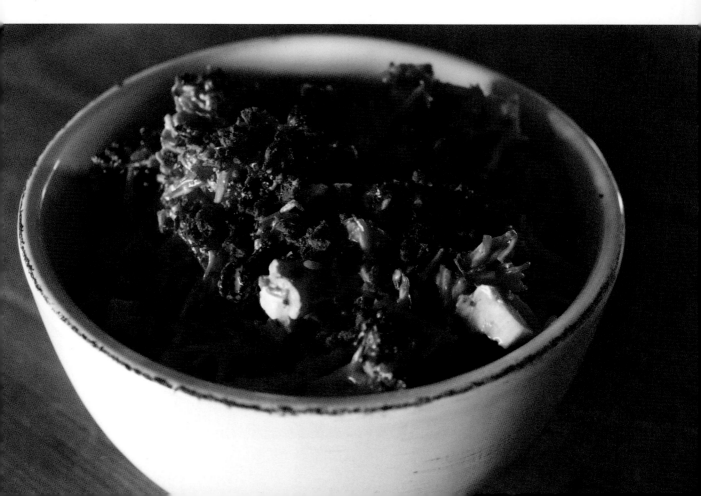

Tortilla Pinwheels

Courtesy of Linda Trumbower

> *"My sister and I were experimenting in the kitchen. We needed something for one hundred people, and we came up with this."*
> *—Linda Trumbower*
> *Yields 50*

Filling:
8 ounces sour cream
8 ounces cream cheese, softened
1 4-ounce can green chilies (well drained), diced
1 4-ounce can black olives (well drained), diced
1 cup cheddar, grated
½ cup green onion, chopped
garlic powder, to taste
salt, to taste

5 or 6 10-inch flour tortillas

° Mix filling ingredients and spread evenly over tortillas. Roll each in jellyroll fashion. Wrap each tightly in plastic wrap. Refrigerate 24 to 48 hours.
° Using a serrated knife, cut into ½- to ¾-inch slices. Lay flat to serve. Can be served with salsa.

Cowboy Grill Cobbler

Courtesy of Toby Cavness

This recipe comes from Toby Cavness's former restaurant in Alpine: Cowboy Grill.

1 cup flour
1 cup sugar
1 tablespoon baking powder
1 teaspoon cinnamon
1 cup milk (give or take, depending on how thick the batter is)
1 stick butter
4 cups your fruit of choice (peaches, apples, cherries, pineapple)
brown sugar, to coat cobbler
cinnamon, to taste, to sprinkle on top of cobbler

° Mix together the flour, sugar, baking powder, cinnamon and milk. Melt a stick of butter, pour it in a 9x13 pan and pour the flour mixture on top of the melted butter. Add fruit on top of the batter, but do not mix the fruit into the batter. Cover the fruit layer with brown sugar and sprinkle cinnamon on top of the sugar to taste. Put it in the oven at 350 degrees for about an hour. During the baking process, the batter will bubble up on top with a nice layer of crust and the fruit on bottom.
° I get creative at times. I put crushed pineapple in with peaches or apples or blueberries in with cherries or apples. You just cannot ruin this. Happy baking.

Cracker Pie

Courtesy of Linda Trumbower

"This is my great-aunt's recipe."
—Linda Trumbower

6 egg whites
2 cups sugar
2 teaspoons baking powder
2 teaspoons vanilla extract
1 cup ground pecans
1 cup crushed saltines
whipped cream, for garnish

° Beat egg whites until stiff. Mix in sugar thoroughly, then mix in remainder of ingredients. Stir well. Bake in an oiled 9x13-inch pan at 350 degrees for 30 minutes. Serve with whipped cream.

Crazy Chocolate Cake

Courtesy of Marilyn Shackelford, from
The Marathon Cookbook: Bicentennial 1776 to 1976

When I interviewed Marilyn, she shared a copy of The Marathon Cookbook: Bicentennial 1776 to 1976. *Each recipe title was written in Spanish and English: Crazy Chocolate Cake (Loco Pastelillo de Chocolate) and Icing (Escarchado).*

Crazy Chocolate Cake:
3 cups flour
2 tablespoons vinegar
2 cups sugar
2 teaspoons vanilla
6 tablespoons cocoa
2 cups cold water
2 teaspoons soda
1 teaspoon salt
$^2/_3$ cup liquid oil or oleo

° Preheat oven to 350 degrees. Mix and bake for 40 minutes.

Icing:
2 cups sugar
2–3 tablespoons cocoa
½ cup milk
½ cup chopped nuts

° Cook to a soft boil sugar, cocoa and milk. Add nuts, then punch holes into cake with fork and pour hot icing over top of warm cake.

Daisy's Coconut Cake and Seven-Minute Frosting

Courtesy of Meredith Beeman, as adapted from
Betty Crocker's Picture Cook Book, *1958*

Daisy's Coconut Cake:
2¼ cups cake flour
1½ cups sugar
3½ teaspoons baking powder
1 teaspoon salt
½ cup unsalted butter, softened
 (I use European style to
 approximate farm-fresh butter)
1 cup milk, divided
1 teaspoon coconut flavoring
½ teaspoon almond extract
4 egg whites, unbeaten

° Grease and flour two 8- or 9-inch round cake pans or one 9x13 oblong pan. Preheat oven to 350 degrees.
° Sift together cake flour, sugar, baking powder and salt.
° In a separate bowl, combine butter, ⅔ cup milk and flavorings. Add to flour mixture. Beat for 2 minutes. Add ⅓ cup milk and egg whites, unbeaten. Beat for 2 more minutes.
° Pour into prepared pans and bake until cake tests are done, 30 to 35 minutes (35 to 40 minutes for oblong pan). Turn out onto a wire rack and cool. Finish with Seven-Minute Frosting.

"Daisy made wonderful cakes— German chocolate for my birthday with buttermilk from their dairy. So when I was about ten and spending a few weeks at their farm (they were living in Miles then), I decided to make her a birthday cake—her favorite, Coconut Cake with Seven-Minute Frosting. I wanted to decorate it, but there were no candles (and it was quite a trek to the store), so I used daisies from her huge flower garden. I believe it was the best gift I ever gave her—she talked about it for years."
—Meredith Beeman

Seven-Minute Frosting:
2 egg whites
1½ cups sugar
¼ teaspoon cream of tartar
½ cup water
pinch salt
1 teaspoon vanilla or 1 teaspoon coconut flavoring
shredded coconut

° Combine all ingredients except flavoring and coconut in the top of a double boiler. Place over boiling water and beat with a rotary beater until the mixture stands in stiff peaks, scraping bottom and sides of pan occasionally. Remove from heat and add flavoring.
° Spread on cooled cake. Sprinkle shredded coconut on top and press lightly on sides of cake. Optional: Use apricot preserves or lemon curd for filling. Decorate with fresh daisies—watch out for bugs!

Fruit Cocktail Cake

Courtesy of Marilyn Shackelford, from The Marathon Cookbook:
Bicentennial 1776 to 1976

*Use a can of fruit cocktail to
make a delicious dessert.*

2 eggs
1½ cups white sugar
2 cups flour
2 teaspoons baking soda
#303 or #2 can fruit cocktail
flour and grease for lining cake pan
½ cup brown sugar
½ cup pecans (optional)

° Mix eggs, white sugar, flour and baking soda. Add juice of #303 or #2 can fruit cocktail. Mix until smooth. Pour into greased and floured cake pan. Sprinkle ½ cup brown sugar on top. Add ½ cup pecans (optional). Bake in moderate oven 40 minutes.

Frosting:
1 cup sugar
1 cup milk
1 stick oleo
1 teaspoon vanilla

° Boil all ingredients except the vanilla for 5 to 8 minutes. Add vanilla. Pour over cake.

German Fruitcake

Courtesy of Patsy Ruth Cavness and Janie Roberts, from their cookbook In the Kitchen with Patsy and Janie

¾ cup margarine
2 cups sugar
4 eggs
3 cups flour
½ teaspoon allspice
²/₃ cup pineapple preserves
²/₃ cup apricot preserves
²/₃ cup cherry preserves
1 cup buttermilk
1 teaspoon soda
1 cup pecans, chopped

° Cream margarine and sugar. Add eggs one at a time. Beat well and add dry ingredients. Add preserves, buttermilk and soda. Beat well. Add nuts and beat. Bake in two loaf pans at 350 degrees for approximately 1½ hours.

Patsy's favorite recipe from her cookbook is the German Fruitcake. "However, it's not my recipe," she says. "A cousin gave it to me. But I made it all the time, and it's just one of my favorites. It was Markellen Garrett's recipe."

Sopapilla Cheesecake

Courtesy of Patsy Ruth Cavness and Janie Roberts, from their cookbook In the Kitchen with Patsy and Janie

"The Sopapilla Cheesecake was another great recipe from our cookbook. It was Janie's recipe," shares Patsy. "We had a quilting club that had a Christmas meal, and that was the first time I remember her making it."

2 tubes crescent rolls
3 8-ounce packages cream cheese
1½ cups sugar, plus 1 tablespoon reserved
1½ teaspoons vanilla
1 stick butter, melted
1 teaspoon cinnamon

° Spread one can of crescent rolls in a 9x13 pan that has been sprayed with Pam. This will be the bottom crust.

° Mix together cream cheese, 1½ cups sugar and vanilla. Spread this mixture on the bottom crust. Now spread the second can of crescent rolls on top of the cream cheese mixture. This will be the top crust.

° Spread melted butter evenly over top. Mix the remaining sugar and cinnamon and sprinkle over the top crust. Bake at 350 degrees for 45 minutes, taking care to watch the cooking process to not burn the crust. Cut into 2-inch squares and serve.

LOCAL LORE AND LEGENDS IN MARATHON

LYNDELL "SHACK" SHACKELFORD

Dead Horse Mountain Ranch

Lyn "Shack" Shackelford is one of the most colorful characters you'll have the opportunity to meet in Marathon. Whether you see him riding down the road in his tractor, hauling Spanish daggers in a trailer behind his big white truck or kicking back with a toddy, Shack doesn't know a stranger and welcomes just about anyone to the conversation. He owns the liquor store in town with his wife, Della, and they split their time among their home in Marathon, their ranch house at the Dead Horse Mountains and the lake in Del Rio.

Shack graduated high school from Marathon ISD in 1985 with thirteen in his class. He played football, went to state in track and was on the basketball team when it won the state championship. "Mom [Marilyn] and Dad [Macky] both went to school here in Marathon. They were born and raised right here. I got six generations in the cemetery on both sides," says Shack as he sips a toddy of Weller and water while we chat.

"This family has been here since before the train came in. My great-grandmother was born here in 1892 at the town that was at the Post [a community meeting area formerly known as Fort Pena]. Then my grandparents ran the Combs ranch. My dad, aunts and uncles were all born at the Post," shares Shack.

In the early '80s, the Shackelfords acquired the Dead Horse Mountain Ranch. A little under ten thousand acres, it borders the east side of the park and the south side of Black Gap. The Rio Grande is six miles from their house.

"In 1983, I was a junior in high school at Marathon ISD," shares Shack. "Me and Dad went hunting out there—my uncle had it leased—and I fell in love.

The mountains on the map are the Caballo Muerto (Dead Horse). A doctor from Austin owned it at the time. In 1986, the doctor wanted to sell it. I was in college at Sul Ross. We got it bought. I told Dad I would quit school and go to work, but I didn't have to. We started deer hunting it and selling plants off of it, and it paid for itself."

Shack offers mule deer hunts under the MLDP (managed land deer permits). "On average, I get about fourteen to fifteen tags a year now," he shares. "At the beginning I didn't. To go back, the ranch never had fences, water wells, houses, etc. I put twenty-eight miles of pipeline in, thirty water troughs and then the deer started showing up. That's when we got on the MLDP. I feed cottonseed and protein. Back when it was raining, we had some [mule deer] that were 200-class deer. Last year [2013], we killed two that were in the high 170s and one in the 190 on the Boone and Crockett. We just need Mother Nature to help. My last survey I had a little over two hundred deer in the count."

Selling plants from the land is another income producer on Dead Horse Mountain Ranch. "Spanish daggers, giant whites, yucca rostrada and sotol are the bestsellers," says Shack. He shared a funny story about his sotol plants from his college days: "I was taking an economic botany class in college at Sul Ross. Everyone had to pick a plant to research and do a project with. I was going to make candelia wax, but Rowdy McBride picked candelia wax right in front of me, so I had to come up with a different plant that I was going to produce something with. So I picked sotol. So I go out to the ranch and come back to class with all my stuff: the stalk, how they make fences and shade arbors, the leaves, how they make roofs to shed water. Then I made the tequila from the sotol. I brought my old still to class that I used to boil the sotol. I went to the bar while it was cooking, and when I came back it had overboiled and turned bad. So I went to Boquillas and bought a real bottle of sotol and mixed it in with mine. I knew the professor wouldn't know the difference. Both of those bottles were half full. I brought salt and lime and shot glasses for the whole class. I asked the professor if he wanted a shot to see if my product was any good. He must have liked it because I made an A in the class, and it was the only A I ever made at Sul Ross University."

MARILYN LEE COE SHACKELFORD

When I went to interview Marilyn, her youngest son, "Shack," was there hunting parts for his RV. After rummaging through some drawers, she found what he needed and sent him on his way. He and his wife, Della, were headed out to their lake house in Del Rio. Marilyn and I sat down at her kitchen table and flipped through an old cookbook the citizens of Marathon had put together during the bicentennial year: *The Marathon Cookbook: Bicentennial 1776 to 1976.*

"We are both fifth generation here," says Marilyn about herself and her husband, Macky. "My grandmother [Lizzie Reynolds Crawford] was born at Fort Pena ["the Post"] in 1892, when it was still an army post. Her family came in 1886 with the Reynolds, the Tindells and the Simpsons. To back up a little further, my grandmother's daddy fought in the Civil War and my granddaddy's daddy fought in the Civil War—one fought for the North, and the other fought for the South. We have both of their discharge papers.

"When my grandparents came to the area, they homesteaded land in the Marathon Basin. Over a period of time, they got land that connected together so they could try to have a ranch, but during the drought, they lost it and the Combs bought it. My grandmother [Lizzie] was the postmistress here from June 1939 to December 1962. My mother [Lyda Coe] was a postmaster after that from 1976 to 1982, but she had worked in the post office for twenty years before that."

Before she was the postmistress, Lizzie worked at the original bank before it closed (where the vault still stands in town). The bank burned in 1920 and was eventually rebuilt across the street from where the bank is now. Lizzie also taught school at the Hidalgo Ward School. In 1911, she had an enrollment of seventy-five pupils using only one room.

"My grandmother was the first schoolteacher at Hidalgo Ward," shares Marilyn. "She taught grades first through eighth, and she was the only teacher. She got her degree from Sul Ross Normal. Mama and myself went to Sul Ross College." Several kids from the next two generations of Shackelfords went to Sul Ross State University as well.

"Daddy was a newcomer," continues Marilyn. "He came in 1933 with the CCC [Civilian Conservation Corps] down in Big Bend National Park. Daddy was a cook for them. He was eighteen years old when he came, and he stayed until 1936, then moved into town and worked. Where the liquor store is now, that was his icehouse. He worked for Granddaddy Bill too. That's where he met Lyda. Marathon was pretty booming back then; we had five big grocery stores.

"The Yellar Dab stop was a filling station that Granddaddy Bill built. Now it's the RV supply store where Dewey and Shan are. Bill did heavy equipment operations. He worked for the railroad and had Fresnos; a Fresno is a piece of machinery you pull behind mules to push dirt. He laid the foundation for the tracks for the railroad ties to go on."

When I asked Marilyn how she met her husband, Macky, she said, "We were born knowing each other, but the first time we ever danced together, I was four and he was five at the Post at the Fourth of July. This is his homestead [where I interviewed her], and I was across the alley from him. He was one year ahead of me; he graduated in '58 and I graduated in '59.

"We used to go to Fort Davis for basketball games in our school bus, and it couldn't make that hill, so we'd get out and push it. It was a 1947 school bus. Pretty new in my time," she says, laughing.

"Macky and I got married at church in Alpine in 1958, July 5, after he graduated. We left here, and he went to work for road construction. We were gone for four years. During that time, we had our oldest and middle boys. Then Macky went to work for Alfie Butane company in Alpine. We stayed there for four years, and while we were there, I got my degree in education from Sul Ross as a reading specialist. I got my master's after that. Then we moved down here and our youngest, Lyn, was born in 1966. Macky bought Alfie out and put the Marathon Butane company here in Marathon. Been here ever since."

In addition to her three sons, she raised Coe Duanne Pratt, her sister Gayle's son, after Gayle passed when Coe was twelve. Gayle was also a teacher. "She taught in Austin for the blind and deaf, as well as Midland and Fort Stockton," shares Marilyn.

Marilyn taught school for forty-seven years: twenty-nine in Marathon, six in Presidio and eleven at Sul Ross. "I was a pretty strict disciplinarian, so I didn't have too many problems," she told me after I asked her if she had any trouble with the kids.

I asked Marilyn why she thought the population had shrunk so much. She said, "Because of the businesses. We don't have any of the industries that brought people in, and then because of the droughts, ranchers downsized. And new equipment—ranchers started rounding up cattle with helicopters instead of cowboying, and all the rest just closed down."

Marilyn had a few more stories for me about her family roots in the Marathon Basin: "My mother had a sister (we called her Snooks), Ella Louise Crawford Lester. When she was nine years old, she played the piano for the silent movies here in Marathon. She played by ear; she didn't read music. They were in a building across from the general store where Dan Klepper's office is today. It was an adobe building. Snooks was born in 1914, so that was in 1923 when she was playing. When she was eighteen, she taught school at Molinar, Texas, which is within the boundaries of Big Bend National Park today. She had one classroom and had her piano in the classroom. She had a room behind that where she slept, an outdoor toilet and a place for the kids to tie their horses. I have one of her pay stubs, and it was for thirty-five dollars a month."

BRANDY RAINEY-AMSTEL

"I grew up on Chalk Draw Ranch with no electricity and no telephone," shares Brandy Rainey-Amstel. She comes from a long line of at least five generations of cowboys on both sides of her family. "My favorite pastime was riding my horse, climbing the mountains and connecting with nature. I was home schooled for a few years with a very unique upbringing. I was not the first in my family to have this experience. I come from a long line of cowboys that settled in the Big Bend country. Members of my family came to Texas in the mid-1800s, making me a ninth-generation Texan. In 1931, my great-grandparents Mildred Babb Adams and Ulice Adams came down to ranch in the Big Bend with Grandmother's uncle Boye Babb on the southeast side of the Chisos Mountains before it was part of the Big Bend National Park.

"They purchased land and ended up settling the Adams Ranch on the Rio Grande between La Linda and Boquillas Canyon or Black Gap Game preserve and Big Bend National Park. Mildred and Ulice Adams were ranchers. They were very hospitable, and the ranch became popular with visitors. People came great distances to enjoy the scenic country, hunt and fish, hunt arrowheads or just to ride the mountains on horseback. They raised cattle, Spanish goats and Angora goats, and they did candela wax work."

When they passed away, their sons Apache and David took over the ranch. "Apache is somewhat of a Big Bend country living legend," shares Brandy. "He has a book about his adventures titled *Tied Hard & Fast*. It is a fascinating read. He ranched for years in the Terlingua area and now owns a ranch in between Fort Stockton and Sanderson.

"David was very entrepreneurial and went on to build one of the largest plant nurseries, selling exotic cactus around the world, and then Rope-O-Matic, a team roping tool. He also started the annual burro gathering on the Adams Ranch and the Marathon Burro Ropings, which lasted many years.

"My aunt Ann, who grew up on the Adams Ranch, married Carl Potter, and they now live on the Potter Ranch at the foot of Santiago Peak. On the other side of my family, in 1904, A.C. Stewart came to Brewster County, and their son bought the Stewart Ranch south of Marathon from David Combs.

"My granddad was Glynn Babb and my uncle was Buster Babb, both of whom were working cowboys on the ranch. Buster became the deputy sheriff in Sanderson.

Opposite, top: A chuck wagon on the Adams Ranch. *Bottom*: Mildred Babb Adams. *Photos by Brandy Rainey-Amstel.*

"My dad, Richard Babb Rainey, and mom, Katherine Derrington (granddaughter of Mildred Adams), were married in Marathon, Texas, after graduating from Marathon High. Later, Richard became ranch foreman at Chalk Draw Ranch. He raised cows and horses. Eula Mae Adams (my grandmother) still resides in Marathon. Ann Potter still resides on the Potter Ranch with her husband, Carl, at the base of Santiago Peak. My grandmothers attended school in Marathon together many years ago."

Brandy attended high school in Marathon and left in 1988 to attend Sul Ross State in the early entry program. Later, she attended and graduated from Stephen F. Austin State University in Nacogdoches. "When I drove from my home in the desert of West Texas to the piney woods of East Texas, it was a bit of culture shock to go from one environment to the other. And I went from a town where everyone knew me and my family to a place where I didn't know a soul and there were so many people. There were three times more students in my classes than there ever were back home.

"After I graduated, I made my way to Austin and get back to the area as often as I can. I love the area [Marathon], and it will always be a part of who I am," she shares.

In high school, she participated in almost everything. "That seemed like the thing to do in such a small town," shares Brandy. "I played basketball, tennis and ran track. I was in the band playing the flute and was a part of the FFA, as well as showed horses and pigs. I participated in a one-act play and various other UIL [University Interscholastic League] activities."

There were twelve students in her grade. "My fondest memories come from grade school, when we attended school on the ranch," says Brandy. "My aunt Ann and uncle Carl had an old cattle trailer that they transformed into a small schoolhouse fully arranged with chalkboards, desks, an American flag and a library. My brother Clint Rainey and I attended classes with our cousins Kellye and Kent, while our aunt Ann would deliver the classroom material."

Brandy shares her earliest childhood memory of the area: "I remember one time we were on our way from Hondo, Texas, to see my cousins at the Potter Ranch. After hours of driving, we finally made it to the dirt road turnoff just inside the park. To our surprise, a huge storm had come through, dumping some much-needed rain to the area. We made it through the first couple of gates, and the road seemed fine. As we made our way to the third gate area, we ran into some caliche, and the truck just sank straight in. We tried a few times to get unstuck, to no avail. We were in a bit of a bind. We were a little over two miles to the Persimmon Gap headquarters, where there was a pay phone, but in '79, there weren't tow trucks to come get you fifty to eighty miles one way, and there was no telephone at the ranch. We decided

our best bet was to walk the last nine miles to the Potter Ranch. The first few miles seemed fun. It was an adventure. Then as it became darker and darker, it became far more mysterious. The stars and moon were our guiding light reflecting off the pale white dirt road. It was so quiet; you could hear the crickets, the occasional rock or bush moving from a rabbit speeding by and the howl of coyotes in the distance. I just remember thinking that it was so peaceful and beautiful. It was very early in the morning when we finally walked up to the door of the ranch house, and we were so glad to see the family. We stayed up and talked the morning away.

"As a young girl growing up, we always looked forward to the roping/ BBQ/dance at the Post for the Fourth of July, where we heard live music from Craig Carter and the Spur of the Moment Band. It was a celebration where the whole town and surrounding ranchers came together, as well as past attendees of Marathon High. It was a time of joy, laughter, good food, tall tales and lots of dancing. My brother Clint won champion at the burro roping and gathering. Also, we had a cabrito cook-off that still happens every year. My dad had a team that competed for the best cabrito, and they would fry up some goat meat."

Deer meat, beans, enchiladas, tortillas, fideo, mashed potatoes and macaroni and cheese were standard family meals. "For special occasions, we would have fried goat, venison or chicken-fried steak with mashed potatoes and gravy," Brandy shares. "We also had corn bread dressing on Thanksgiving and potato salad for Mother's Day, Easter or anytime my grandma was around.

"As a child, I was responsible for cooking one meal per day. We had bread of some sort (tortillas, biscuits, corn bread, rolls, pone bread) and beans (fresh or refried) at every meal. Since I grew up without electricity or a telephone, we didn't have television. As a family, we had to find other things to occupy our time. Cooking was a family ritual. Everyone pitched in, and we made it fun. We always welcomed visitors, which might only be once a month or so. It was great to hear a fresh perspective on the world, and I remember thoroughly enjoying sitting and listening to the stories. My favorite meals, though, were the staple refried beans and homemade tortillas with a fresh jalapeño from the garden. One of the things that I learned from my family is that most often, the simple things are the best."

Brandy met her husband at a society wedding in Kingwood. "We were both in the wedding party of nine bridesmaids and nine groomsmen," she shares. "He was my escort. We were married in Austin on Lake Travis at our home, and family came from miles away. We celebrated with the famous Adams Goat Meat (found on page 43). My husband is a serial entrepreneur

and CEO with a background in engineering, and I am a filmmaker/creative entrepreneur/artist.

"I was named Austin's Fearless Woman in 2010 and was featured in celebrity photographer Mary Ann Halpin's number-one bestselling book (Amazon) *Fearless Women: Visions of a New World* with fifty women visionaries from all over the globe who are making a huge difference for people throughout our world." Brandy's award-winning films have screened around the world at festivals, making a huge difference for people, shifting their perceptions and raising their awareness about issues, topics and causes that impact us all. She is the owner of Set It Off! Productions, a full-service film production company. Her works include the documentaries *In Her Shoes* and *World, Water & Health*, as well as narrative shorts *Little Dove, Open House* and *Snake Pit*. She is also the CEO and founder of LivingPowerfully.com.

When I asked Brandy what she wanted people to know about her community, she responded, "That it is the gateway to the Big Bend National Park, God's country and a piece of history frozen in time."

MEREDITH JEAN BEEMAN

Regarding Melba, Daisy and George Washington Watson

Born in San Angelo and currently residing in Austin, Texas, where she works for Central Market, Meredith Beeman's family roots are strong in the Marathon area. "My maternal grandparents, Daisy Gibson Watson and George Washington Watson, moved to Marathon during the Depression. My grandmother also lived in Alpine two different times," shares Meredith. Her aunt Melba Watson, wife of Gene, ran Mel's Bar in Marathon from the early 1970s until the '90s.

"My grandmother Daisy Watson worked for a while as a chambermaid at the Gage Hotel. She was quiet, sweet and generous, with bright blue eyes and a shy smile. She taught me that ladies always protected their skin from the sun when gardening. She wore a gingham bonnet and gloves to work outside. She was an excellent baker. My mother used to say that she never learned to make biscuits as well as Daisy, even though she watched her and worked beside her. She didn't use recipes or measuring cups, just knew the right amounts of everything.

"My grandfather George Washington Watson was a ranch hand and sometime bootlegger. A colorful character, but not much of a husband or

father. He was half Native American, half Scotch-Irish, so you can draw your own conclusions about his propensity for alcoholism.

"Uncle Gene Watson owned and operated the Exxon Station and a tow truck business in Marathon. He was my mother's baby brother, always kind and ready to tell a story. He remembered moving with his parents to Marathon from Barnhart in a covered wagon. He described a time when the U.S. cavalry came through looking for Mexican outlaws. They camped at the spring, and he would run barefoot through the desert to meet them. If he watered their horses, they let him stand in the chow line, and he thought that was a wonderful treat."

Meredith's earliest childhood memories of the area include long drives with mountains on the horizon, playing in a mountain pool near Alpine and riding with her step-grandfather, Johnny Breg, on his horse-drawn milk delivery wagon. "We didn't usually drive over to Marathon because my mother did not approve of Melba's bar," Meredith shares. She still treasures her grandmother Daisy's dishes, an apron and cookbook: *Betty Crocker's Picture Cook Book*, 1958 (a Christmas present from her husband, Johnny). Another family heirloom is the *Ladies' Guide to Homemaking: A Guide for the Servantless Household*. "I find that particularly touching, since they lived in dirt-floor shacks during my mother's childhood and had to tote wood and carry water," says Meredith.

Pinto beans and corn bread with chowchow were some standard family meals. "Still one of my favorite comfort foods. Sadly, I have never persuaded my kids that it is one of the most wonderful dinners you can have on a cold night. But I still make it occasionally for myself," shares Meredith.

PATSY RUTH CAVNESS

Ask anyone in Marathon for a good recipe and they will point you to Patsy Ruth. Born on November 12, 1930, in the original house where Eve's Garden (bed-and-breakfast) is now located, Patsy raised her four boys in the same community. When I sat down at her kitchen table to interview her, she shared a copy of her very own cookbook, *In the Kitchen with Patsy and Janie.* We flipped through it and talked about her family's roots in the area.

"Both sets of my grandparents came to Fort Davis around 1888 on a wagon trail from Beeville, Texas. They lived there fourteen years, then they moved to Marathon. There were still Indians in the area at the time," shares Patsy.

She went to school at Marathon ISD. "There were about twelve or fourteen in our class. I played volleyball, and we won district one year. We didn't play

basketball at that time. There wasn't a lot for young people to do, so we all spent a lot of time down at the Post, our county park, swimming or just goofing off or whatever," she says. "If we went to a movie in Alpine, there was a passenger train that came through Marathon in the morning. We could get on the train to Alpine, go to the movie and get on the train going east going home all for about $1.50; about $0.50 to ride the train, a quarter for a movie, $0.10 or $0.15 to get popcorn. The movie theater was the Granada, where the dance hall is now."

She met her husband, Sam Cavness, after he came home from World War II. "I got married too young, when I was sixteen. He came to Marathon when he was seventeen. He was from Mason County, but his sister lived here and he came here. He went in the service when he was twenty-one. I knew who he was, but I never met him until he came back from the war. Sam was with the cavalry and the infantry when he went overseas. He was stationed in Fort Bliss El Paso, then he spent three years in the Philippines, Guam and all those little islands," says Patsy.

"Sam worked on a ranch for the Combses about twenty miles south of here. We had two kids, then we moved down to Dove Mountain, which is about fifty-four miles south of here. Then we had two more kids. We had four sons, and we lived there for thirty-one years. He [Sam] was the manager of the ranch, and they had sheep. When we first went down there, the varmints were so bad we finally had to sell the sheep, so we had cattle and horses instead. It was more or less a recreation place that a doctor (Marvin Overton) and lawyer (Phil Overton) owned to bring their friends hunting. They were brothers who loved to hunt deer. I had to be in town to send the kids to school because it was too far to bus the kids, so I was only down there at the ranch on weekends, summer and holidays. We were married sixty-three years before Sam passed away."

In addition to raising her family, Patsy was on Marathon's first chamber of commerce. "We had what they call civic clubs for men and women," she explains. "The men weren't interested in keeping anything going, so a group of ladies got together and formed the Marathon Chamber of Commerce in 1964. We just advertised for the community, and one of the main things we worked on was trying to work with Mexico with the Highway 385 Association to continue the road. We went down there to Mexico to meetings but never did get it done. That's just one of the things we worked on. The first of every year, we would have a social, some kind of get-together for the new teachers in the community to recognize and honor them."

Remembering Marathon as it was when she was growing up, Patsy shares, "We had two main stores: Ritchey Brothers Mercantile and the French

Company. We always had a drugstore to go get ice cream from. We had a lumberyard, and usually someone sold feed. The Fourth of July BBQ and dance was a big event that brought the community together. It used to be the ranchers furnished the beef, and it was a free thing. During the war, we didn't have it for two or three years, and the American Legion had it."

Macaroni and cheese, corn bread, chicken-fried steak and gravy and French fries are the things she said her four boys loved her to cook the most. "I made a lot of peach cobblers and cakes, too," she says. "I learned to cook from Mother and Daddy both. Then I got married young, so I had to learn. After we married and lived out on the ranch, the first pan of biscuits I made, I didn't know if they were going to be any good. We had a wood stove. I saw Sam coming and got nervous and dropped them on the floor. I put them back in the pan like I just took them out of the oven," she says, laughing. "They weren't too good, but over the years, I learned how to make them pretty good. My grandson and I like to bet on different things. He especially likes my biscuits, so whenever I lose one of our bets, I have to make him biscuits."

Patsy's father, Leroy Granger, cooked chuck wagon meals on the nearby ranches when they had to work cattle. "The Longfellow Ranch is one he cooked on," she remembers, "also the Gage Ranch and the Combs Ranch. He didn't use recipes. He'd tell you he put a little of this and a little of that. He made a vinegar pie that was delicious, and we were always trying to get it from him, but he'd just tell us what he put in without telling us the amounts."

Eventually, Patsy shared some of her favorite recipes in a cookbook her friend Janie Roberts put together. "Janie's husband was an FFA [Future Farmers of America] teacher here, and my boys of course were in school, the youngest ones. They [the Robertses] moved away down close to Houston, then they moved back and lived on this ranch just north of where we were. We weren't neighbors because the road was too rough to visit, but I saw her in town and we would visit. We talked for several years about our recipes because we knew they were different somewhat. And everybody said, 'Well, why don't y'all put a cookbook together,' so we gathered up recipes. Then her daughter typed it out on the computer, and that's how we did it."

Patsy's favorite recipe from the cookbook is the German Fruitcake. "However, it's not my recipe," she says. "A cousin gave it to me. But I made it all the time, and it's just one of my favorites. It was Markellen Garrett's recipe. I also really like that Santa Fe Stew. A niece gave me that one, Julie Gamel. We have always traded recipes; that's part of the family we always visit with.

"The Sopapilla Cheesecake was another great recipe from our cookbook. It was Janie's recipe," shares Patsy. "We had a quilting club that had a

Christmas meal and that was the first time I remember her making it. The quilting club was a group of ladies that got together and we quilted. J.P. Bryan let us have the spot where Johnny B's is now, and we had a lot of fun. We had a quilt show every year where we gave ribbons and some of us sewed a quilt or two, but mostly we gave our quilts to family. We made a quilt every year for the cowboy social, which is a fundraiser for the Marathon Health Center. We sold tickets on it and gave them the money. We made two or three for the Cancer Society too. Janie was an excellent quilter, and we taught two or three women to quilt. People moved away, and we don't have it anymore, but we had it for about ten years. So now we have what we call the crafty ladies, and we meet every week. Some sew, some knit, some crochet; I just go and talk," she laughs. "This is the third year we have made things for the elderly or sick in town. We make throws and shawls, and we give about sixteen each year. I think that's pretty good for such a small town. Also, they are making blankets for the animal shelter for the dogs and cats and donating those. So what we've been doing is not only for us, but we help other people too. When we had the quilt show, people came from everywhere. We had over 160 quilts here down at the patio on the Gage Hotel. We put up ropes and hung them up in the trees with the green, and they were beautiful out there."

When I asked her what is something she wanted people to know about Marathon, she responded, "We are a bunch of friendly people that welcome people to come to our community. Everyone helps everyone else. When there is a benefit for something, just about everybody participates."

TOBY CAVNESS

Born in Alpine but raised in Marathon, Toby Cavness is one of four sons. He opened the Cowboy Grill in Alpine on April 10, 2012, and moved the restaurant from 2700 East Highway 90 to 709 East Holland Avenue on September 1, 2013. He claims his cooking skills were handed down from his grandfather Leroy and his mother, Patsy (see page 79).

"Leroy is where I came by the cooking more than anybody," shares Toby. "We were raised on a big ranch south of Marathon. When you're raised out there, you learn how to do everything, and cooking is part of that. We didn't think anything about it. I saw my grandfather made part of his living cooking, and though my mom never cooked professionally, she's a fabulous cook. My grandfather Leroy had an old chuck wagon and an old truck. He went around to all the big ranches and cooked for the ranchers during roundup time."

Roundup is done during the spring and fall. Ranchers will brand, castrate and work with the cattle herds. "A typical roundup was probably thirty days with twenty to twenty-five men," says Toby. "He [Leroy] fed three times a day per ranch, then he'd go to another ranch. Once they got started, they'd go 'til they were finished. The time it took varied based on the cattle they had. He made chicken-fried steaks, beef stew, chicken and dumplings, cabrito and hearty cowboy food. He also made cakes and pies. All of this was done with wood fire and Dutch ovens.

"Grandfather made a dish that he called Son of a Gun; people know it now as Menudo," shares Toby. "Instead of being a red color, his was brown, but it's basically the same thing. I asked for years for recipes, but he always said, 'You damn scalawags would just mess it up,' so he didn't give us any," Toby says, laughing and remembering his grandfather. "Mom has his peach cobbler recipe, but that's the only one we have of his."

"Leroy had to eat lunch at 11:30," Toby says, sharing a story about his grandfather. "If you were [there at] 11:45, you were out of luck. So I went by for lunch one day, and the old man was mad. I said, 'Grandpa what is wrong with you?' He said, 'I'm getting old. I can't see. I went to set out my stew meat and accidentally set out T-bone steaks. I made the damn stew anyway.'" Toby said it was the best stew he had ever eaten.

Leroy lived until he was eighty-nine. "He smoked cigarettes, cigars and pipe," shares Toby. "He'd smoke almost a pack of cigarettes before 5:30 in the morning, then he'd smoke cigar and pipe the rest of the day. Edwards tobacco is what he liked for his pipe.

"My grandmother Leta Mae had a restaurant here in Marathon, the Squeeze Inn. It was in the alley between Johnny B's and the Gage. They served hamburgers and steaks, cowboy food, beans and cakes and pies in the late '30s and '40s. In the early '50s, my grandparents moved to Alpine, and my grandmother went to work at the hospital as a dietician. She was the head of food service at Brewster County Memorial Hospital for nine years. Then she went to work for the Alpine Independent School District and was head of their cafeteria for twelve years before she retired."

Toby and his brothers Sammy, Robert and Leo went to Marathon for school. "I graduated in 1976 with ten kids in my class," Toby shares. "There were seven guys and three girls. We had a running joke that you couldn't go out on a date because everyone was related!

"When I was in school, the town population was close to eight hundred. Now it's shrunk by half at least. It's sad for the little town, especially for the school because there's hardly any sports and that's what we were known for for years and years and years. We had unbelievable sports teams for such

a small school," he continued. "We played five straight years in the football championship in six-man division and won state two years (one in '74 and one in '76). We were champions in basketball and track, too. Sports was the big thing for us here when we were in school. We had great athletes. One of our guys [Vance Jones] was drafted by the Denver Broncos. He was a kicker and kicked barefooted, and in those days, it was illegal to kick without a shoe so he didn't make it; he couldn't kick with a shoe on. He is still coaching in Balmorhea. His mother was my first grade teacher, and his dad was our superintendent.

"In 1972, we got to show hogs through the FFA at our county show for the first time," Toby remembers. He won grand champion with a cross-bred hog at the Big Bend Livestock Show.

Outside of sports and FFA, Toby says everyone looked forward to the annual Fourth of July party. "Fourth of July back in those days was the big thing because we had a huge meal on Saturday and a big dance. All the area ranches would donate the beef. My grandfather and my dad [Sam Cavness], along with the other guys here, would cook everything, and it was free. We held it at the Post. In the old days, they used to slaughter the beef at the Post and cook it the next day. They cooked the whole side of beef and would cut it in different cuts to barbecue. They had beans and potato salad too. There used to be a five-hundred-gallon tank, and they would bring blocks of ice and make lemonade in it. It had a valve on the side you could fill pitchers with. It was all free back in those days—but times have changed."

Toby and his brother Leo had a cooking team for years and won awards all across the state. "The first one was at the Barbado sheep cook-off in Rankin—it's not a goat, it's a sheep. We've been to BBQ cook-offs in Iraan, Midland/Odessa, Brady, Marathon, Alpine, Fort Davis, Big Lake and San Angelo. We have competed with brisket, ribs, chicken, beans, bread, margaritas, cabrito, menudo and desserts. And we've won first in every category at one time or another."

Toby worked in several food-related jobs in the area prior to opening his own restaurant. "I worked at the Gage for four years from 1996 to 1999. It touches everyone's lives here. Without the Gage Hotel, Marathon would be a dust bowl. The Gage has kept this little town alive, simple as that," he says. From there, he went to work for Sysco food services as a salesman for five years. "Then I went to work for the Fort Davis Drug Store for ten years for my good friend Rusty Wofford. In 2009, they sold the business, and it didn't work out with me and the new owner, so I went to Midland and opened a BBQ house called Big Bubba's BBQ station. It was a struggle to get it going with all of the regulations. One day, this guy came by and said he wanted to

buy it. I needed to come home to take care of my mom, so it worked out for him to purchase the business in 2010.

"Then in 2012, a friend of mine that owned Texas Fusion in Alpine called me and said he wanted out of his restaurant. I thought he was nuts, but I went to talk to him anyway. He made me an offer I couldn't say no to—so I've had Cowboy Grill in Alpine since April of 2002 to the present [2014]."

The BBQ or steaks are Cowboy Grill's bestsellers. "BBQ brisket outsells everything by far," Toby says. "I have an incredible staff, but I do all the BBQ myself. My brisket people say is really great, and I don't doubt 'em because I am a legend in my own mind," he says with a chuckle. "Catfish Friday is a big day at Cowboy Grill," says Toby. "The catfish is nothing special; it's how we do it—and it's called 'the love.' All of my food is made with love. That should be the secret to any restaurant. Anyone can fry fish, but it's how you take the time to do it right."

Cowboy Grill has had the opportunity to serve some interesting characters, including senators, football players, basketball players and artists. "We served Clint Black," Toby says. "He played for Clayton Williams's big bash he has every year. We also fed Baxter Black. He autographed his book and gave it to me."

When I asked Toby what was next for him, he said, "I think God has put me on this Earth to be a server, a giver, not a taker, and that's what I am. I truly believe God has put me here to be a server, a giver and not a taker."

MARCI ROBERTS AND JAMES EVANS

Owner of the French Company Grocer and long-standing volunteer in the community, Marci Roberts also produces the Marathon 2 Marathon, a 26.2-mile foot race.

"There are many Robertses in Marathon, and I am related to none of them," Marci shares. "I was raised in East Texas, though my family moved around before landing there. I was always the newcomer growing up...never belonging anywhere. I was not around my aunts, uncles, cousins and grandparents much at all growing up. I cannot imagine what it is like to grow up with that support system around you your whole life. I am fascinated with that culture here in Marathon and often fantasize what it would be like to grow up in their tribe.

"I moved here in 2005 from Austin to help my sweetie, James Evans, move his gallery across the railroad tracks to Main Street. I remember sleeping on top of his truck in Big Bend National Park looking at the stars and feeling like I was home. With this feeling came a deep pull to become involved in the town like I had never done before. I bought the grocery store and became

involved with the school, the chamber, the library, the Marathon 2 Marathon and finally the Marathon Foundation. Being an architect and designer in New York City and Austin was a ride, but Marathon has taught me lessons I never would have learned anywhere else."

Professional photographer James H. Evans moved to Marathon in 1988. His books *Big Bend Pictures* and *Crazy from the Heat* offer his vision of the Big Bend landscape through photographs that span several years of documentation. His work is featured in multiple esteemed museums, and his current images can be found in the Evans Gallery in Marathon or on his website, www.jameshevans.com.

RUSS TIDWELL

Russ Tidwell started coming to the Marathon area more than fifty years ago. "I grew up in Del Rio. My oldest sister [Cathie] is ten years older than I am," says Russ. "She was first in our family to go to college, and she went to Sul Ross in Alpine. So she was eighteen; I was eight in 1960. Every holiday, I'd be loaded in the back seat of the car to visit her with my family. My other sister [Janet] joined her at Sul Ross the following year, and the visits continued. My older brother [Bubba] went to Sul Ross as well.

"I graduated high school in Del Rio in 1970," shares Russ. "After high school, I broke the family tradition and did not go to Sul Ross. I went to UT Austin because my high school counselor said to go to a bigger school if I wanted to go to law school," which is what he thought he wanted to do at the time. "But my heart was in the Big Bend. I continued to come out from Austin with different groups of political friends that would go camping and enjoy canoeing through the canyons of the parks."

In Austin, Russ became involved in political affairs and was elected a state representative from Austin briefly (1984–85). After that, he became the political director for the Texas Trial Lawyers Association for twenty-six years. "I did not retire," shares Russ. "I quit that job in protest of internal problems. Fortunately, I had decided to make Marathon my home years ago. I came out here in 1993 to find a small place and ultimately bought what became Captain Shepherd's Inn. I became invested in the town." Marathon became his official voting residence by the mid-'90s, and although he still worked in Austin, he declared Marathon his home. "In October 2013, I quit the day job in Austin and came out here to help finish my new house, which had been under construction for a while. I don't consider myself completely retired; I will go back to Austin for independent work," says Russ.

HAROLD COOK

Originally from Houston and an Austin resident since 1989, Harold Cook started frequenting Marathon beginning in 1997. "It was a political deal," he shared with me while sipping tequila on his picturesque back porch, his dog Travis misbehaving. "There was this big huge group of politicos who were either in politics or writers or journalists. They would all troop off in a big herd to Marathon, Texas, for New Year's Eve and two or three other weekends a year. Twenty to forty people per group. It included our friend Russ Tidwell and Molly Ivins, the legendary liberal columnist."

In fact, if it wasn't for Molly, Harold would never have made a second home for himself in Marathon. "The one reason I ended up with a place out there was when Molly got sick with breast cancer, she called me and said, 'I know you love it out there. I always intended to build a writers' shack out there, but I realized the drive was just too long.' She asked me if I wanted her property, to which I said, 'Sure I do, but I doubt I can afford it.' She said, 'Oh, I'll just give it to you.' She wasn't in it for the money. But then her accountant freaked out and said, 'Can you at least pay for it what Molly paid?' So I wrote Molly a check, and we didn't even bother to transfer ownership for years. That's the only reason I ended up with the place. Then four or five years ago, I built the writers' shack that Molly always intended to build. The politico group still comes up for New Year's, Fourth of July, summer solstice and various other reasons."

Splitting his time between Austin and Marathon, Harold stays active in the political community. "I started out as a political hand doing campaigns and working on getting people elected," he said. "These days, I'm a political analyst. I have private clients that get my advice on analyzing political situations and figuring out the public messaging that goes with it. I work with the media and clients that want to work with the media. I also do some lobbying in the Texas legislature." Cook can also been seen on his TV show, *Capitol Tonight,* Monday through Friday.

LINDA AND CRAIG TRUMBOWER

"Craig has been coming out to this area looking for reptiles with buddies since the '70s," Linda told me. "We have vacationed here since the '80s with our four children. We liked to stay a few weeks in the Davis Mountains and would drive through Marathon." On one of their trips out west, the Trumbowers were staying at the Gage in 2000. "We talked with the bartender about buying a house they had put for sale that day—and we bought it." Craig and

Linda moved to Marathon full time in 2007 to "downshift and slow down," as Linda puts it.

"We lived in central Florida between Tampa and Orlando. We both grew up in military families so were transient," shares Linda, who now runs the outpatient surgery department in Alpine at Big Bend Regional Hospital. Craig and Linda were both oncology nurses prior to making the move out west. Craig has authored *More Than Snakehunting* and has completed a second book that includes stories from West Texas, Florida and South Carolina with his characteristic tongue-in-cheek humor.

"We both grew up in families with sit-down meals because we were children of the '60s. We cooked together, we ate together and had usual roles of the household. It was our rule that if you didn't like it after one taste, you didn't have to eat anymore. The recipes I shared are recipes I picked up along the way in different places," says Linda.

Part II

SOUTH COUNTY

A QUICK TRIP TO TERLINGUA AND LAJITAS

BRIEF HISTORY OF SOUTH COUNTY

Best known for its famous chili cook-offs, Terlingua is an abandoned mining town that is home to a diverse and eccentric population. Located in the southwest corner of Brewster County, the population in 2010 was reported to be only fifty-eight. It remains a popular tourist destination for people traveling through Big Bend Park. Several activities are offered in the area, from horseback riding and river rafting to mountain biking and camping. Nearby Lajitas offers a golf resort with upscale dining options. The town boasts Clay Henry, a beer-drinking goat, as its mayor.

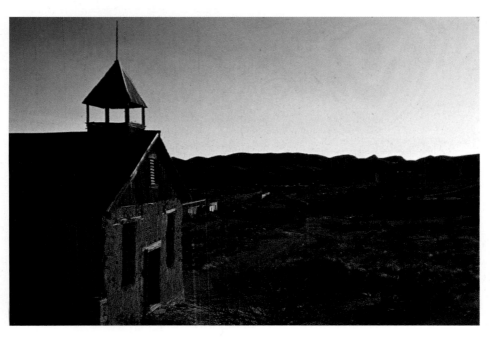

Above: National Archives Record number 545813, Blair Pittman, 1973.
Opposite: Lesley Brown

Lesley Brown

Above: National Archives Record number 1244799, Blair Pittman, 1973.

Big Bend Bucket List:
South County (Terlingua and Lajitas)

- Eat at the Starlight
- Attend the Chili Cook-off
- Play golf or relax at the Lajitas Resort
- Hire a guide to take you down the river
- Cross the river over to Mexico at Boquillas (be sure to bring your passport!)

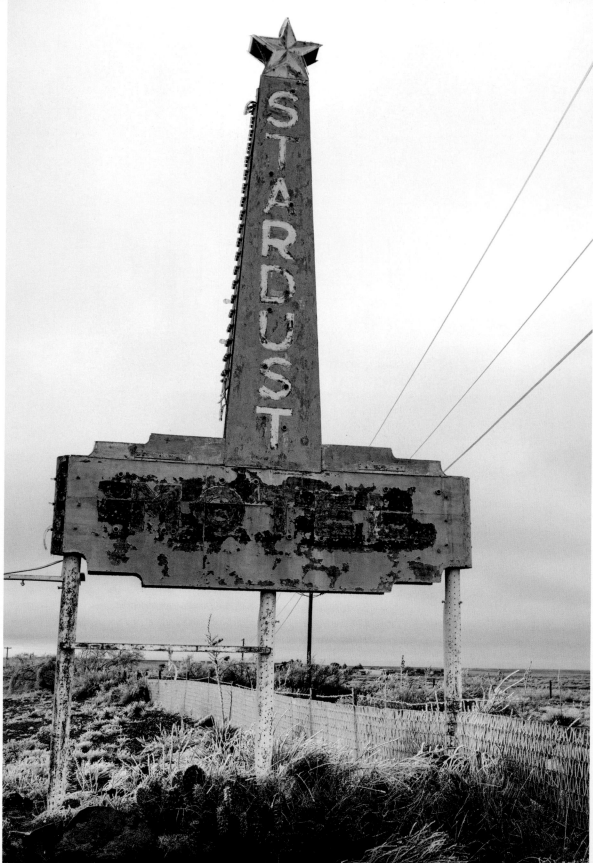

Lesley Brown

Chicken-Fried Steak

Courtesy of J.R. Rodriguez, Lajitas Golf Resort and Spa

> *"The Chicken-Fried Steak—that was actually my boss Ruffian. He made me pull the Chicken-Fried Steak off [the menu] because he loved it, but this one wasn't good. He was right; it wasn't that great. I started going to different restaurants and ordering chicken-fried steaks to see how it was. Ruffian's mom used to make it one way, and I tried to make it like he suggested. He loved it, so we put the revised version back on the menu at Candelilla."*
> —*J.R. Rodriguez*
> *Serves 4*

1½ cups whole milk
2 large eggs
2 cups all-purpose flour
2 teaspoons seasoned salt
1½ teaspoons freshly ground black pepper
¾ teaspoon paprika
¼ teaspoon cayenne pepper
3 pounds cube steak (tenderized; if you don't have a mallet, a rolling pin or empty glass bottle will do)
kosher salt
½ cup canola or vegetable oil
1 tablespoon butter

Gravy:
$\frac{1}{3}$ cup all-purpose flour
3–4 cups whole milk
½ teaspoon seasoned salt
freshly ground black pepper

° For the steak: Begin with setting up an assembly line of dishes. Mix the milk with the eggs in one; the flour mixed with the seasoned salt, black pepper, paprika and cayenne in another; and the meat in a third. Then have one clean plate at the end to receive the breaded meat.

° Work with one piece of meat at a time. Sprinkle both sides with kosher salt and black pepper, then place it in the flour mixture. Turn to coat. Place the meat into the milk/egg mixture, turning to coat. Finally, place it back in the flour and turn to coat (dry mixture/wet mixture/dry mixture). Place the breaded meat on the clean plate, then repeat with the remaining meat.

° Heat the oil in a large skillet over medium heat. Add the butter. Drop in a few sprinkles of flour to make sure it's sufficiently hot. When the butter sizzles immediately, you know it's ready. (It should not brown right away; if it does, the fire is too hot.) Cook the meat, 3 pieces at a time, until the edges start to look golden brown, about 2 minutes each side. Remove the meat to a paper towel–lined plate and keep it warm by covering lightly with another plate or a sheet of foil. Repeat until all the meat is cooked.

° After all the meat is fried, pour off the grease into a heatproof bowl. Without cleaning the skillet, return it to the stove over medium-low heat. Add ¼ cup of the grease back to the skillet and allow it to heat up.

° For the gravy: When the grease is hot, sprinkle the flour evenly over the grease. Using a whisk, mix the flour with the grease, creating a golden-brown paste. Add more flour if it looks overly greasy; add a little more grease if it becomes too pasty/clumpy. Keep cooking until the roux reaches a deep golden brown color.

° Pour in the milk, whisking constantly. Add the seasoned salt and black pepper to taste and cook, whisking, until the gravy is smooth and thick, 5 to 10 minutes. Be prepared to add more milk if it becomes overly thick. Be sure to taste to make sure gravy is sufficiently seasoned.

Jalapeño Chocolate Cake

Courtesy of J.R. Rodriguez, Lajitas Golf Resort and Spa

"I got the idea recently from a lady who came through for a wedding and wanted jalapeño cheesecake. She gave me a recipe for jalapeño jelly and was telling me how much her family loves spiciness. I played with it a little more and came up with the Jalapeño Chocolate Cake. There was a lot of trial and error: peanut butter and jalapeños didn't work out too well. Then I came up with chocolate-dipped jalapeños stuffed with a sweetened cream cheese. I tried to put them in the cake and messed up a few. Then I candied a bunch of jalapeños and put it on the top, and that's eventually how I got the idea to develop a Jalapeño Chocolate Cake."
—J.R. Rodriguez

Cake:
1 cup semisweet chocolate chips
1¼ cups granulated sugar
¾ cup (1½ sticks) unsalted butter or margarine, softened
1 teaspoon pure vanilla extract
3 large eggs
2 cups flour
1 tablespoon ground cinnamon
1 teaspoon baking soda
½ teaspoon salt
1 cup milk
1½ tablespoons finely minced seeded jalapeños

Icing:
3¼ cups sifted confectioner's sugar
1/3 cup milk
¼ cup (½ stick) unsalted butter or margarine, softened
2 ounces unsweetened chocolate, melted

2 teaspoons pure vanilla extract
¼ teaspoon salt

° Preheat oven to 350 degrees. Grease two 9-inch round baking pans or one 9x13 baking pan. Microwave chocolate chips in an uncovered medium-size microwave-safe bowl on high power for 1 minute; stir. (Chips may retain some of their original shape.) If necessary, microwave at additional 10- to 15-second intervals, stirring in between, just until melted
° In a large bowl, combine granulated sugar, butter and vanilla; beat with electric mixer until creamy. Add eggs; beat for 1 minute. Beat in melted chocolate chips. In a medium-size bowl, combine flour, cinnamon, baking soda and salt; beat into chocolate mixture alternately with the milk. Stir in jalapeños. Pour into prepared pan(s).
° Bake for 30 to 35 minutes, or until a toothpick inserted into the center comes out clean. Cool in pan(s) for 20 minutes, then invert onto wire rack to cool completely.
° Meanwhile, prepare frosting. In a small bowl, beat confectioner's sugar, milk, butter, melted chocolate, vanilla and salt until smooth and creamy. Frost cake.

J.R. RODRIGUEZ

Director of Food and Beverage, Candelilla Café at Lajitas Golf Resort and Spa

Originally from San Antonio, J.R. Rodriguez attended A&M University and then completed culinary school at the Art Institute of Pittsburgh prior to accepting an upper management position at Lajitas Golf Resort and Spa.

"In culinary school, I got to cook alongside Mario Batali and Lidia Bastianich. It was a good experience for me," J.R. shares. "Mario gave me pointers, and Lidia was there all the time. Mario took me to all the restaurants that they owned. It was fun to drink wine and eat a lot.

"I got here last November of 2012," says J.R. about joining the management team at Lajitas Golf Resort and Spa. "We've always had a southwestern Tex-Mex theme. I came in and changed the menu to what I thought would be geared toward tourists and locals as well. I've been toying with the menu and asking people what they like and try to change the menu to accommodate as many patrons as possible."

J.R. said their bestseller is the salmon. "It's kind of weird; you don't think of salmon being the bestseller in the middle of nowhere," he shares. "But I found this place to drop-ship salmon overnight. They catch it, ship it and we get it the next day. It's as fresh as you can get in the middle of the desert, and it's wild caught."

"I really like our lunch menu with our BBQ sandwiches," says J.R. "I like the way I smoke BBQ," he smiles. "It always has good flavor. I make my own BBQ sauce."

The resort is busiest late September through January, has a lull and then picks up again March through May. "We have the Candelilla restaurant, but we also cater for the resort and all weddings. We have our own bakery here; we make cakes. We are very versatile as far as what we make. Everything is homemade except for our pasta, which I was trying to make but couldn't get into it.

"We are about twenty miles to Terlingua. Sometimes people come in for special occasions or concerts and holidays like Christmas, Mother's Day, etc. because we do elaborate brunches." There are no other restaurants in Lajitas. "That's why I try to stress to guests if there is something they like, that I will create it for them while they are here. After seven days of looking at the same menu, you want to give them options to keep them happy." J.R. employs sixteen people at the Candelilla restaurant and Thirsty Goat bar.

MARFA AND VALENTINE

BRIEF HISTORY OF MARFA AND VALENTINE

Established in 1883 and purportedly named after a character in Fyodor Dostoyevsky's *The Brothers Karamazov*, Marfa is the county seat of Presidio County. As it is home to many artists, several art exhibits and galleries are open at any given time. The famous Ghost Lights are a tourist attraction that remain unexplainable. The film *Giant* helped put Marfa on the map when James Dean, Rock Hudson and Elizabeth Taylor filmed there in the 1970s. The population hovers around two thousand.

With fewer than two hundred citizens, Valentine is located in Jeff Davis County. The Prada Marfa sculpture is a popular place for tourists to take pictures. For Valentine's Day, you can send envelopes to be postmarked from the Valentine Post Office.

Big Bend Bucket List: Marfa and Valentine

- Take pictures at Prada Marfa
- Check out the art galleries and stores
- Watch the Marfa Lights

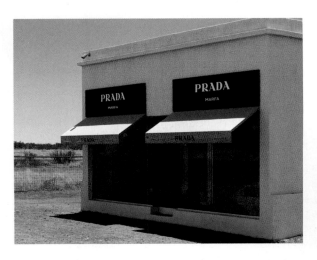

Opposite: Creative Commons Attribution 4International. Patrick Denker via Nan Palmero

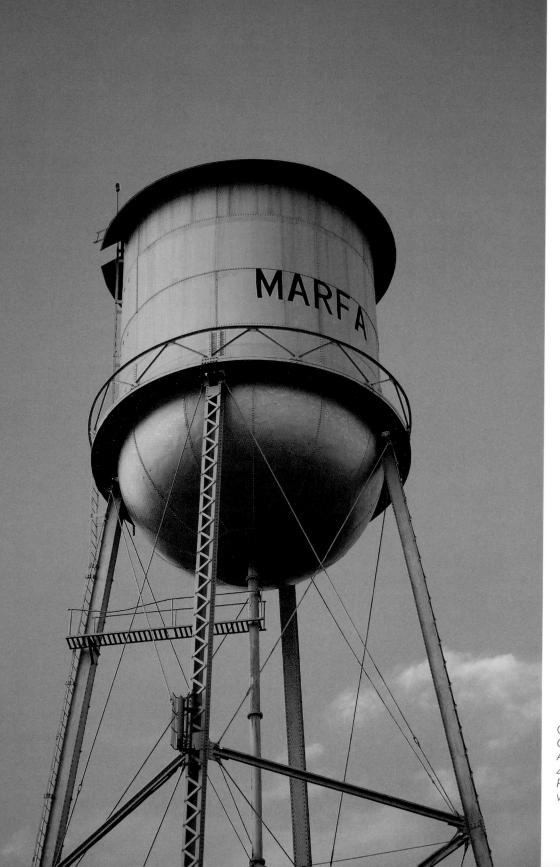

Asado

Courtesy of Magda Drawe, formerly of the Petan Ranch

> *"I learned how to make this in West Texas, from friends in Van Horn. Serve warm with tortillas or pan de campo, beans and rice. I love to put sour cream on it, and some like it with lime on it."*
> —Magda Drawe

3-pound pork roast
vegetable oil (canola) or lard
2 small potatoes, cubed
2 cloves garlic, minced
½ teaspoon cumin
¾ teaspoon salt
12 red chili pods (dried)
2 tablespoons flour plus ¾ cup
 water for a slurry

° Cube raw pork and put it in a pan with oil to brown over medium heat. Cook it all the way through, approximately 15 minutes. Add two small potatoes, raw and cubed. Add 2 cups of water to help the meat and potatoes cook. Put the lid on.

° Using a mortar and pestle, grind garlic, cumin and salt and add about ¼ cup of water to rinse all the spices out. Add spice mixture to the pan while the pork and potatoes are cooking.

° To make a chili sauce, remove the stems from the dried red chili pods and shake out the seeds. Boil them until they are soft, about 5 minutes. Throw the water out, put the chilies in a blender and add fresh water (about 1.5 cups). This will make

your chili sauce. Next, run the sauce through a strainer and add a little more water to get your desired consistency. Add chili sauce to the pork that has been cooking and cook another 5 minutes or so. By that time, your pork should be ready.

° Put 2 tablespoons of flour and ¾ cup of water in a mason jar, shaking to combine. Pour the slurry over the whole dish with the pork/chili sauce and stir to combine thoroughly. This will thicken up the gravy.

Beebe's Brisket

Courtesy of David Beebe

Presidio County justice of the peace and Boyz2Men food truck owner David Beebe shares his approach for smoking brisket.

1 USDA Choice Angus brisket (or Select)
coarse black pepper
kosher salt
garlic or onion salt
brown sugar
Jane's Krazy Mixed-Up Seasoning

° Trim fat on brisket to no more than ¼ inch in depth wherever layers of fat exceed that thickness. Place in full stainless steel hotel pan
° Massage brisket using coarse black pepper (5 percent), kosher salt (or regular salt) (25 percent), garlic salt or onion salt (5 percent), brown sugar (40 percent) and Jane's Krazy Mixed-Up Seasoning (25 percent). Refrigerate covered in pan overnight, if possible.
° Prepare fire of 50 percent smoking wood (such as pecan, oak or mesquite) and 50 percent high-quality charcoal in smoker.

Heat smoker to 350 degrees and bring fire down. Once fire is below 300 degrees, place seasoned brisket on smoker point side closest to flame or firebox (do not cook over direct heat) with fat side up.

° Bring temperature down to between 220 and 260 degrees and smoke for 12 to 16 hours. Check temperature periodically and adjust coals and venting if need be.

° Check brisket after 12 hours for complete cooking by using a steak fork on each end of brisket and in the middle as well. Fork should enter easily and should not hit sinewy material. Adjust position of brisket to heat as needed to achieve uniform cooking, and cook to preferred completion.

° Slice briskets as thinly as possible. Slices should be 3 to 4 inches long max. Serve on a hot tortilla with finely diced onion, cilantro and jalapeño. No sauce required.

Bibimbap with Ghetto Gochujang

Courtesy of Michael Serva of Cochineal

"It's a great hangover food, and it's a filling comfort food. The flavors are all familiar, and it's one of our few vegetarian entrées, which people in this town seem to be pretty thankful for."
—Michael Serva

Rice:
3 cups sushi rice, rinsed 3 times, at least, until the water runs clear

° Cook the rice in a rice cooker until hot and fluffy, approximately 20 minutes, or use automatic settings. You can also cook rice in a pot with water. When the water comes to a boil, cover the pot and lower flame. Cook for 20 minutes.

Vegetables:
° Cook each vegetable properly and separately, using whatever vegetables you have on hand or your personal preferences. At Cochineal, we typically use carrots, spinach, mushrooms and red bell peppers. Everything in the dish serves a purpose: fleshy soft carrots, crispy mushrooms, the creamy spinach and not too withered give the Bibimbap well-rounded textures and flavors.

° 2 pounds carrots, julienned into matchsticks and blanched. We do not use ice to blanch the carrots. Rather, after removing from the hot water, we put them on a sheet tray in the fridge so the flavor is not diluted. The goal is to have them barely cooked.

° 10 cups raw spinach, blanched or sautéed in sesame oil, dried with a paper towel so the juices don't leak.

° 2 pounds raw mushrooms, trimmed. At Cochineal, we use shitakes, but you could use oyster or portabellas as a substitute. Sauté the mushrooms with salt and pepper until crispy. They should be tender on the inside like a medium-well steak but have a rendered crispy outside. They impact the dish with flavor and crunch.

° 5 red bell peppers, deseeded and julienned, blanched or steamed for a minute. Again, cook just long enough to soften the flesh of the fruit.

Ghetto Gochujang:
1 small 8-ounce jar sambal oleek
1 tablespoon sugar
2 teaspoons salt
2 tablespoons toasted black sesame seeds

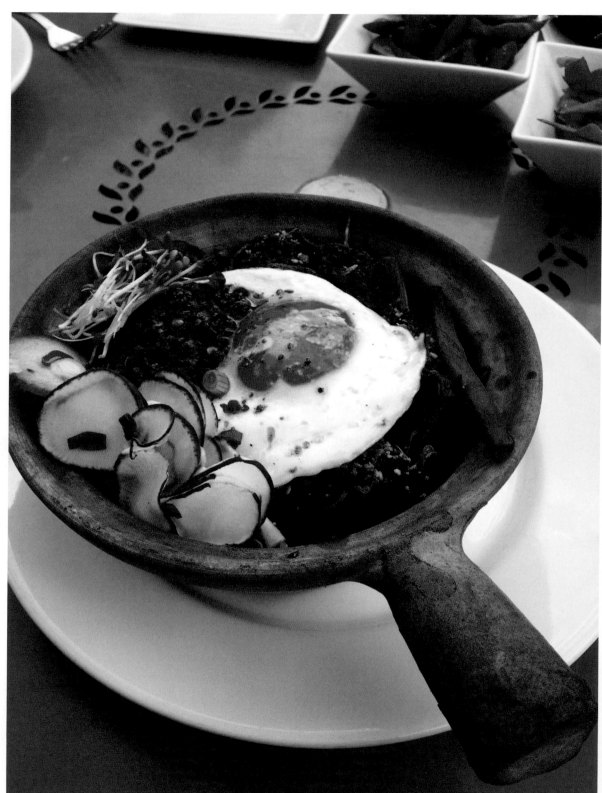

Cochineal

° Combine all ingredients and stir with a spoon, continuing to mix until sugar and salt are dissolved.

soy sauce
rice vinegar
pinch salt
scallion
nori seaweed
Shiso Furikake Rice Seasoning
1 egg
butter
alfalfa or mung bean sprouts
shaved radishes

Assembling the Dish:
° Toss rice with a dash of soy, a dash of rice vinegar, a pinch of salt, fresh chopped scallion and torn nori seaweed in the oven-safe serving bowl or crock. Fluff the ingredients like you would sushi rice.
° Add the carrots and bell peppers on top of the rice. They will look like a little pile of lumber on either side of the dish. The spinach is fluffed and placed in one corner and mushrooms in the other corner. Then, hit it with a little bit of a secret ingredient we use at Cochineal: Shiso Furikake Rice Seasoning. It's made with powdered chiso. There are different versions of it, but we use it to season a lot of things in the kitchen, including our butter and edamame. In this dish, we use it to season the vegetables so they don't need to be salted. It has a little more backbone to it.

"Typically a Gochujang (Korean chili sauce) sauce is used. It can be difficult to find unless you're in a city with an Asian market. I have created a similar sauce using sambal oleek, which is a chili paste that has a lot of flavor and is really delicious. If you dress it right, you can get it pretty close to the taste of the Gochujang."
—*Michael Serva*

° Top the bowl with a classic sunnyside-up egg cooked in a clean butter on low heat, uncovered so the egg slowly gets to the point where it's beautiful. Place the egg on top of the vegetables, placing the chili paste next to the egg for contrast.
° Garnish with fresh sprouts such as picked alfalfa or mung bean sprouts and shaved radishes. For the radishes, I like to clean them and leave a little bit of green stem, shaved lengthwise to see every part of the radish from the sprout down, then toss them in rice vinegar. They add crunch and freshness to the dish.
° You can bake it in the oven or serve fresh. We do ours clean, warmed in the oven, and then add the egg, sprouts and radish on top.

Dill Pickle Mustard Chicken

Courtesy of Boyd Elder

> *"This recipe is one I made up using what I had, and it's really delicious."*
> —*Boyd Elder*

chicken breasts
French's yellow mustard
dill pickle juice

° Marinate chicken breasts overnight in equal parts mustard and dill pickle juice. Take the chicken out of the marinade sauce and grill it until it's light brown in color (cooking times vary depending on thickness of meat). Put the chicken back in the sauce, wrap in tinfoil and bake slowly to finish so that the chicken is cooked completely through until there is no pink color in the center.

Hawaiian Steak

Courtesy of Boyd Elder

Marinade (Use Ingredients According to Taste):
ginger, sliced or shredded
green onion, chopped
garlic, minced
tamari or soy sauce

º Marinate steak with ginger, green onion, minced garlic and tamari or soy sauce for no longer than 1 hour.
º Cook the meat with the marinade on top of it. Cook it in a fire with no flame, preferably mesquite wood, for 4 to 7 minutes on each side, depending on the thickness of the meat. The ginger will help tenderize the meat and flavor it. Note: Only turn the meat over once. The best way to tell when it is time to turn the steak over is when the blood comes to the surface, so depending if you want it medium or well done, you want to turn it according to your desired taste and put more marinade back on the other side as it continues to cook.
º Serve with a fresh salad (no garlic; you don't want to combine the same flavors). I like to serve it with a chopped salad: cheese, romaine lettuce, onion, tomato and garbanzo beans with good olive oil dressing.

> *"This is a traditional Hawaiian recipe I learned from Frank Finlayson (my daughters' grandfather) and Bill Phillips (their mother's uncle). I advise using USDA choice or prime beef."*
> —Boyd Elder

Jett's Pistachio Fried Steak

Courtesy of Jett's Grill

Jett's Grill shares the recipe for their highly sought-after Pistachio Fried Steak.

pounded sirloin steak
flour
buttermilk

Breading:
1 cup flour
1 cup bread crumbs
½ cup crushed pistachios

° First coat the pounded sirloin with flour, then dip in buttermilk and finally the breading mix.

° Fry at 350 degrees for about 7 minutes.

Jalapeño Gravy:
1 cup butter
2 cups flour
1 quart milk
salt and pepper
3 roasted jalapeños, chopped finely

° Melt butter in a saucepan. Add flour and brown a little. Add milk and salt and pepper, stirring constantly. Cook low until it thickens. Add roasted jalapeños.

Peasant Chicken

Courtesy of Marfa Table

2 pounds boneless, skinless market
 chicken thighs
juice of six limes or lemons
 (reserve rinds)
1 tablespoon smoked paprika
1 tablespoon kosher salt
1 tablespoon cracked black pepper
1 tablespoon light brown sugar
2 tablespoons fresh chopped
 Mexican marigold mint
 (substitute oregano, sage,
 rosemary and/or thyme)

° Rinse thighs and toss in large bowl with remaining ingredients, including citrus rinds.
° Marinate in airtight container or Ziploc baggie for 4 to 24 hours.
° Grill on a hot fire; use a metal spatula and tongs to turn thighs so the small bits are not lost in the coals.

To Serve:
° Stack 2 to 3 thighs atop or against one another and sprinkle with more fresh chopped herbs. They are happy paired with easy stacked mole or verde enchiladas.

"My English mother prepared traditional old-world fare from scratch. She grew up in the country during World War II when food shortages and outages were common events. She learned to marinate and braise smaller portions of side cuts and always said they had more flavor than prized tenderloins and breast meats. When I prepare chicken thighs for house parties, guests frequently ask for some more of that 'pork tenderloin.' Double the recipe for next-day chicken tacos or lime soup."
—Bridget Weiss
Serves 4–6

Quail a la Plancha

Courtesy of Marfa Table

"Fresh quail straight from the hunt is best, but it can also be purchased through specialty groceries or online. The sauce will hold in the refrigerator or can be frozen and is delicious with other grilled meats and vegetables."
—Bridgett Weiss
Serves 4

Sauce:
8 dried chipotle (hot) or pasilla (mild) peppers, or 4 ounces canned chipotle peppers
16 ounces fresh or frozen raspberries, blueberries or blackberries
½ cup dark brown sugar

° If using dried chilies, break open and pull out seeds and veins. Cook pepper skins in oiled skillet until toasting and pliable. Soak skins in boiling water just to cover. Once softened, puree peppers with enough soaking water to process into paste.
° Combine fruit, chilies and sugar in heavy pan and cook over low heat until berries have lost their integrity. Purée mixture and set aside.

Quail:
8 quail breasts, preferably with legs on
juice of 4 limes
½ cup olive oil
¾ cup chopped pitted dates or dried apricots
2 large jalapeños, seeded and quartered
12 ounces bacon, or 8 slices
1 tablespoon minced parsley

° Marinate cleaned birds in lime juice and olive oil. Stuff breast cavity of birds with 1 tablespoon of dates and 1 slice of jalapeño.
° Wrap each bird with 1 strip of bacon and use a toothpick to secure bacon by piercing the quail through.
° Start a fire with charcoal or kindling. Add pecan, mesquite or oak wood and cook down to large coals, or 200 to 250 degrees. Grill quail, turning two or more times for even browning; bacon should be crispy.

To Serve:
° Lean two quail against each other.
° Drizzle with fruit sauce.
° Sprinkle parsley and sea salt on top.

Ranchland Dove

Courtesy of Boyd Elder

> *"One of the best ways to cook dove is to stuff roasted and peeled jalapeño with asadero cheese (preferably goat cheese), put it in the chest cavity of the dove and wrap it with raw bacon."*
> —Boyd Elder

dove, cleaned
balsamic vinegar
olive oil
jalapeños, roasted and peeled
asadero cheese
bacon

° Marinate the dove meat in balsamic vinegar and olive oil to keep it from being so tough. Take a clean and raw dove and stuff the chest cavity with roasted and peeled jalapeños and asadero cheese. Then wrap the dove with raw bacon, using toothpicks to secure bacon and keep jalapeño/cheese mixture inside the cavity.

° Cook it slowly, placing the dove high and away from the flame, about 3 to 4 feet, almost smoked, for a couple of hours.

° Note: You can also make an egg flour/cornmeal batter where you dip the bird into whipped egg and then batter and deep-fry it as another technique

Teriyaki Chicken

Courtesy of Boyd Elder

"This is my daughter Shaula's favorite."
—Boyd Elder

1–2 cups soy sauce, or as much as you need to cover the amount of chicken you are marinating
sesame seed, roasted or plain
garlic
chopped green onions
olive oil
balsamic vinegar to taste
chicken thighs

° Combine all ingredients. Marinate chicken overnight, cook it slow on medium heat and keep marinating the chicken with the sauce. You want to be sure the sauce is heated up to at least 220 degrees. Then put the chicken back in the sauce when the sauce is cooked for 10 minutes.

Baked Ricotta

Courtesy of Marfa Maid

1 gallon pasteurized milk (cow or
 goat milk)
white distilled vinegar or lemon
 juice; have 8 ounces ready
good-quality olive oil or butter
kosher salt
ground black pepper
1 teaspoon minced fresh garlic
additives (chopped onion: green, red
 or white; artichoke hearts; olives;
 tomatoes: fresh or sundried; nuts:
 pine nuts, pumpkin seeds, toasted
 walnuts or pecans, almonds;
 herbs: chopped basil, oregano
 or parsley)

° Pour milk into a large pot and bring slowly up in temperature, stirring occasionally. If you have a thermometer, we are looking to bring the milk to 185 degrees. If you don't, bring the temperature up to almost a boil (but not a boil), where there are

Add your choice of chopped onion, artichoke hearts, olives, tomatoes, nuts or herbs to personalize this dish.

small bubbles on the surface of the milk inside the rim of the pot.
° At this point, pour vinegar or lemon juice into the milk in a small stream, stirring as you go. In less than a minute, the milk should curdle. If this doesn't happen, bring the heat up further. As soon as it curdles, move the pot off the heat and let the curds float to the top, resting for 10 minutes.
° Spoon curds into a colander with a bowl underneath. Once it's drained, move to a new bowl, toss lightly with olive oil (or butter), salt, pepper, garlic and additives to taste.
° Spoon into ramekins or other small baking dishes and put in 350-degree oven for 20 minutes. Serve warm with crusty French bread.

Caesar Salad

Courtesy of Boyd Elder

"This yields 1 serving for 2 people. This is inspired by Tony Palermo's, one of our favorite restaurants in Los Angeles."
—Boyd Elder

¼ cup or less Worcestershire
 sauce, to taste
½ cup olive oil
cayenne pepper, to taste
1 egg yolk
½ clove to 1 clove garlic, minced,
 to taste
1 small can anchovies
good romaine lettuce—not knife
 cut but hand broken, washed
 and cleaned and dried
Parmesan cheese, finely shredded
black pepper, fresh ground, to taste

° Mix the dressing, using all ingredients except the anchovies, romaine, Parmesan cheese and black pepper, according to taste. With this salad, you can add meat, such as fish or chicken—whatever you desire. You could use tuna, mahi mahi, ono, wahoo, anything you like precooked.

° Mash the anchovies up or blend, put dressing on salad and then top with Parmesan and fresh ground black pepper.

Chevremale

Courtesy of Marfa Maid

Chevremale is a tamale appetizer or side dish using chevre cheese.
Serves 8

Marinade:
1 bunch cilantro, chopped fine
¼ cup red onion, chopped fine
½ fresh jalapeño, seeded and
 chopped fine
2 garlic cloves
1 teaspoon kosher or sea salt
pinch red pepper flakes
1 juiced lime

° Prepare marinade by mixing all ingredients together in a glass jar. Refrigerate for at least a few hours or up to one day.

1 package dry tamale wrappers
2 4-ounce packages of chevre logs
natural twine

° Take 8 tamale wrappers and dunk in a pot of boiling water for 15 seconds. Lay on a plate with paper towels.
° Keep chevre logs chilled until ready to use and then cut into quarters, making rounds.
° Spoon approximately 1 tablespoon of marinade on inside of each wrapper, lay the quarter of chevre log on the wrapper and then spoon another tablespoon of marinade on top of the chevre. Close the wrapper and tie like a package with natural twine.
° Serve with toasted tortilla pieces or chips, salsa, slices of avocado and chopped tomato or pico de gallo.

Crispy Fried Brussels Sprouts Haystack

Courtesy of Fat Lyle's

"There's no gray area when it comes to Brussels sprouts: people either make the shiniest of happiest faces or the most scrunched-up faces, indicating that they will never eat it. This dish also has blue cheese and onions—two other ingredients you either love or hate. This dish is a bed of hand-cut French fries topped with fried Brussels sprouts, caramelized onions, blue cheese and then a spicy aioli. (To the general public, it's just mayonnaise, but when you call it aioli, it makes you feel like you're not eating a trough of mayo.) We top it off with an extra touch of Sriracha for color and spice. It comes in a big tray and is good for sharing. This recipe is enough to serve 4 to 6 people."

—Mark Scott and Kaki Aufdengarten

1–2 large yellow onions, julienned
soybean oil for cooking (vegetable oil will also work)
1 pound Brussels sprouts, or to taste
4 potatoes (1 per person), cut into French fries
salt
blue cheese
Aioli
Sriracha

º Caramelize the onions: put the julienned onions in approximately 2 tablespoons of cooking oil on low heat for about 45 minutes. Stir constantly. (Kaki jokes and says, "Mark thinks that's what hell is going to be like.")
º Chop the bottoms off the Brussels sprouts, then take your knife and score the bottom with an X to help with the blanching. Blanch Brussels sprouts in boiling water for about 6 minutes. Then immediately put them into an ice bath to stop them from cooking further. This can be done ahead of time, and they can be refrigerated until ready to use.
º Fry potatoes (French fries) in oil at 350 degrees until crispy and brown, about 5 to 8 minutes. Lightly salt.
º Chop blanched Brussels sprouts in half lengthwise. Fry in oil (350 degrees) about 2 to 3 minutes or until golden and crisp. The leaves will start to pull back, and they will look like crispy roses.
º To build: Top a pile of fries with fried Brussels sprouts and sprinkle with blue cheese crumbles, caramelized onions, spicy aioli and a little Sriracha.

Aioli:

1 cup mayonnaise
Sriracha to taste

º Combine it in a squirt bottle, enough to make it as spicy as you like. For the above recipe, you'll use approximately 2 tablespoons per serving.

Chicken Sopa

Courtesy of Michelle West, Rancho Escondido

> *"The Mitchell women have all been great cooks. Aurie, her daughters and nieces use recipes that have been handed down for generations. Chicken Sopa is a popular dish here in Marfa."*
> —Michelle West

1 fryer chicken, boiled, deboned and shredded; reserve broth
2 cans cream of chicken soup
3 small cans Pet Milk (evaporated milk)
1 small can chopped green chilies
1 medium onion, diced
1 can Rotel tomatoes
8–9 corn tortillas cut into 8–9 pieces each
2 8-ounce packages of sliced Swiss cheese (or a mixture of grated Swiss and cheddar)

° Preheat oven to 350 degrees.
° Heat the following ingredients thoroughly on the stove: broth, soup, evaporated milk, green chilies, shredded chicken, diced onion and Rotel.
° Line a large casserole dish with cut tortillas. Layer the warm soup mixture on top and add sliced cheese or cheese mixture. Repeat the layering process. Heat in the oven until bubbling.

Grilled Romaine with Chorizo and Goat Cheese

Courtesy of Marfa Table

> *"This dish can be served as a starter or a side and is best when made with young romaine. Vegetarians can use vegetarian chorizo."*
> —Bridget Weiss
> Serves 4

2 small heads young romaine or 1
 large head romaine
olive oil to drizzle
8 ounces chorizo
8 ounces fresh goat cheese (feta
 or chevre)
sea salt and cracked pepper
1 lemon

° Slice young heads in half or large head into quarters. When trimming the bottom, leave enough of the base so that the leaves remain attached. If using a large head, pull away outer leaves and trim an inch or more off the top.

° Drizzle wedges with olive oil and grill for a few minutes on each side until grill marks show and lettuce begins to wilt slightly. Alternately, use a skillet with raised grill ridges.

° Remove casing from chorizo and break into small pieces in hot skillet. Cook until sausage bits are crispy and very brown.

° Place one piece of romaine on each plate. Sprinkle with cooked chorizo, goat cheese, salt and pepper.

° Squeeze fresh lemon juice over each portion. Drizzle with olive oil.

Lesley Brown

Endive Salad with Toshi's Slightly Asian Dressing

Courtesy of Michael Serva of Cochineal

At Cochineal, after using the pickled red onions, they save the pink-colored vinegar for other uses as well.

endive
Florida or blood oranges, sliced
pickled red onion
toasted pine nuts
freshly picked mint
salt and pepper

° The red onions are pickled in white vinegar.
° Assemble ingredients into a salad.

Toshi's Slightly Asian Dressing:
1 cup olive oil
1 cup rice vinegar
½ cup grated carrots (using a Japanese grater)
2 cloves grated garlic (using a Japanese grater)
$1/8$ cup red onion (using a Japanese grater)
1 lime grated zest (using a Japanese grater)
¼ cup lime juice
salt pepper to taste

° This is a broken vinaigrette. Combine equal parts olive oil and vinegar, whisking. Add remaining ingredients and stir to combine.
° Toshi's dressing is very strong; use it lightly, just enough to kiss, not cover, the ingredients.

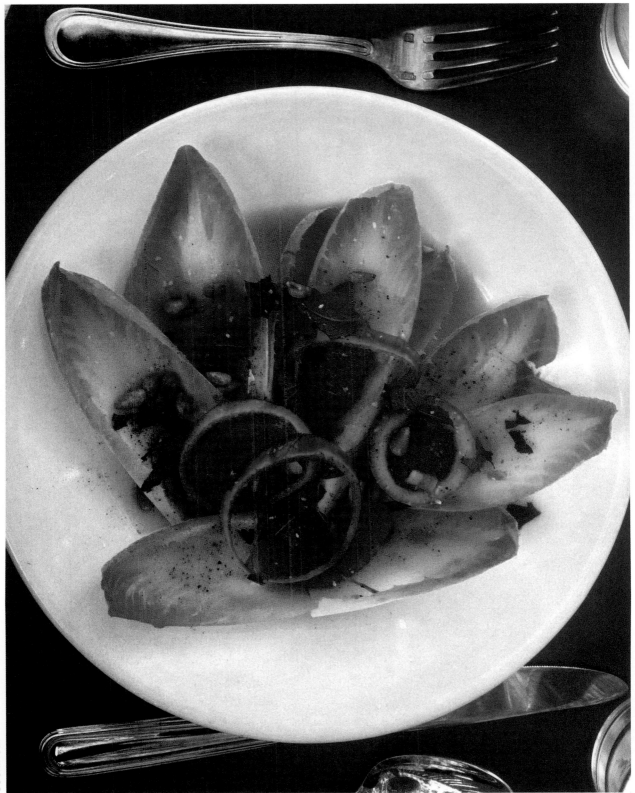

Jalapeño Potato Soup

Courtesy of Magda Drawe, formerly of the Petan Ranch

"This recipe is from Grandpa (Burney Drawe). We used to cook it when we ranched at the Wild Horse in Van Horn all the time. Serve with a grilled cheese sandwich, and it's delicious."
—Magda Drawe

3 large potatoes, diced
¼ teaspoon pepper
½ teaspoon seasoned salt (3 shakes)
2 shakes garlic powder
1 fresh jalapeño, deseeded and deveined
1 cup whole milk
cheddar or Colby jack cheese

° Dice potatoes, put in a pot with about 3 cups of water and cover with lid. Season potatoes with pepper, seasoned salt and garlic powder. Add one fresh jalapeño, deseeded and deveined. Boil until the potatoes are fork tender, about 20 to 30 minutes.

° Reduce heat to low and add milk (do not bring that to a boil because the milk will curdle). When you serve it, put grated cheddar cheese or Colby jack over the top. Serve with a grilled cheese sandwich.

Roasted Carrots with Orange, Pineapple and Marjoram

Courtesy of Marfa Table

Lesley Brown

"These carrots make an appearance at almost all Marfa Table events because even small children (and my dog) love them. Carrots are available year round, but in the spring, buy them small and young with greens attached at the market. The leafy tops are natural breath fresheners, highly nutritious and can be minced into salads or pestos or cooked into stock."
—Bridget Weiss
Serves 4–6

1 pound carrots
2 navel oranges
8 ounces fresh pineapple
2 tablespoons dried marjoram
olive oil to splash
sea salt

° Preheat oven to 425 degrees. Line a large baking sheet with parchment paper for easy cleanup.
° If carrots are large, peel and cut into slender 3- to 4-inch strips. If carrots are small and young, scrub the skins and trim the tops, leaving 2 inches of green stalk attached.

° Slice oranges in half and then thinly slice halves into half moons. Leave rinds on.
° Slice pineapple into thin strips or 1-inch chunks.
° Toss carrots, fruit and marjoram with olive oil to coat. Sprinkle with sea salt.
° Bake on parchment-lined sheet for 20 to 35 minutes, tossing once in the middle of baking. They are ready when you can push a dent into the carrot using your finger and some of the edges are browning.

Coffee-Sprinkled Ice Cream

Courtesy of Big Bend Coffee Roasters

> *"I can't think of anything that gets you closer to heaven, and the preparation time is only two seconds."*
> —Joe Williams

coffee grounds, to taste
Blue Bell vanilla ice cream, to taste

° Sprinkle coffee grounds on a few scoops of Blue Bell vanilla ice cream and dive in.

Marfa Table Cinco Leches Cake

Courtesy of Marfa Table

> *"Tres leches cake has its origins in crafting a delicious dessert from stale bread or cake. Our recipe starts from scratch and elevates the humble cake to a higher calling. Double the recipe for larger groups or freezing. Cinco leches cake holds for several days in the refrigerator, travels easily and does not mind being frozen and thawed months later if well wrapped against freezer frost. Cream of tartar in the whipped cream allows it to stiffen and keep well in the refrigerator."*
> —Bridget Weiss

2 cups unbleached white flour
2 teaspoons baking powder
1 teaspoon baking soda
½ teaspoon salt
8 ounces butter
1 cup light brown sugar
5 yard eggs
1 cup sour cream
1 teaspoon vanilla
1 jar cajeta, warmed and poured into squeeze bottle
½ cup unsweetened shredded coconut, toasted in dry skillet until just browned

Milk Sauce:
1 can sweetened condensed milk
1 can evaporated goat's milk
1 cup light brown sugar
1 teaspoon vanilla
¼ cup bourbon or rum (optional)

Whipped Cream:
2 cups heavy whipping cream
½ cup powdered sugar
1 teaspoon cream of tartar
1 teaspoon vanilla

° Preheat oven to 400 degrees. Butter and flour an 8x11 casserole dish or 8x8 deep dish.
° Whisk dry ingredients together in a large bowl.
° Using a mixer, combine in the following order: butter, beaten until fluffy; light brown sugar; eggs, one at a time; sour cream; and vanilla.
° Add wet ingredients to dry ingredients and stir by hand until just combined. Bake for 30 to 40 minutes until cake is lightly browned on top and pulling away from edges of pan.
° Pierce hot cake with fork or knife and pour Milk Sauce over the top. Let sit for 20 minutes to 24 hours. Refrigerate or freeze if sitting longer than 2 hours.

° Cut cake and put on individual dessert plates. Zigzag warmed cajeta over cake, allowing the sauce to run onto the plate. Top with an upright spoonful of whipped cream. Sprinkle with toasted coconut.

° To travel or freeze: Allow cake to cool completely in refrigerator. Using a rubber spatula, spread whipped cream over cake in stiff waves. Zigzag slightly cooled cajeta over whipped cream. Top with toasted coconut.

LOCAL LORE AND LEGENDS IN MARFA AND VALENTINE

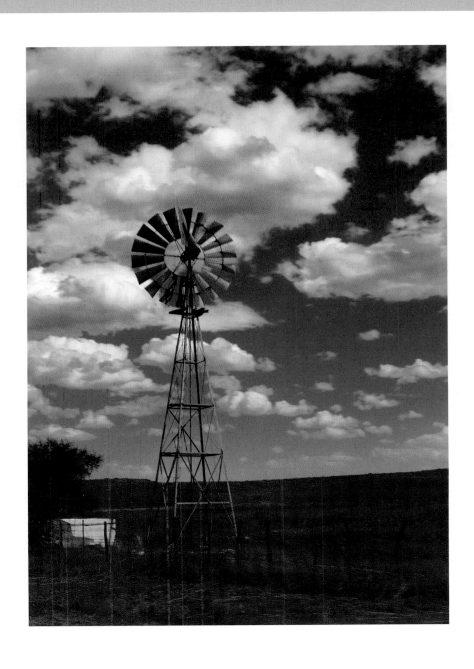

MICHELLE AND HAYES WEST

Rancho Escondido

I met Hayes and Michelle while on a cull hunt at the Maravillas Ranch in January 2014. Michelle and I sat down at the Famous Burro in Marathon so she could tell me more about their family history in the Marfa area. "My husband is a fifth-generation rancher," she says. He runs his family ranch, El Rancho Escondido, outside Marfa, and it's a family-owned ranch, which means it's not supported by any other industry (i.e., oil), so it has to survive on cattle. The drought has been hard on local ranchers. In addition to managing the family ranch, Hayes also manages the Maravillas Ranch for J.P. Bryan, which is a large ranch south of Marathon.

The Rancho Escondido is a twenty-section ranch that has been in the family since 1882. Frank Mitchell came to the area in the late 1870s from the San Antonio area and became a very large landowner. His son W.B. Mitchell was one of the founders of the Highland Hereford Association. One of the few remnants of the Mitchell ranching legacy belongs to Aurie Mitchell West, who with her late husband, Gene West, operated the ranch since her father, Hayes Mitchell, passed away in 1969. Aurie and Gene have five children: Guy West, Adele Coffey, Laura Whitley, Elaine West and Hayes West.

JOE WILLIAMS

Big Bend Coffee Roasters

Joe Williams is the sole owner of Big Bend Coffee Roasters. I sat down with him at the headquarters to visit over a cup of their latest brew to learn more about the history and future of his coffee business.

"My family has been here since 1880 in Fort Davis," says Joe. "My mother's family came there, and I grew up in Sanderson. Great-grandparents came out here in 1880." His great-grandfather Mr. Pruett put together the 06 and Leoncita Ranch and sold that to Mr. Kokernot in 2006. That became the Kokernot 06 Ranch. "My grandmother [Lola Espy] built a house 1907 in Fort Davis that I live in now," Joe tells me. "My mother [Tommie Williams] was born in that house and passed in that house."

Although the coffee business is rooted in Marfa, Joe still lives in Fort Davis. "I have two businesses: one is a livestock brokerage of many, many years, and the other is Big Bend Coffee Roasters." He purchased Big Bend

Coffee Roasters in 2008 from Jean Sinclair. "Erica Billingsley was with the company when I bought it, and she is still with us," says Joe. "We have grown massively. We have four full-time employees, not including myself. We have had zero employee turnovers in five and a half years—this is the best job in West Texas," he smiles and nods as an employee walks through the office where we are chatting.

Joe says his bestsellers are the Big Blend of Texas in retail sales and the Northern Italian Espresso in terms of commercial sales.

When I ask Joe how he came into the coffee business, I am surprised to learn this isn't his first rodeo. "I was a coffee grower in Australia," he tells me. "My partner and I had the largest coffee plantation in Australia that we grew from seed. We started that project in 1980; 1988 is when I sold out to my partner, Check Wanchou."

About his current blends, Joe shares some of the bones of the business with me: "The process of roasting takes fifteen to sixteen minutes per fifty-pound rotation. We ship all over the U.S. in both retail and customer sales. I have lots of coffee shops that buy my coffee and a tremendous Internet trade, and it gets bigger every day. Our growth is a real easy 25 to 30 percent per year.

"We have twenty-one blends, and we roast to make sure our bins are full. Most bins will carry sixty to eighty pounds; some of the smaller ones are thirty pounds. Everything that is roasted is generally gone in twenty-four to forty-eight hours. We are 100 percent organic, 100 percent fair trade and kosher certified."

Joe's personal favorite blend is the West Texas Wildfire: "We worked for over one hundred days to find that blend. It's a blend of three different country origins, then you have to put it together with different percentages and then you have to discover which level of roast works best with those origins. So we did a lot of coffee drinking and tastings over one hundred days, and the day we found it, we nodded our heads in agreement that we had nailed it. That was the day before the big rockhouse fire. My son Joey did the website for the Jeff Davis County relief fund. I was talking to him a day after the fires, and we were talking about naming this coffee. He said, 'Dad, it's a no-brainer—call it Wildfire.' So we named it West Texas Wildfire. We gave 100 percent of our profits for eleven weeks and raised $4,000 for the relief fund.

"We run a giveback program every month, twelve months a year, to support different organizations in the tri-county area having to do with kids and nutrition. Last year, we gave away just short of $10,000. This year, we will be well past that. We use one of our normal blends—like, this month, it's Mexican Chiapas, and we are benefiting the orphanage in Ojianga. I wrote a check this morning to the Rainbow Room in Brewster County; this is an organization that puts together clothing and PJs and toothbrushes for kids who have been removed from difficult family situations—they don't pack a bag when they take the kids. That's what this organization does." I tell Joe my personal favorite is their Davis Mountain blend, to which he responds that I am supporting the Jeff Davis County Library after-school project with my purchases.

"What we want in coffee is for it to have character," Joe says, "but primarily we want it smooth and low acid. We have spent thousands of pounds of coffees perfecting that technique. I'm an excellent roaster; Tyler is even better than I am and pays more attention. I also understand that I only want to make coffee for 70 percent of the people around here. The other 30 percent aren't coffee drinkers or don't like my coffee. If I can satisfy that 70 percent, I have a business for decades. The things I want to hang my hat on are that we are organic, fair trade, kosher, smooth, low acid and giving back to the community that supports me so well. I have some of the highest-paid people in the tri-county area working for me, and I pay them every week. These are all plusses in my book in terms of taking care of people. We have a vehicle to do that [coffee], and I take care of my people really well. We spend

more time with each other than we spend with our families—you come back in three hours' time, we will all be sitting back here with a bottle of bourbon or beer, joking and laughing and getting things talked about, working stuff out, our mistakes, et cetera. We are still discussing the name with regional hooks late into the afternoon. The back pats in this business are tremendous: our staff often gets stopped on the street, and our customers brag on the coffee that they had something to do with."

DAVID BEEBE

Justice of the Peace for Presidio County and Owner of Boyz2Men Food Truck

David Beebe graduated from Lamar High School in Houston, Texas. He ran cross-country and played in rock bands. Eventually, he moved to this area in March 2007. Growing up, David said he wanted to be a bus driver and one of his favorite things was music. So it would make sense that in his adult life, he would perform in a reputable band and own a food trailer (it's kind of like driving a bus, right?). Also a justice of the peace, Beebe is a pillar in the community.

"My grandfather had a shrimp boat, and my grandmother was an excellent cook. We had lots of great meals," shares David. Some advice he has for other restaurants starting out in the area: "Wow, it's hard. Either choose low overhead or super high pricing and run with it."

If he had the opportunity to give someone a food tour in Marfa, here are some of the restaurants he would suggest: Pizza Foundation, Maiya's and Mando's Food Shark. "We have diversity in flavors and cultures in a small area," says David. "Wine tastings at Maiya's are cool. Farm Stand and BBQ for Chinati Community Day are all good food events here."

WILLYS BURNETT "BURNEY" DRAWE II AND MAGDA GLORIA CANTU DRAWE

The Former Petan Ranch Foreman and His Wife

Burney met Magda when she was working at a convenience store in Hebronville. "The first time he asked me out, I said no because I was going through a divorce, but the second time he asked, I said yes," shares Magda.

Burney was in the area working for his dad on a ranch they had leased. "In 1977, he made $300 a month working for his dad; can you believe that?" Magda says with a smile. "He's always been a cowboy."

Burney's dad, Willys Burnett Drawe, had a ranch called the Weatherby just west of Toya, Texas. Burney would go help his father on the ranch two or three times a year, and Magda would tag along. "There was no running water and no electricity, so on weekends we would go to Van Horn to do laundry, buy burgers, rent a room. Burney would get this magazine called the *Livestock Weekly*. We saw an ad that someone needed a foreman there in Van Horn. So he answered that ad, and we got to Van Horn in February 1991. It was called the Wild Horse Ranch, and he worked for Mr. Carter out of Houston, Texas."

Mr. Carter eventually sold that ranch to the Walkers, and in 2001, the Walkers sent Burney to ranch for them in Mexico. After they sold the ranch in Mexico, Burney found another job in Carlsbad, New Mexico, on the DF Ranch. "I loved that ranch because it had so much water," says Magda. "I could grow gardens, pecans, walnuts, peaches, apples, apricots. After one year and eight months, we found the Petan Ranch. Mr. L.R. French, the owner, passed a year ago, but now his son Powie, he's the one that's running their five ranches out here."

The Petan covers forty-eight thousand acres about forty-five miles south of Marfa on the Palo Pinto Canyon Road. The ranch headquarters is six miles from the Rio Grande. The land is used for a cow/calf operation and is not hunted, except for the occasional mountain lion to keep the deer population safe.

"The original old man was Mr. Cleveland. The high peak out here is called Cleveland Peak, and the flat is called Cleveland Flat," shares Burney. "I know they were here before 1926 in the teens. He was the one who established the boundaries of the ranch. Then sometime along in the 1930s, Pete and Ann Jackson bought it and did the major improvements." Taking the first letters of Pete's and Ann's names is how the Petan Ranch got its name.

"They built a lot of the water systems and drilled a lot of the wells. They were here for a long time. He built the pens and put the ranch together," says Burney. "After that, Bowen McClain owned the ranch in the '70s, '80s and '90s. Then Mr. L.R. French bought it in 1994. He's an oil man from Midland who always loved the land. He bought a lot of ranches around here to improve them, and he put a lot of work and effort into it. The Petan was always Mrs. French's favorite, and that's why it never sold when he sold the others. Mr. French has passed, but Mrs. French lives part of the year in Fort

Worth and part of the year in California."

As the ranch foreman, Burney's day-to-day tasks encompass a broad variety of ranching activities. "Water is so important here," says Magda. "He always has to check water because here in West Texas, there's not much water. You have to be real, real careful. Sometimes I can't water our orchard or our yard to make sure we have enough water for the cattle. When the cattle are calving, he has to ride around and make sure all of the mamas are okay. He rides the fence line to make sure the fences are up." Burney adds that some of their fences were built in the 1920s.

"Right now [April 2014], we are feeding three times a week because of the drought," says Burney. "We fix water leaks, we do a lot

of heavy equipment work like dozer and road grater fixing roads when we aren't working cattle. We also get in the pastures and slow the erosion down; you can never stop it.

"We put the bulls in with the heifers March 15 through July 4. They are with the cows about ninety days. We fertility test the bulls every year and test for several diseases, and we worm them so they don't have any internal parasites," says Burney. "When Burney grew up in South Texas, the bulls were always with the cows," says Magda. "Here, we take the bulls out to let them rest. This is different than how he used to ranch."

"We shoot for our first calves to be born around December 10," says Burney. "We brand in early April and wean and ship in September. Last

year, we did everything a little earlier because of the drought. The weather dictates everything to us. If we have a lot of grass and it's good, then we hold our calves a little longer to get them heavier, but if it's dry, we get them off early to save them.

"We used to go to an individual buyer, but lately we've been going to feed yards in the panhandle. Usually one of their feeding customers will want to buy them, which is good for us. They try to cut out all the middle men because it's cheaper for them and we get a little better money."

When Burney started, they held about nine hundred cattle on the ranch, but due to weather and conditions, they currently hold about six hundred cattle.

When it's time for the roundup, Burney hires hands to help gather the cattle so they can work on the calves. "He has six staying at the bunkhouse right now," shares Magda. "When we got here, he was lucky if he had three people helping him."

To start the roundup, the cowboys ride out into hundreds of acres of pastures and gather the cattle in little groups. "Some cowboys might be riding the east pasture, some the west, then they gather the cattle," says Magda. "They go into big pastures and bring them to what is called a trap, which is located next to the pens. From there, they bring the cattle into the pens. The big pen has little sections, so they will divide the cows into 'dry' (not bred) and 'wet' (bred). Then they have to take the babies away from their mamas to have all the work done. They vaccinate, brand, castrate and ear mark the cattle.

"I used to cook for roundup: guisados, peach cobblers, upside-down cake, everything from scratch. We were famous because people would come help for free as long as I was cooking. Last year [2013] was the first year Burney said they would just throw meat on the fire. When we were on the ranches in South Texas, that's how we would do it in the old days—just buy a bunch of steaks and throw on the grill with onions, jalapeños, tomatoes and wrap in a tortilla to make burritos."

When Magda cooked for the Petan roundup, she would take all the materials down to where the men were working in the pens. "There's a little portalito there, so I would transfer all my groceries and take them to the cowboys," she says. "I'd set the table out so all they would have to do is wash up and pig out. I'd make fresh tortillas, carne guisada, rice and beans. I would make a whole menu ahead of time because they were working five days and I'd have to buy all the food to prepare. Sometimes I made green enchiladas with rice and beans, red enchiladas with rice and beans or meatloaf and mashed potatoes or potato salad. The enchiladas I

do the casserole style. I like the ones you make with the cream of chicken and cream of mushroom and make my own sauce with that."

When I ask Magda who taught her to cook, she says it wasn't until they moved from South Texas to West Texas that she acquired the knack. "According to my girls, I was such a horrible cook until we moved to Van Horn in 1991. They would say, 'Mom used to feed us the most horrible spaghetti.' So I didn't really learn to cook until 1991. I guess in South Texas, our food was so bland. Here you boil your chili pod and make your own sauce; in South Texas it was all powdered and canned. So moving to Van Horn and getting fresh ingredients, I guess going to restaurants and seeing how different the food is here really made a difference. I also worked at Papa's Pantry, a café in Van Horn, and learned more about cooking."

Magda was born in Hebronville, Texas, and Burney is from Mercedes, Texas. They have four children: Myra Kristy Ryker, Willys Burnett Drawe III, Mary Lorraine (Lorrie) Holguin and Magda Lynn (Lynn) Glenn. "My kids grew up in Van Horn and then New Mexico. We moved to the Marfa area in September of 2005," says Magda.

When I ask Burney what the future of the Petan is, he says, "From what I'm told, the heirs who are coming up behind Mr. French have no intention of selling it. It's one of their favorite places and will still be a cow/calf operation. They try to improve the range conditions and the land. The profit is a goal, but they won't sacrifice the environment/ecology to make a profit. They will sell cattle before they would keep them in order to not abuse the land. I imagine I'll get too old to work and Jed or someone will take over for me here when it's time."

MARFA MAID

Malinda Beeman and Allan McClane

Malinda Beeman moved to Big Bend in 1999 by way of Newport Beach, California. As a child, she wanted to become an artist, and one of her proudest moments is having exhibited her art extensively throughout the United States and being recognized by major art awards. She has traveled around the world to places like Bora Bora, Tasmania, Australia, New Zealand, the Arctic Circle (Norway) and beyond before settling down to manufacture artisan goat cheese in Marfa.

"Marfa has become a significant destination town for art enthusiasts and people wanting to get out in our beautiful landscape [Big Bend National

Park]," shares Malinda. "It's a small but peaceful place with a diversity of cultures and interests. Marfa is a gem of a town set in the breathtaking Big Bend area of Texas."

She and her partner, Allan McClane, met in Marfa in 2000. Allan worked in his grandfather's dairy on Cape Cod as a young boy and then became a teacher and a contractor, ultimately settling in Marfa. Their "Little Dairy on the Prairie" is a fifteen-acre homestead located about two miles outside Marfa. They also grow vegetables and herbs for the cheese on their property. They are defined as a Grade A goat milk facility, and they offer classes and group tours on artisan cheese making. They milk twice a day and offer a fresh chevre, several chevre spreads that are flavored with their homegrown herbs or seasoning, feta, ricotta, queso frescos, soft mold ripened and farmhouse cheddars.

About the food in her area, Malinda says the most memorable food from Marfa was the nopales tacos from a defunct restaurant, Tacos del Norte. If she had the opportunity to give someone a food tour in Marfa, she would recommend Cochineal, Future Shark, Pizza Foundation and Maiya's. "They are labors of love by all the owners doing fine food in the Chihuahuan Desert," says Malinda.

PIZZA FOUNDATION

Ronnie O'Donnell and Saarin Keck

"We originally came down to Marfa to help Saarin's sister Maiya, who has lived here since 1994," shares Ronnie O'Donnell. "Maiya was a good friend of Rainer Judd in high school, so when his father, Donald, had passed, Rainer asked Maiya to help come settle the estate. She and her boyfriend at the time fell in love with the place and bought property. Saarin and I had been coming to visit a couple of times. When Maiya was looking to get her place open, we came down for a couple of weeks. Her husband at the time, Joey, had just bought this building [the Pizza Foundation building]. We were looking to get something open in Providence [Rhode Island], but it was going to be a very serious undertaking. Joey said, 'Why not do it here?' And talked us into it on the drive back to El Paso to the plane."

"It didn't matter to us where we did it, as long as we had each other," continues Ronnie. "A combined forty years' experience in the restaurant industry, a beautiful location—you have to pass this place to get to the Big Bend. We, at the time, had no idea about the art tourism and all that. We figured we would do X amount of sales per day with the two of us, plus hire a dishwasher."

Pizza Foundation opened in the spring of 2003. "We got here to Marfa in September of 2002 and were open the following spring," says Ronnie.

"Why pizza?" I asked him. "I made pizza in Providence for a guy named Paul Schneider who started a place in Provincetown, Massachusetts, on Cape Cod called Spiritus. He opened another place, too. I grew up in New England in Italian neighborhoods where we would ride the bus to go play video games and eat pizza. He had a sign on the door that said help wanted, so I started working for him, running the ovens, in 1990. Paul has a couple places in Maine, so he's still at it. I credit him with what I know about making pizza.

"Saarin was managing a pretty successful place in Providence when she was eighteen," continues Paul. "She was bartending and managing for years."

"I was always a front-of-the-house type of person and worked at a bunch of restaurants," Saarin says. "Right before we moved here, I was a personal assistant and front-of-house manager in Providence. I took a leave of absence to help my sister open her restaurant. When we visited Marfa, it was a dead town with not much going on. We were coming from where there was a nightlife, so we couldn't imagine living here. But we were here for two weeks and got integrated with the community, and it was a whole different feel. My brother-in-law mentioned we might think about his building in the car ride to the airport, and by the time we got home, we thought it would be a good idea. I knew the food costs, bookkeeping and front-of-house management, while Ronnie is the more creative person with the dough and pizza taste."

"When we first opened, there wasn't a pizza place like us," Saarin continues. "We had slices. That was a weird concept to our early customers. We had to price the slices cheap so everyone would get the concept. They were used to personal pan pizzas, expressions from the chains—it was a funny experience. We still get new people that have lived here their whole lives and are finally giving us a chance, and they still haven't seen slices. It was a foreign concept initially. We've had over one hundred employees, and they've all grown up on our pizza and it's a norm for them. It was a very funny introduction to slices for this community. We were also on the fence about what kind of pizza place we wanted to open; al metro was an idea, where you sell pizza by the weight. It's a different shape, and they do it in Rome. They have a deli display case sheet pan style, you kind of point at what you want, they throw it on the scale, charge you by the weight, warm it up and off you go.

"What I was totally charmed by, at the end of the workday, was that we had everyone from guys in nice business suits to kids in their backpacks; everyone was eating our food."

"Kids will come and get a slice of pizza, and the limeade is very popular," shares Saarin. "We were emulating this frozen lemonade that people wait

for the summer for the trucks to start coming around the neighborhoods. It's huge in Rhode Island. We had a Caesar salad that had lime juice in it and were squeezing limes. The limes were starting to go bad, so we came up with this frozen slushy drink as a way of not throwing away a case of limes. Now we have to buy pre-squeezed lime juice because they are so popular. Mango limeade, watermelon limeade, cherry limeade—they are all good."

"Saarin was born in Rome," says Ronnie. "That's the other thing about this community; we both went to Rhode Island School of Design." Saarin says, "My dad was an assistant professor while my mom was in Italy; he was teaching at the Rhode Island School of Design. I was born in Italy. When I was five, he went back for a couple years. When I was nine or ten, he was there for three or four years. We would be three months with my mother and three months with my father back and forth between Italy and Providence, Rhode Island, and then New York. So my sister went to art school, Ronnie and I both went and my brother-in-law went—and we've all ended up here."

When I asked their personal favorite item on the menu, Saarin said, "I love pizza. When we travel, people can't believe we eat more pizza everywhere we go. We are always trying everyone else's pizza to see what's out there. For me, pizza is my favorite food. Once you have the pizza dough, the possibilities are endless. You can stretch it out, play with things. On Sunday we had some leftover asado someone made us; we put it with cheese in some dough and made a calzone. For me, it's all about the pizza. I just like cheese. That's my favorite. Cheese or extra cheese. "

When I ask what their bestseller is, she says, "To be perfectly honest with you, pepperoni or pepperoni and jalapeño or pepperoni and mushroom. Far and away, pepperoni is the bestseller, I'm pretty sure it's a universal thing."

"We use fresh yeast cake, which is tough to get hold of in a household setting," explains Ronnie. "99 percent of the pizza dough recipes will have you use dry active yeast, but the fresh yeast cake is a better result. It's like the difference between using processed sugar and cane juice.

"We used to do six different salads. When we did the move, we stripped off a lot of the menu. All but one of the salads went. One thing that used to be very popular was a tomato and bread salad that Saarin made. It was a take on a Tuscan salad.

"We've been getting into bread making too. Take a couple pieces of dough and let it rise, and the kids love it. Focaccia has been the beginnings of the pizza flatbread for thousands of years. We used to do focaccia with the dough, let it rise overnight and bake it in the morning. Cube it up, toast it,

make croutons, tomato, basil, onions, feta cheese, roasted garlic and balsamic vinaigrette—that's just our take on it. It's an age-old Tuscan thing, and you can substitute other cheeses. Some recipes use fresh mozzarella balls.

"It's important to us that we thank Maiya and Joey, who were instrumental in helping us get started."

MARFA TABLE

Bridget Weiss

Born in Austin, Bridgett Weiss moved to Marfa in 2009. "I attended St. Stephen's School in Austin with twenty-five students in the class. I lived there forty-five years and was a competitive swimmer for twenty years. I moved to Marfa because the surroundings are beautiful, the people are kind and supportive of one another and there is no crime." When I ask her what is one thing she wants people to know about her community, she says, "We take care of each other."

Through Marfa Table, Bridget caters private events, including special events at hunting leases and ranch parties, weddings, celebrations and fundraisers. Known for using fresh and local ingredients from area producers, they also are proud of their presentation and strictly word-of-mouth marketing. "Signature Marfa Table offerings include wood-fired meats and seafood, beautiful vegetable color plates, toothsome sauces, accoladed appetizers, aperitif mixes, fresh flower and herb garnishes and brilliant desserts," shares Bridget.

FAT LYLE'S

Mark Scott and Kaki Aufdengarten

Mark Scott and Kaki Aufdengarten, his partner in the business and in life, opened Fat Lyle's food trailer in Marfa in August 2012. "In Marfa, when it comes to food trucks, it's always a little difficult coming up against the Food Shark. In one way, it's easy because they've put in the hard work. Who would have thought you'd be able to serve Mediterranean food in a town of two thousand people?" says Mark with a smile. "They took the 'weird' off of it [food trucks]. They are great friends of ours, and we help each other on a daily basis. It'll be nice to hit two years. I still feel like the new guy."

Kaki is a sixth-generation Texan in this area. "My family, the Mitchells, came out to ranch cows, and my granddad, dad and brothers all still do," shares Kaki. "They ranch seventeen miles south of here on the Fletcher. They operate on several different places. It's big country. I grew up here in Marfa but went to school in Fort Davis and went to college at Texas Tech. I graduated with a degree in communication studies." "That's why she works the window," Mark chimes in.

Mark has lived in Marfa more than half of his life, but he and his brother were born in New Orleans. "My mom was born in Pecos but moved to Marfa when she was in second grade. I also moved to Marfa when I was in second grade," shares Mark. "My granddad Pat Ryan ran the *Big Bend Sentinel* for several years. I grew up here, graduated from high school here and tried to leave a couple of times, which were unsuccessful because I love it out here so much." Mark was in high school when he had his first kitchen job at Maiya's in downtown Marfa. "I worked there for seven years and Padre's for a couple of years, and then I worked at another kitchen with a couple guys called the Miniature Rooster. We [Fat Lyle's] do fried chicken every Sunday, and that's where I learned a lot of southern soul food cooking. The restaurant was open for less than a year, maybe nine months."

"The last day the Rooster was open was on Valentine's Day, and they did record numbers," shares Kaki. "One of the owners got the job-of-a-lifetime opportunity, so he split out, and everyone went their separate ways," says Mark.

After the Rooster, Mark did some catering and handyman work around town. "The day came that I couldn't work in any more kitchens in Marfa, so it was time to get my own," says Mark. "That's when we started looking for a food truck. Property is so expensive in Marfa it would take an entire lifetime to own, so we found this food truck in Austin at a good price and bought it. It's on the lot of the house that I grew up in. My mom grew up in this house too. It's definitely a family affair over here. My mom bakes all the biscuits for fried chicken Sundays and all the desserts. It's pretty cool; we all get together to work on this project, this business."

Their bestseller depends on the day since the menu changes frequently. "On Friday, our burgers bring out a lot of the border patrol guys, meat eaters, ranchers and locals," says Kaki. "Saturday, you don't know. Then Sunday, people come out for fried chicken and biscuits. On Monday, we do a Korean-style fried chicken."

Regarding the name Fat Lyle's, Kaki explains, "We have two Australian shepherds. One of them is named Lyle, and he's been a fat dog all his life. Lyle Lovett had come to town, and I was thoroughly impressed. My parents had a litter of puppies, and we found one we loved and named him little fat

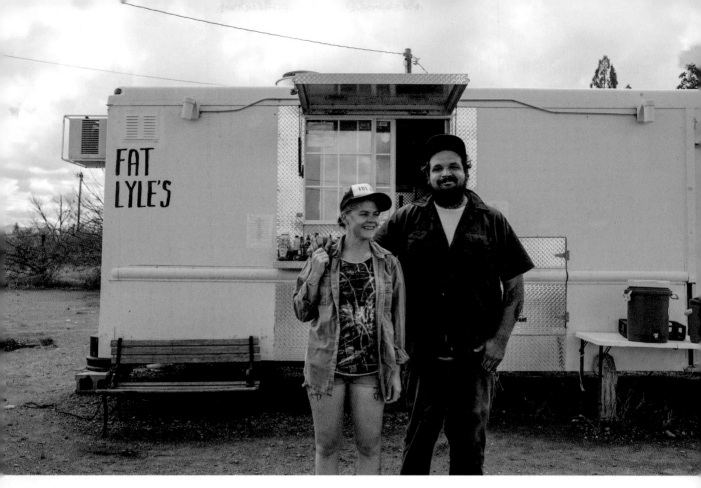

Lesley Brown

Lyle. I don't know if we ever even had any other ideas. It's funny to tell people it's named after our dog. Sometimes Mark's dad will come and visit when there are people he knows. People see him welcoming everyone and talking with people 'in his living room,' and they assume he's 'Fat Lyle.' It's pretty funny. It could be anybody's name."

The lot is BYOB, "and please recycle when you're done," says Mark. It's also dog friendly.

"We depend so much on tourist traffic, the amount of business we do depends on what's going on in town. One weekend a big band will be playing a show and there are six hundred extra people in town. The next day, it will be two hundred of our friends. We look for three-day weekends and weddings or holidays, anytime people have extra time to travel. Our sales are very event driven. We fax our menus to the hotels every morning," shares Mark.

"Marfa is such a service industry. Unless you work for the city or are a cop, if you're trying to make it in Marfa as a young person, you're probably in the service industry, so we do it together," says Mark. "We work hard, then drink

hard and sigh a sigh of relief together. We support each other's restaurants. We are all friends, and I like that. Especially all the mobile food units like Food Shark and Boyz2Men.

"We're just Marfa kids trying to stay Marfa kids. It's a yearly struggle; wintertime gets slow, but you hunker down and keep moving forward so we can keep living in paradise."

BOYD ELDER

West Texas can be a pretty small world. Boyd's daughter Shaula is a friend of mine in Austin, Texas. It wasn't until I moved out west that I realized their relation. I ran into Boyd at the Valentine's Day party in Valentine in 2014 and asked him if he would be willing to contribute some recipes to this cookbook. "I've become a good cook out of necessity; I had to cook for the family. A lot of people say I should open a restaurant because when I do cook I am a good cook," he told me and agreed to meet up. Several months later, we sat down on the porch of the Pizza Foundation in Marfa to talk shop. He drank a bottle of Rolling Rock and smoked a cigarette. We had to pause in conversation periodically, as the train would interrupt.

"My great-grandfather Willie E. Bell founded the town of Valentine before the railroad came through," Boyd told me. "He and Bill Foley came into Valentine looking for five hundred head of cattle. They were working a ranch in New Mexico somewhere, so he came and plotted out Valentine in the mid-1800s. There's a semi-historical plaque there that will tell you some of that stuff."

Born in El Paso, Boyd was raised in Valentine until he was seven. "Then we moved to El Paso. We were back and forth every holiday," he said. "Spent a lot of time in Juarez when I was growing up, when it was great to go there. I went to high school in El Paso, then college at Chouinard Art Institute in Los Angeles. Walt Disney paid for my entire education through scholarships. They had merit and financial needs; mine were all merit. I had certain things I had to do to comply with the scholarship; for example, I was class assistant in all my classes. I was also part of the selection committee for sophomore screening, that kind of thing.

"I left LA in 1967," Boyd continues. "Came back to El Paso. Moved to Valentine in 1970. Population has shrunk since then; there's probably not 59 people that live in the city itself. The census sign says 217, which is real wrong."

Boyd is an esteemed artist. He told me his preferred medium is anything experimental. "I've used film, paint, light, reflection...the stuff I'm working

on now involves projection and reflection." He has taught classes in drawing, design and airbrush. One of the highlights of his career was creating the cover art for an Eagles album. I asked him to tell me the story:

"The studio I had in Valentine was an old garage; it was the first general store, the post office and a car dealership. But it was where my studio was. It caught on fire in 1973 [May 31] and burned to the ground. I didn't have anything to work with, so we went out to visit my cousin Arlene Leslie Williams, who had married Mike Williams. Mike was working on part of the X Ranch at the time, and it was the fourth-largest connected ranch in the United States. We found these cattle that had been drowned in an arroyo, in a flash flood. There's actually wild cattle up there that have never been branded or dehorned. I painted two of those like a

Junie Villareal

motorcycle tank. The first one was used on the eagles cover *One of These Nights*, and the work was entitled *Zacatecas*, which is a town in Mexico.

"I'd met the Eagles when I was going to art school," Boyd told me. "I had a big show in Venice, California, called 'el Chingadero.' Griffin did the invitation for it, which was a big map of me driving from Valentine to California. The Eagles only knew seven songs. The work I was doing then were seven and a half feet in diameter. After my studio burned, I painted those skulls, and a mutual friend of mine, Gary Burden, called me on my birthday of 1974 and they'd wanted to use *Zacatecas* on their cover, which they'd seen in a hotel room in Dallas with an image projected on a wall. So I came to Valentine, picked it up and drove it to California. Then I went to Montecedo and did the lettering with airbrush and pinstriping brushes.

"It was one of those things that just happened; I never wanted to do album covers in the first place. I was asked to work for Warner Brothers out of college but didn't want to do that. Crosby, Stills, Nash & Young; America; Jackson Brown; Tom Waits; Joni Mitchell were all buddies of mine from LA. I was always around a lot of actors and writers also."

One of Boyd's most recent projects was designing the beer label for the Big Bend Brewery with a special blend they developed for their Valentine's Day party in Valentine in 2014. "That was a piece called *y6 sunrise*," says Boyd. "That's the brand. Bode Means (their family property borders our property in Valentine) gave me that skull in the early '80s, and it was a white face Hereford bull skull. I painted that sometime in the mid-'80s, and it was adhered to a big painted panel with a sunrise. The skull is from the Y6 and Moon Ranch."

I asked Boyd to describe a normal day in Valentine. He said it was mostly quiet, but there was a lot of noise from trucks and trains. "A lot of people ranch," he said, "but the main community is the school; it's the only employer except for Red Brown, and he employs two truck drivers and that's it."

Boyd has applied for artisan residence in Marfa. He was one of the first people to show at the Ballroom Marfa and was close friends with Marfa elite Donald Judd from 1972 until Judd passed. Boyd is involved with the Prada Marfa art installation between Marfa and Valentine as well. "I put the place back together two days after it was vandalized in 2004," he shares. Boyd remains active as the project representative.

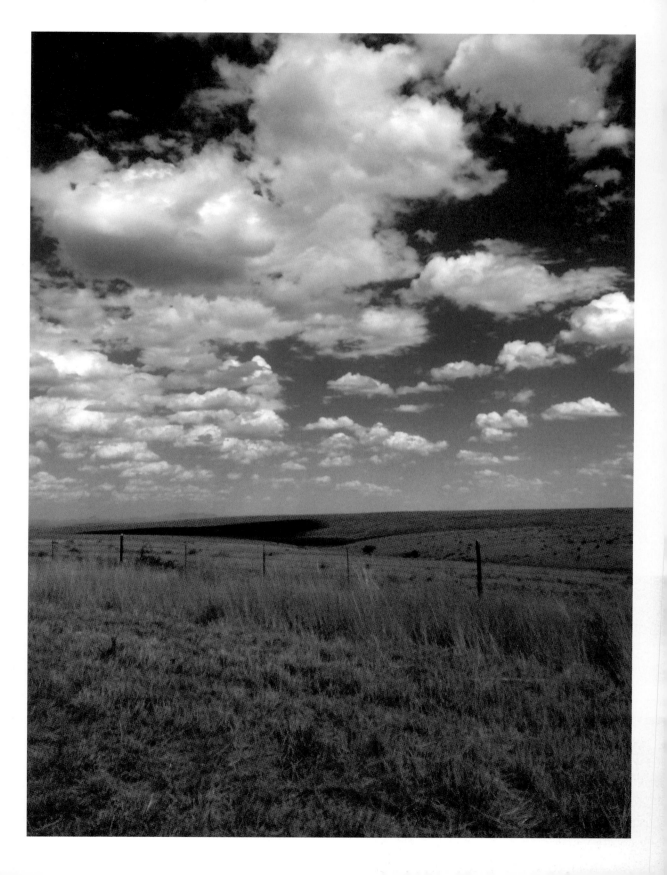

BRIEF HISTORY OF FORT DAVIS

Fort Davis is the county seat of Jeff Davis County. Established originally as a military post in 1854, the town was named after Secretary of War Jefferson Davis. The population of the unincorporated town hovers around one thousand, and it is situated along the Limpia Canyon. Fort Davis offers several unique points of interest, including but not limited to the Davis Mountains State Park, the McDonald Observatory, Fort Davis National Historic Site and the Chihuahuan Desert Research Institute. Fort Davis is known for having one of the highest elevations in Texas at just over five thousand feet.

Some events that are unique to Fort Davis include its Fourth of July celebration, the mule rodeo and military reenactments. The Hammer Fest is a seventy-five-mile road bike race that is one of the most difficult races in Texas as far as elevation changes.

Big Bend Bucket List: Fort Davis

- Star parties at the McDonald Observatory
- Visit the historic fort
- Drive over to Balmorhea
- Attend the Fourth of July festivities
- Chihuahuan Desert Research Institute
- Hike or camp in the Davis Mountains State Park

Chicken à la King

Courtesy of Black Bear Restaurant at Indian Lodge/CCC

$2^2/_3$ cups chicken in ½-inch cubes
1 12-ounce can mushrooms, or to taste
¼ cup butter
$^1/_3$ of 12-ounce can pimentos, or to taste
$^2/_3$ cup peppers
$^1/_8$ cup fat
$^1/_8$ cup flour
3 egg yolks
$1^1/_3$ cups chicken stock
$^1/_3$ cup cream
parsley, to garnish
toast, for serving

The Indian Lodge is a historic adobe hotel nestled in Davis Mountains State Park. Within the Indian Lodge is the Black Bear Restaurant. The original recipe shared with the Black Bear Restaurant from the CCC was enough to serve 55, costing only 13.4 cents per serving at the time of its original use in the early 1900s. We have reduced their recipe to yield 10 servings.

° Singe and clean chicken. Cook whole chicken in boiling water until tender. Remove bone and skin from chicken and cut in ½-inch cubes. Sauté mushrooms in butter and season. Chop pimentos and peppers and make a white sauce of fat, flour, egg yolks, chicken stock and pepper and pimentos. Heat thoroughly. Add cream just before serving and garnish with parsley. Serve on slices of toast (toast only on one side).

Chile Rellenos

Courtesy of Poco Mexico

Anaheim peppers are used in this recipe. Typically they are have a mild heat, unless you specifically purchase a different kind of Anaheim.
Yields 1 dozen

12 Anaheim chilies
1 block mild cheddar cheese (or your cheese of preference), cut in thick slices to stuff in the peppers
vegetable oil, for frying

Batter:
3 cups flour
1½ cups whole milk
1½ cups warm water
1 tablespoon baking powder
1 teaspoon salt
2 eggs, beaten

° Roast raw, fresh chilies over an open flame on high heat. Some people use hot coals; those come out the best, but we can't do that in the restaurant because we do so many per day. The skin of the peppers will start peeling itself as it blackens and pops. Once you can see the skin start to separate, place the hot peppers in some wet paper towels so they get steamed a little. The steam helps loosen the outer skin and makes it easier to peel.

° Peel the chilies. Stick a slice of the cheese in the pepper. Once those are done, you are ready to make your batter. Mix all batter ingredients together (flour, milk, water, baking powder, salt and eggs) and beat until it is smooth. You can play with your desired thickness by adding more flour for thicker batter or more water/milk for a thinner batter. Note: If your batter is thicker, you will need to cook the chilies slightly longer.

° Lightly roll the stuffed chilies in a thin layer of regular flour so the batter sticks to it. If you do it without the flour, the batter will not stick.

° At the restaurant, the commercial fryer is set at 280 degrees, and once dropped in, the chilies will usually float right up to the top. If you're pan frying, turn the chilies after approximately 2 minutes, cooking them for a total of 5 minutes. They will turn golden brown when they are ready. Serve with rice and beans.

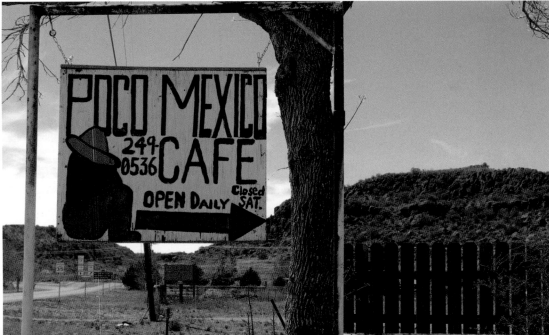

Cranberry-Almond Chicken Salad

Courtesy of Stone Village Market

*Yields 7–8 pounds or 14–15
½-pound servings.*

2 cups almonds, sliced and toasted
10 pounds chicken breast, boneless
 and skinless
salt
pepper
5–8 sprigs fresh rosemary (5–6
 inches long)
2 cups cranberries, sweetened and
 dried
1 medium red onion, diced
1 stalk celery, diced
5–6 cups mayonnaise

° To toast almonds, spread them on a baking sheet in a single layer. Lightly sprinkle with salt. Bake at 350 degrees for 5 to 7 minutes or until lightly brown.

° Place thawed chicken breasts on foil-lined baking sheets and spray with cooking spray. This helps to keep them moistened. Generously sprinkle the breasts with salt and pepper. I like to use coarse ground pepper, but fine ground is good too. Next, take the leaves off the rosemary sprigs and sprinkle on top of the chicken breasts. Loosely cover chicken with foil and bake at 350 degrees for 45 minutes to an hour depending on how thick the chicken is. Chicken must be cooked until it reaches an internal temperature of 165 degrees or, when cut in the thickest part of the breast, it is white and no longer pink.

° Cool chicken for at least 30 minutes, or I like to let it sit overnight in the fridge so all the spices soak in. Dice chicken and mix with cranberries, onion, almonds and celery. Next, mix in the mayonnaise and let it chill for a couple hours. You can serve on a sandwich or by itself on a bed of lettuce.

Plata Roast

Courtesy of Glenn Moreland

3 onions, sliced
1 teaspoon cooking oil
7 pounds shoulder clod
4 or 5 roasted green chilies
1 teaspoon salt
1 teaspoon lemon pepper
1 teaspoon pepper
2 teaspoons cumin
1 teaspoon garlic salt
fresh garlic

° Brown 4 or 5 onion slices in oil, then brown meat in this or use Kitchen Bouquet, a spice. Cut slits in the top of the roast and stuff with more onion slices and the green chilies. Season with spices and garlic. Cook with coals on the top and bottom for 1½ to 2 hours. Remove roast from the oven, cut into bite-size pieces and return to the oven to cook in juices until tender.

"Plata is a little water stop on the Orient Express between Marfa and Presido. We used to ranch down there, and Plata was on the north end of the ranch. My brother-in-law calls this dish Plata Roast. To make it, use a 16-inch-deep Dutch oven."
—*Glenn Moreland*

Stacked Red Enchiladas

Courtesy of Susie Liddell, Calamity Creek Ranch

Each serving is made separately, so you can scale this recipe to fit how many people are eating and each person's appetite. On average, a serving contains 3 to 4 tortillas. This recipe is based on 4 people eating 3 tortillas each.

1 package New Mexico red chili
 pods, extra hot (½-pound bag)
8–10 cups water, 2 cups reserved
¼ cup flour
salt, to taste
12 corn tortillas
canola oil
1 pound Colby cheese, grated
½ one white onion, diced
eggs, fried, to top

° Remove stems from chili pods and shake off excess seeds. Put dried chilies in a medium stew pot with 8 to 10 cups water. Boil, then immediately lower heat to simmer. The chilies will turn from a bright red to a dull red (approximately 30 minutes). Note: If you boil too long, they get bitter.

° After the chilies cool a little, fill a blender with 3 cups of cooked chilies and then add some of the chili water to the blender (about a cup) until the chilies are totally immersed. Blend on high until liquid, then strain the liquid. You'll have enough chilies to do this process twice. It will yield two 24-ounce containers of thick chili paste. Use half the mixture (or one of the 24-ounce containers) and start heating it on low in a saucepan.
° In a separate bowl, whisk ¼ cup flour with enough water to dissolve it. After the flour is dissolved, to make sure it doesn't clump, use a strainer and pour the flour mixture into the chili paste in the saucepan, turning the heat up to high and stirring continuously. If it's too thick, add water to desired consistency. Add salt to taste. After cooking for about 10 minutes, the sauce is ready.
° Fry whole corn tortillas in hot canola oil so they are soft (approximately 20 seconds on each side, not too hard). Drain as many as you are going to serve/eat on a paper towel.
° Dip the tortillas in the chili sauce and then top with grated cheese.

Layer with more tortillas in sauce and cheese to build a small stack (however many each person wants in his or her stack). Build on oven-friendly plates. Top with onions and bake each plate at 350 degrees until the cheese melts (just a few minutes). Watch them closely. Serve with rice and beans and a shredded lettuce salad with red tomatoes. If anyone wants an egg on top of his or her stack, add it just before serving.

Cheesy Baked Pozole

Courtesy of Come and Take It BBQ

olive oil
1 red onion, diced
2 red bell peppers, diced
#10 can white hominy
27-ounce can chopped green
 chilies
¾ cup matchstick carrots
salt and pepper, to taste
½ cup water
grated cheddar cheese

° Coat the bottom of a 14-inch Dutch oven or deep-dish baking pan with olive oil. Heat oil at about 350 degrees until sizzling. Add diced onion and bell pepper and sauté until soft. Add hominy, green chilies, matchstick carrots, salt and pepper and water. Stir all together. Bake for 30 to 40 minutes, stirring occasionally, until it is heated through. Sprinkle grated cheese to just cover the dish and cook another 8 to 10 minutes, until cheese is melted and bubbly. Serve hot.

"I first tasted this creation at a benefit BBQ at Fort Davis National Historic Site. Jeff Davis County Mountain Dispatch editor Bob Dillard bakes this tasty side dish in a Dutch oven, and it is a huge hit with the guests. With Bob's permission, it has become a staple side dish at Come and Take It BBQ."
—*Jenny Turner*
Serves up to 24

Dutch Oven Potato Recipe

Courtesy of Glenn Moreland

1 pound bacon
3 carrots
1 summer squash
1 zucchini squash
4 large onions
1 green pepper
12 good-sized red potatoes
10 slices white pasteurized cheese

° Cook bacon in a hot Dutch oven. Add vegetables and potatoes to Dutch oven, stirring occasionally to mix vegetables, potato and bacon grease. When potatoes and vegetables are done, remove heat from bottom and add slices of cheese.

One of the most famous chuck wagon cooks in all of West Texas, Glenn Moreland shares one of his Dutch oven recipes.

Golden Salad

Courtesy of Black Bear Restaurant at Indian Lodge/CCC

6 tablespoons and 2 teaspoons
 lemon gelatin
⅔ cup boiling water
2 cups pineapple juice
1⅓ cups raw grated carrots
⅓ of one 12-ounce can crushed
 pineapple, or to taste
¼ small bunch celery
¼ teaspoon salt
8 leaves lettuce
½ cup mayonnaise

Within the Indian Lodge is the Black Bear Restaurant. The original recipe shared with the Black Bear Restaurant from the CCC was enough to serve 40, costing only 3.9 cents per serving at the time. We have reduced their recipe to yield 8 servings.

° Dissolve gelatin in boiling water. Add pineapple juice and enough cold water to make required amount. Wash and peel carrots and run through food processor. Add carrots, pineapple, celery and salt to cooled gelatin mixture and pour into individual molds. Serve on a bed of lettuce dressed with mayonnaise.

Hot Potato Salad

Courtesy of Black Bear Restaurant at Indian Lodge/CCC

2 ⅛ pounds potatoes
3 eggs
⅛ pound bacon
1⅓ cups celery
½ cup peas
⅛ cup pimento
⅛ cup parsley
⅛ cup onion
⅓ cup water
⅓ cup vinegar
⅛ cup sugar
⅛ cup bacon fat
⅛ cup salt

The original recipe shared with the Black Bear Restaurant at Indian Lodge from the CCC was enough to serve 100; we have reduced their recipe to yield approximately 8 servings.

° Marinate potatoes in dressing. Mix other ingredients. Put in steamer and keep hot.

Cranberry-Oatmeal Cookies

Courtesy of Stone Village Market

These are some of the patrons' favorite fresh-baked cookies at Stone Village Market.

1 cup softened butter
1 cup white sugar
1 cup light brown sugar
2 eggs
1 teaspoon vanilla extract
½ teaspoon salt
1 teaspoon baking soda
1 teaspoon cinnamon
2½ cups flour
1 cup oatmeal
2 cups cranberries, sweetened
　　and dried

° Cream together butter, white sugar and brown sugar. Add eggs one at a time, mixing well after each. Add vanilla. Mix together in a separate bowl salt, baking soda, cinnamon and flour. Add flour mixture to batter mixture and stir until flour is just mixed in. Stir in oatmeal and cranberries. Spoon onto parchment-lined baking sheet and bake at 350 degrees for 10 to 12 minutes.

Diane's Pecan Pie

Courtesy of Susie and Randall Liddell, Calamity Creek Ranch

3 eggs
⅔ cup sugar
⅓ cup melted butter
1 cup dark karo syrup
dash salt
1¼ cups pecan halves

° Thoroughly beat eggs and sugar together—by hand, not mixer. Stir in melted butter, karo and salt. Mix well. Add pecans and pour into unbaked pie shell. Bake at 375 degrees for 50 to 60 minutes. Check by inserting knife in center. If knife comes out clean, pie is done.

"This pecan pie is from Randy's mom and sister. It is the one I make. Diane is Randy's older sister, and the picture features Grandma Ginny (Genevieve)'s handwriting."
—Susie Liddell

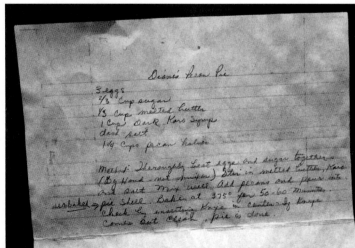

Millionaire Pie

Courtesy of Cueva de Leon

> *"I make a special buffet on Sunday with fruit salads and homemade desserts. This is a recipe my customers love. Very easy and very good."*
> —*Lorina Wells*

1 large package cream cheese
2 cups powdered sugar
8-inch graham cracker pie shell
2 cups Cool Whip or regular cream
1 small can crushed pineapple, drained
1 cup chopped pecans

° Mix cream cheese with powdered sugar until very light and creamy. Put it into 8-inch pie shell. Top it off with Cool Whip combined with pineapple and pecans. Let it chill and serve.

Pineapple Dump Cake

Courtesy of Cueva de Leon

2 cups flour
2 cups sugar
2 eggs
2 teaspoons baking soda
1 large can crushed pineapple
 with juice
1 teaspoon vanilla
½ cup chopped pecans

° Mix all ingredients together in an oblong pan and bake for 30 minutes at 350 degrees. Prepare icing while cake is in the oven because you will need to ice the cake while it is still warm.

Icing:
1 8-ounce package cream cheese
2 cups powdered sugar
1 cup chopped pecans
1 teaspoon vanilla

° Whip the cream cheese, mix with other ingredients and ice the cake while it is still warm.

"This is one of my mom's recipes. I have a cookbook in memory of my mom. When she died, she had a file full of yellow, old-looking recipes, so I typed up a bunch of her recipes and did a notebook and gave one to each of my family members for Christmas. This is a recipe everyone loves at Cueva de Leon on Sundays. It's very easy and very good."
—Lorina Wells

GLENN MORELAND

Two or is it three black and white dogs greet me as I pull up to Glenn's workshop on a sunny Tuesday afternoon in April. He has his irons hot and is working on bending a piece of metal. Stopping to shake my hand and welcome me, he pauses on his work, and we make our way into his home to visit about his chuck wagon building and Dutch oven cooking and, generally speaking, how he preserves the American West through Texas Cowboy Outfitters.

"For twenty-some-odd years, I've been going to the Cowboy Hall of Fame, which is at the National Cowboy Heritage Museum in Oklahoma City," Glenn tells me. "We go up there and cook for about six thousand people. There are ten wagons there at the children's festival too. Mainly we cook beef stew, sourdough bread, peach cobbler and spotted pup [a recipe that uses rice with raisins, milk and eggs]."

Glenn tells me he learned how to cook through trial and error. "I started cooking and I've had a chuck wagon for forty years. I first built it to display artwork, and then they started having these chuck wagon cooking competitions in the late '80s. Chipper Prude at Prude Ranch cooked, so we combined forces and started going to competitions. He sort of faded out of it, and I kept cooking. I went to the first chuck wagon race they had in '73 or '74; it was an RV show and chuck wagon show. The only one was Buster Welch's, and there was a driving competition. When they started the cooking competitions, we mainly cooked fried steak, camp potatoes and peach cobbler. They furnished the food, so you cooked what they had. We

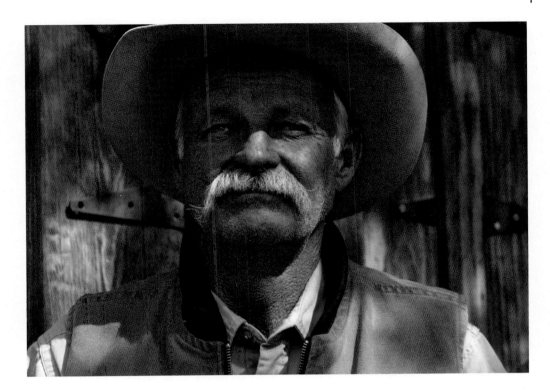

usually do a bread cobbler because it's easy. Normally they furnish cutlets or steak to make the fried steak with, so you can chicken fry it or country fry it.

"In Ruidoso, they will give a big clod and you can cut it up for steaks. I usually make a Plata Roast or green chili roast (see page 161). Plata is a little water stop on the Orient Express between Marfa and Presidio. We used to ranch down there. Plata was on the north end of the ranch, and my brother-in-law called this dish Plata Roast. It has roast meat cut in slices with onions and green chili, cooked in a Dutch oven for a couple hours."

I ask Glenn to give us some pro tips for Dutch oven cooking. He says, "You have to have the oven seasoned first; nowadays they come seasoned. If you're using wood, mesquite is the hottest followed by red oak or ash. Any hard wood can be used, but the softer woods like cedar or pine don't work as good. Some people use briquettes, and it takes usually five or six briquettes. It's a lot of trial and error experience under heat that will teach you how to cook with a Dutch oven."

Glenn was raised on the south side of Austin. "I didn't know there was a mountain in West Texas until I married my wife," he shares. "Her father came out in 1917 and ranched below Valentine at the Coal Mine Ranch. They were going to mine coal down there, and they built a bend in the railroad through a bunch of investors. They dug a tunnel through the mountain to get to the

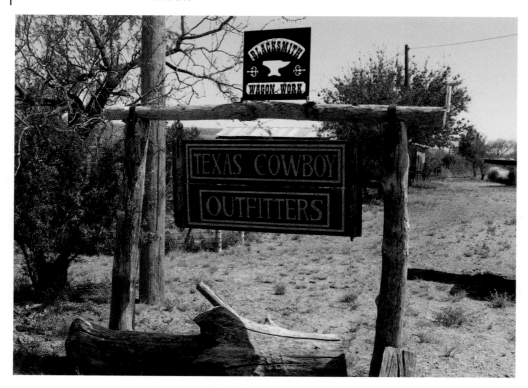

coal. They only got one load of coal out of there, and it went defunct during the Pancho Villa days. He had it up to the '40s or '50s. My wife Patty's mother was raised in Marfa. Patty was raised in Pecos and then Alpine. I met her in college at Southwest Texas State University.

"I worked as a cattle inspector in Fort Bend County near Houston," Glenn continues. That is when he started collecting wagons. "Patty got a job teaching in El Paso, so I worked at a feed lot there for a year. Then we heard the drugstore was for sale here in Fort Davis, so we bought the drugstore and ran it for five years. Her mother had a ranch at Balmorhea, so I would work there one day and the drugstore one day—so I was an official drugstore cowboy.

"I was collecting wagons when I was a cattle inspector. I'd see them laying around people's barns. My grandfather gave me a wagon, but I couldn't ever go get it. I was always interested in wagons, so I'd pick up the old ones and play with rebuilding them. The one I've got now, it's the second bed and third chuck box I've put in it over the years. Twenty years ago, we started Texas Cowboy Outfitters, and I started doing it [making chuck wagons] for a living. A lot of the older guys have died off, but there's always someone comes along and starts doing it. There's a big builder up in South Dakota with fifteen guys working for him, and they do the Amish wagon building.

"I've built for Tommy Lee Jones and cooked for him on roundups. I built one that went to Australia. There was one at the Gene Autry Steakhouse at the Angels stadium in Anaheim. I build them for people for competitions, authenticity, museums—the wagon at the Museum of the Big Bend is one I did. I did one for the Chisolm Trail Heritage Museum in Cuero. There's one in Marshall, Texas, at the Harrison County Museum."

Depending on what his clients want, Glenn can build a whole wagon or just half of a wagon. Some of his clients request the wagons be furnished with everything like coffee pots, bed rolls and Dutch ovens. "I just finished a half a stagecoach at the museum here in Fort Davis. They have a video screen in the window of the door, and they'll tell you information," Glenn shares.

"I was self-taught. If it looked right, it was. A friend gave me a book written by a guy in California that was typewritten on how to build a stagecoach. For wagons, I save the old original parts and make new parts. This one I'm building now will go to a ranch out here, and he doesn't have to be authentic, so I can use a Phillips head screw, but if I'm building for originality, it's all square nuts, rivets and authentic pieces—no drywall screws."

I ask Glenn more about how the chuck wagon cooking competitions work. He says you are judged on the wagon authenticity, your dress (for the period) and the food (usually in four to five categories: meat, beans, bread, dessert and potatoes). "Depends on the competition whether they pay for one place or three places on the food. If you're cooking for forty to fifty people, they'll let you use pan liners, but I don't use it. I argue against it in a cooking competition. I think we should use the Dutch ovens straight. Starting in March, you can go to two or three a month around the country. In the heat of the summer, they slow down."

Glenn is the director of the American Chuck Wagon Association. "We are discussing to have a national cook-off," he says. "With the association, we give guidelines on how to judge. We have clinics for judges so they know how to judge the wagons. Sometimes we offer clinics for judging the food. Competitions will often have a food editor from the newspaper be a judge. A lot of times, they don't know how to judge camp cooking. It's got to look neat and orderly on the plate. Most of them do blind judging now in Styrofoam containers. Whereas a lot of competitions do garnish, we don't a lot of the times.

"A wagon, if you just went out and bought one, would be $10,000 to $15,000, but then you have to have a trailer, a truck to pull it, then all your antique ovens and tin cans and stuff to make it authentic. You have to have the basic tools they had on the chuck wagon. Then gas to travel to the shows, plus you stay at a motel or whatever. Maybe first place in the food category

is $200 to $300 and goes down from there. Overall, it might pay $750 to $1,500 plus your food categories. The most I've won at a show was $2,500, and that's only once or twice over the years. You're lucky to win enough to pay your gas. People do it because they enjoy it, not for the money.

"There are several hundred chuck wagon owners. We have chapters all over the U.S. Mainly Texas, Oklahoma and New Mexico are the biggest concentration of chuck wagons. Over the years—like in Abilene, I went up Saturday to visit—there wasn't a wagon there [that] I'd started with twenty years ago. Sarah Hatfield, she and her husband cooked years ago; she was there cooking with the cowboy church wagon. People get into it, find out it's hard work and quit.

"The first thing you do when you set the chuck wagon up is make a pot of coffee. On the chuck wagon, you'll need utensils to cook with: flour can, sugar can, lard cans, alarm clock, an axe by the woodpile, shovel to dig your fire pit, fire irons, meat cleaver, meat saw, other saws for cutting wood, any tools you use on the trail to repair your wagon, sledgehammer, bits, your cover over your wagon and water barrel. For authenticity, we use granite-wear bowls for mixing bowls.

"People are drawn to the nostalgia of it. I don't know, they like the heritage of it, and their grandfathers worked as cowboys on ranches or they just want to be part of the West. I just enjoy working with wood and metal and building wagons."

Glenn tells me his favorite things to cook are peach cobbler, bread cobbler and any pastries. He says he likes to cook sourdough in the Dutch oven, too. "I found out one thing about starters: I've got a kitchen in the shop that we keep stuff out there. Every couple days, I'll pour part of it down the sink, feed it, put more water in it and continue the process. I finally clogged up the grease trap, so now I pour it in a coffee can in the yard somewhere.

"You always hear that chuck wagon cooks are grumpy, but if you get up at 4:00 a.m. to cook in the wind and the cold, dirt and dust, you just get grumpy. Then you get through with breakfast, clean up, start lunch, clean up, prep the next meal and start the next meal. You work 4:00 a.m. to 9:00 p.m. depending on when the crew comes in to eat."

Toward the end of our visit, Glenn gives me his latest CD and leaves me with a story about long hours cooking from the chuck wagon: "I was cooking for Tommy Lee Jones and his crew. At lunch, he came in with a big bowl of calf fries and said, 'The boys want these for lunch.' I'd just got finished cooking everything, and he asked what I wanted him to do. I said he could throw 'em in the trash because I didn't have time to mess with them. I guess they sat in the fridge. It was one of those bad days that I can look back and laugh on now."

MANNY DUTCHOVER

Poco Mexico

The Dutchover family has been a main root of the Fort Davis community since prior to the Civil War. "I'm the fourth generation of Diedrick Dutchover," shares Manny Dutchover. "He was one of the first settlers in Fort Davis." An immigrant from Belgium, he had been kidnapped after witnessing a murder. His ship ported in Galveston, and he was able to escape. "He didn't know a lick of English. Our family name derived from him getting enlisted as 'Dutch all over,' and later it was shortened to Dutchover. He ended up here in Fort Davis and was a landowner/rancher/sheep guy. He got a job working for the stagecoach Butterfield as a shotgun rider and eventually married a local lady." Much has been written about his involvement riding as a guard and fighting Indians.

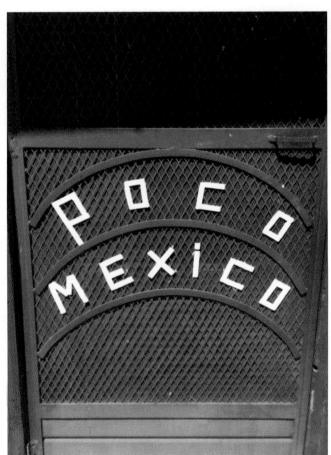

"My mom started Poco Mexico in 1980," shares Manny. "She ran it until 2010. I lived in Lubbock at the time. I went to school there and became a cattle manager over there. When she decided to retire, since I already knew what was going on having grown up in the business, I decided to try my hand at the restaurant business.

"We started as a little one-window shack in town. People would walk up to the window and order. It was mostly a burger joint then. Two years later, in 1982, we moved down to its current location."

Manny says the Chile Rellenos or burgers are big sellers. "Green enchiladas aren't too far behind," he shares. "Everything is my mom's recipes; as far as I know, it was just an evolution of trying different things and finding something that worked.

The cooking has been dropped down from three or four generations. We've all been cow camp cooks. We've been working at hunting camps and local ranches for a long time. My dad has been doing that for forty years. We have quite a bit of cooking outside of this place," Manny shares.

JENNIFER AND SCOTT TURNER

Mountain Trails Lodge B&B/Come and Take It BBQ

"Scott was born in San Angelo, but his grandparents lived in Fort Stockton. His grandparents moved to Far West Texas from Mason, Texas," shares Jenny Turner about her husband, Scott. "Scott's grandfather was a member of the CCC group that built Davis Mountains State Park, Indian Lodge and Balmorhea State Park infrastructure. He frequently visited the Big Bend and Davis Mountains with his family and loved camping and fishing the Rio Grande. He owned a BBQ restaurant in Fort Stockton and later opened a liquor store.

"Scott was raised on a ranch, twelve miles of bad dirt road and a Terlingua Creek crossing from the pavement. His dad was ranch manager for 3 Bar Ranch, nestled in an oxbow of Terlingua Creek, with Hen Egg Mountain behind. Scott drove the twelve miles of dirt road and another twenty on pavement to the bus stop, where the bus drove him the other sixty miles to high school in Alpine, Texas.

"Brian Bourbon, our BBQ pitmaster, has family ties to Georgetown, Texas, but has spent most of his life growing up in Alpine and Terlingua."

Jenny claims to be a relative newcomer. "I moved here twenty-one years ago, a Colorado River guide, to guide the Rio Grande during spring break," she says, and she never left. "Scott and I lived in the Terlingua Ghostown, and our daughter was born in Alpine, in the old hospital. I helped raise money for the new Big Bend High School in the early '90s, and Scott graduated with both his bachelor's and master's degrees in history from Sul Ross. We took over the Davis Mountains Education Center, organizing and leading school group and elderhostel educational tours."

Scott and Jenny met guiding the Rio Grande for Outback Expeditions. Jenny says it wasn't until Scott saw that she was staying and not just a transient Colorado boatman that he asked her out. They own and operate Mountain Trails Lodge, which officially separated from the nonprofit education center and began operating as a bed-and-breakfast in January 2012. They added Come and Take It BBQ in October 2013. Brian Bourbon

prepares award-winning smoked meats, and Jenny uses family recipes to make all the homemade side dishes.

"Scott's grandparents were L.V. and Kathryn McAuley, well known and loved in Fort Stockton, Texas. They helped form the Episcopal church in Fort Stockton, moving a church from England and reconstructing it on land near the historic fort. Their daughter, Mona McAuley, married Bobby Turner, who raised her children, Scott and Carissa. Mona still lives in Terlingua.

"Scott went to high school in Alpine. He could not play sports or join any groups because he had to catch the long bus ride back home to Terlingua. He never graduated but moved to San Antonio when he turned eighteen and later joined the army. He followed in his dad's footsteps and became an airborne paratrooper stationed at Fort Bragg. He later attended Sul Ross and graduated with honors."

Jenny grew up on a farm in Michigan and learned to cook and bake using fresh ingredients. "I still follow those traditions of using real butter, heavy cream and buttermilk," she says. "I also treasure fresh eggs, fruits and vegetables when I can find them. Scott grew up on a ranch where chicken-fried steak (well, steak in general), beans and rice were a staple. He makes the beans for the BBQ, and he has perfected his recipe! Ranch-style hash is Scott's favorite. It is a one-pot dish with hamburger meat, ranch-style beans, corn, rice and chunks of melted cheese.

"All of us are self-taught," shares Jenny. "I employ techniques learned from my mother and grandmother, and I get my West Texas influence from Scott's mother and her stories of Scott's grandmother. Brian watched other pitmasters and continually experiments with techniques in his quest for the perfect brisket. I think he is pretty close!" The almond French toast with ham and strawberries is Jenny's personal favorite item on their menu, and the most popular among B&B guests is probably the blueberry oat waffles. The bestseller for the BBQ is a brisket, beans and potato salad plate, although the cobbler is pretty popular as well, Jenny tells me. "Our parents and grandparents influenced our cooking style and ingredients we choose," she says.

When I ask her what she wishes someone had told her before she started, Jenny says, "That you never get a day off, and you can never trust any employee to care as much as you about quality and consistency (hence the never getting a day off part)." She says there is a special story about the lodge she wants to share: "The lodge is a historic tourist court. It was built in the '30s and operated as Spencer's Mountain View Lodge through the '50s. Scott's grandparents visited Fort Davis, and his mom remembers staying at this lodge as a young child! In the '70s, the lodge was remodeled, and a family lived here. It wasn't used as lodging again until the education center bought it in 2000. Scott was hired as director of the center in 2006."

Lastly, I ask Jenny if she could only pick one local ingredient to feature, what would it be. She says, "Hothouse tomatoes. I use them all the time in everything from frittatas and migas to fresh sandwiches. Also Pecos County cantaloupe from Coyanosa."

RANDALL AND SUSIE LIDDELL

Calamity Creek Ranch

Randall "Randy" Liddell was born in Oklahoma City and moved to Fort Davis in 1967. "I was fifteen years old. My dad brought me out here because he came for a job at the McDonald Observatory as a machinist. He basically built the instruments for the telescopes and worked for astronomers," shares Randy.

Randy met his wife, Susie (Susanna Jane Lara Molinar), at Fort Davis High School. She was born in Marfa but raised on Poor Farm Ranch in Jeff Davis County. "When I turned fifteen, I went and lived with my mom in town [Fort Davis]. Her sister Mary Alice and I were the same age. Mary Alice eloped, and Mom didn't want me to do the same thing. She wanted me to finish high school. I met Randall when he moved here in 1967."

They graduated in 1970 in a class of seventeen students and went to Sul Ross. They were married on April 8, 1971, in Alpine by Hallie Stilwell in her home. Hallie was a tough grit pioneer whose family came to Alpine by way of covered wagon in the early 1900s. A ranch woman who lived a rugged and nontraditional life in the Marathon area with her husband, Roy, Hallie also wrote newspaper columns and books and served as the justice of the peace, among other colorful distinctions. "She was a wild old lady," says Randy. "She was in her eighties when she married us. We didn't have anyone to marry us; we looked her up, and she was a JP. She offered to marry us in her house in Alpine. It was a small wedding with family and close friends." The Stilwell Ranch Store and RV Park and Hallie Stilwell Hall of Fame historic site can be found about forty miles south of Marathon, six miles down FM 2627.

After marriage, Randy and Susie began their family with their children, Becky, Adam, Aaron and John. About their youngest, John, Randy says, "We called him Johnny Paycheck because he was born on the fifteenth and that's when you get your paycheck."

Out of high school, Susie worked at the fort as a summer aide from June through August. "I started in 1971 at the fort and worked there until 1980,

when Adam was born and I resigned," says Susie. "I was out seven years having the three boys, and then after John turned two, my same job came open and I applied for it and got it and stayed there until I retired in 2008. Now I work part time with visitors' services at the Chihuahan Desert Research Institute (CDRI) with one of my co-workers from the fort. The CDRI has a mission to educate the people on the Chihuahuan Desert on its diversity and how big it is. The CD encompasses 200,000 square miles."

"I worked at the observatory for about ten years," shares Randy. "Then, the ranch foreman here [at Calamity Creek] offered me a job in 1981. I've been working here since then." Randy's current title with Calamity Creek is foreman. He manages the headquarters as well as their wildlife and game management and predator control.

Calamity Creek spreads out over seventy sections (about forty-four thousand acres) in the Fort Davis area. Although there are no paid hunts allowed on the property, the main game animals that live there are mule deer, elk, white-tailed deer, turkey, quail, dove, javelina and antelope. Feral hogs and Aoudad sheep are not indigenous to the area, so there is no hunting season on them. Coyotes, mountain lions and bobcats are the main predators in the area, and varmints include fox, gray fox and raccoons. The predators and varmints are managed because they prey on turkey and quail eggs, as well as the game populations.

Black bears have been spotted in the area over the years, although Randy says it has been three or four years (as of 2014) since one has been seen. They are a protected species here. "We had a bear that lived here on the ranch for three or four months," Randy shares. "He came during deer season and ate all the carcasses, apples, pecans and everything else. Once he got everything ate, he left. We have hawthorn trees with manzanitos [little apples], and the bears like those. They can eat a lot of them.

"The drought started around 1995, and technically we are still in the drought," says Randy. "It's worse than the one in the '50s. We had what they call the 'rockhouse fire,' which burned 300,000 acres. It burned lots of country. We lost eighty head of yearling cows. The drought and the fire really affected the wildlife population a bunch. The time that it happened was early in the year, and we don't normally get rain until later in the year. So the fire wiped out what the animals would eat and killed a lot of animals. The animals had to move out and couldn't come back until the land recovered. It was extensive—the worst fire I've ever seen in my life.

"Our cattle are steers and heifers and feedyard cattle for meat. We run about half and half," says Randy. "They run 50 percent heifers and 50 percent steers. The market varies." Randy's son-in-law, Worth Puckett, is the ranch

manager. He oversees the water systems, cattle—feeding the cattle, moving the cattle from pasture to pasture, rotation, etc.

I ask Randy to tell me some more about wildlife management, as well as some of his favorite or most bone-chilling stories of predator control. These stories can be found in Part IX (starting on page 271). He also tells me where he has found cave drawings in the area.

"I've found cave paintings here on the ranch that people say are from the medicine men because they don't have flint around," Randy says. "They usually didn't have many artifacts around them because they [the paintings] mainly had to do with their faith—good medicine or bad medicine. Or this one up here they think it had to do with the sun and the moon and the summer solstice to be able to know when the first day of summer was. Some are ceremonial; the one up there we thought might be a map. Not all the drawings are little deers; some are squiggly lines with a circle filled in with other circles that are empty. It could have been indicating how many days to walk to water, etc. Some are circles inside circles."

During our interview, Randy shows me a dinosaur bone his parents had found. "My mother and dad found that down south somewhere. That was found, best I remember, down by Terlingua. It wasn't in the national park," says Randy, whose family has been hunting arrowheads for fun for years. You can also find the Liddells' tips for arrowhead hunting on page 283.

The Calamity Creek Ranch is a special place. Not to be confused with another ranch called the Calamity Creek that is located on the actual creek by that name south of Alpine, the ranch where Randy and Susie live is located outside Fort Davis on Musquiz Creek (pronounced like *moosekey*). This one was named by one of the owners because they had five or six ranches and the owner didn't know what to call this one. They called it the Clawson place and other different names in the past. But it was under the Calamity Creek exchange in the phone book, so "Calamity Creek Ranch" is the name that stuck.

LORINA WELLS

Cueva de Leon

Born in Fort Davis, Lorina Wells opened her restaurant, Cueva de Leon, in her hometown in the 1970s. "My dad and grandfather were born here. My mom was from Marfa," shares Lorina. "I opened this restaurant myself almost thirty-eight years ago. I took over a restaurant and moved on to bigger plates in 1976."

When I ask her how she learned to cook, Lorina credits her mother. "She was a very good cook," shares Lorina. "She made really good homemade corn tortillas and tamales. Desserts were her specialty. When I first started, she used to make all the desserts for me at the restaurant, my tamales, my enchilada sauce, my chile rellenos, until she got too old to do it. I still use her recipes in the restaurant."

The chile rellenos are the bestseller at her restaurant. The name *Cueva de León* means cave of the lion. "My daughter was in high school at the time, and she was in Spanish class," shares Lorina. "I asked her teacher, Ms. Miller, if she would have the Spanish class pick a name for the restaurant. I wanted it to be in Spanish, and I wanted it to be something about the area. So John McKnight is the one who came up with Cueva de León—because the mountain in back of us is called the sleeping lion. They all submitted names, and I picked this one. Then, I offered a free meal for two to the winner. At that time, he [McKnight] was dating my daughter, so it was kind of fun."

Growing up in Fort Davis, Lorina says it has changed a lot. "I think there wasn't as many tourists, but there were more families back then when I was growing up," she shares. "A lot of my school friends were still here, but now it's more like a tourist town since the fort opened and the lodge became a state park. Almost all the families I knew have passed away, and the new people in town I don't know as well. My school friends have moved; kids graduate, and they leave town. There's a lot of gift shops and restaurants now. Back then, we used to have two big grocery stores, a barbershop and a lot more places we don't have anymore. We have a big Fourth of July parade every year with booths and bands and fireworks. It's the biggest and busiest day of the whole year.

"We had about twenty people in our class, but I never graduated; I got married. My husband was not from here, so I moved to the Bright Ranch by Valentine, Texas. I lived there for sixteen years. After my divorce, I came home to Fort Davis. I was offered this café that a man owned and was retiring, and he offered to rent it to me, and I grew a business of my own. I've been back here since 1976. Then I built my own place in 1982, and we moved locations. We are open for lunch and dinner six days a week but Sundays just for lunch."

Lorina was on the board of the chamber of commerce for several years and has been a longtime volunteer for Meals on Wheels. "For twenty years, I have cooked a meal for twenty people every morning," she shares. "There are volunteers that come to deliver the food to their houses for the elderly and homebound Monday through Friday for their lunches."

BELINDA AND RANDALL KINZIE

Stone Village Market

Randall and Belinda Kinzie are second-generation property owners of the tourist camp and Stone Village Market, a full-service natural foods market and full deli in Fort Davis. I sit down with Randall inside the market to ask him about the history of his business. He grabs a sample of soup for me to try and pops open a natural root beer, and we begin to chat.

"I grew up in Alpine," says Randall. "My mom remarried. His parents came down to Fort Davis in 1970 and bought the motel. This used to be a Texaco station. It was built in 1935, and they purchased it in 1970, tore down the Texaco station and built this building to have a grocery store. My parents maintained the grocery store and sold the motel to a family named Tweedy. Her daughter Lana married Joe Duncan, whose family had reopened the Hotel Limpia. They took over the Limpia and bought the motel from the then-owners, the Jenkins, and purchased this building from my parents, Barrick and Patricia Watts. We bought it from them on November 14, 2011. Except for the reconstruction, it's been operable since 1935.

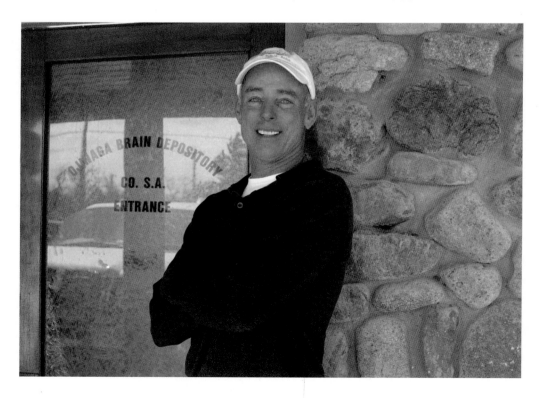

"My wife is from Dallas," shares Randall. "We met here in Fort Davis at a party and got married at Prude Ranch. We have four adult children. Our oldest daughter [Danita] works for us here as a cashier, and our oldest son [Aaron] used to work for us but retired. Our youngest son [Fletcher] works for us in the deli, and our other daughter [Rachel] also works for me at the motel part time. All four kids are still in the area.

"Growing up out here, it's not like the rest of Texas. I'm fifty-four. There's a sense of community with all the people. There is a strong sense of community and strong familial bond because a lot of the families have been related since 1888. If you marry someone from Fort Davis, you are related to half the town. Because of the isolation, even though we aren't immune or isolated from the problems associated with more urban areas, we are limited to the exposure. Everybody is on pretty good behavior out here.

"There is a food history here. There was a strong ranching presence since the late 1880s. Those guys are out there herding cattle, branding and roping, and someone had to cook for them. There is a long line of famous chuck wagon cooks. They are famous for not just their meat dishes but also their cobblers and their baked goods. One of the biggest pieces of cooking heritage in Jeff Davis County is the Bloyce Campground. It's an ecumenical gathering of ranch families. Reverend Bloyce and ranch families would come in and camp and have a week of revival because they had no church. Now it draws thousands, definitely more than the population of Fort Davis."

Randall continues to tell me more about his family. "My stepfather had a family farm in Pecos, and in the late '60s and early '70s, he managed restaurants, so I literally grew up in the restaurant," he shares. "I did it all: short-order cook, made pizzas, bussed tables. Back then, in Alpine it was the Highland Inn, the Stetson Club, the Hut [an independent burger joint famous for the taco burger] and a pizza parlor. He [my stepfather] started managing at the Bienvenido, which is where he met my mom, where she was a waitress going back to school at Sul Ross in the '60s."

Randall says the signature dish of the Stone Market Village is probably the chicken salad. "I don't know if it's the almonds or cranberries or both that make it unique," he says. "It's all white meat. And the rosemary adds a nice touch. It was Heather's recipe; she works at the deli. The only thing we changed on it is we added red onion. It tastes better when it sits a couple of days. We have tons of rosemary bushes around here, so all of that is fresh. The next most popular dishes are probably the curried tuna, salad bar and the cookies, and the chocolate ganache cake is a high-demand item.

"We've been featured on DayTripper, and we are the number one restaurant on TripAdvisor for Fort Davis [as of April 2014]. We've had some

unique customers who have since passed away; John Gardnier was one. They called him Crazy John, but he wasn't crazy. He was an astute investor and understood world economy and global markets. He was a bit eccentric, and people thought he was homeless, but he wasn't. He would spend $100 a day here. He always bought his clothes at the Thriftway. He'd buy a dozen 2x4s and never do anything with them. He'd buy our cabbages and ferment them in jars. The story is he was drafted into the military and got beat up and was never the same since."

I ask if Randall has any ghost stories about their building, and sure enough he has a few on hand. "It goes back," he says. "When I became manager here for the Duncans in 2008, I had a guest tell me, 'I was doing good until the ghost woke me up.' Then he began to describe this ghost. Since then, it's been described the same way by two other people, and several people have commented about its presence. It's also been seen by employees here in the market, as well as a customer in the market.

"The very first day we opened," he continues, "a woman came in and walked all the way to the back. She said she just wanted to see if he was still here. My dad had an employee here who was Native American and had been accommodating the ghost—a tall mountain man with a big beard." The ghosts were described in 2009 and 2010 as dwarves or gnomes, as well as a veiled female. "When you see ghosts, you don't see them straight on—you see them on your peripheral [vision]. I was going into my storeroom, and I felt the veiled one move past but I didn't see it go past. Another guest up in [room] 13 saw the same female. Evelyn saw the gnomes and a man."

BRIEF HISTORY OF ALPINE

Alpine is the county seat of sprawling Brewster County. The population hovers around five thousand, and the town is considered the hub for several area communities. The main campus of Sul Ross State University sits on the east side of town and offers the Museum of the Big Bend. There are several scenic drives, including heading south to Big Bend, west to Marfa or north to Fort Davis. Many of the local girls will tell you to "wave to the black cows for good luck!" although no one seems to be able to pinpoint how the tradition got started. Local shops and restaurants line the main street, which are navigated relative to their location before or after the blinking light. Toward the center of town, picturesque murals are painted on the sides of walls and make a great spot for a photo opportunity. The "twin peaks" or "twin sisters," depending on who you ask, are a notable pair of mountains seen on the west side of town as you head toward Marfa.

Big Bend Bucket List: Alpine

- Attend Viva Big Bend music festival
- Attend the annual Ranch Rodeo
- Attend the Big Bend Balloon Bash
- Attend Art Walk
- Take pictures of the murals

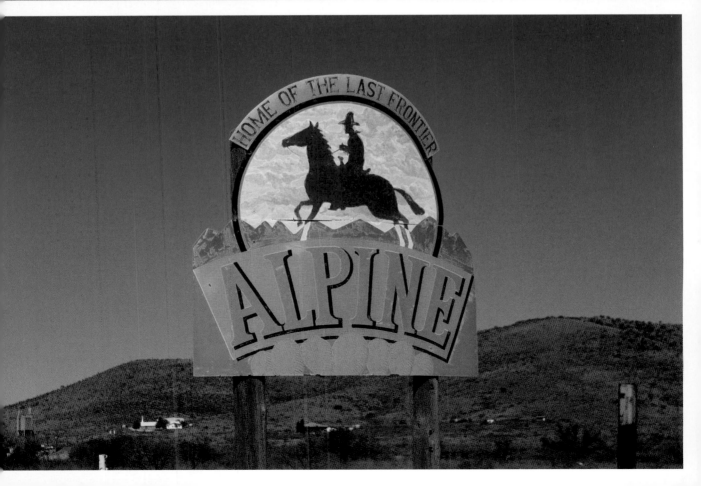

Fideos de Nicolas

Courtesy of Nicolas Gallego

Son of Congressman Pete Gallego, Nicolas has shared one of his favorite recipes his mom makes: Fideos.

2 tablespoons cooking oil
salt, to taste
pepper, to taste
1 pound sirloin steak, cubed
vermicelli noodles
1 small onion, roughly chopped
½–1 red pepper, roughly chopped
1 8-ounce can tomato sauce
3½ cups water
garlic powder, to taste
onion powder, to taste
paprika, to taste

° Heat ½ to 1 tablespoon cooking oil in a 3-quart skillet. Lightly salt and pepper the cubed steak, add to the skillet and sear over high heat. Once meat has been seared, lower heat and cook until done.

° While steak is cooking, heat 1 tablespoon oil in a separate skillet. Add vermicelli noodles and brown/stir fry until the noodles are a golden brown. Halfway through browning the noodles, add the onion and pepper.

° When the meat is done, add the tomato sauce to the meat and scrape and loosen any bits of meat from the bottom of the pan. When the noodles are golden brown, remove

them from heat and add them, along with the onion and pepper, to the meat and tomato sauce in the other skillet. Add 3½ cups of water. Salt and pepper to taste. Then add a dash of garlic powder, onion powder and paprika (optional) and stir.

° Bring mixture to a boil and then lower heat and simmer for 12 to 15 minutes, until noodles are tender.

° Note: Some people substitute chicken broth for some of the water and like to add diced tomatoes in addition to the sauce. If you prefer a soupier fideo, add an additional ¼ to ½ cup water and adjust the seasoning accordingly.

Steve Anderson's 22 Porter Beef Stew

Courtesy of master brewer Steve Anderson of Big Bend Brewery

Big Bend Brewery beer has been used in marinades and glazes all over the state. Master brewer Steve Anderson shares his recipe for beef stew using their 22 Porter.

2 pounds beef stew meat
kosher salt
cracked black pepper
1 tablespoon olive oil
3 tablespoons butter
2 medium-size yellow onions, chopped
1 bunch thyme
1½ cups Big Bend Brewing Company 22 Porter
5 cups beef stock

° Season beef stew meat with kosher salt and cracked pepper. Heat olive oil on medium-high in a large pot and sear beef in small batches until all sides are browned. Remove meat from pot.

° Place pot back on heat and add butter. Once butter has melted, add onions and cook until soft. Add beef, thyme and 22 Porter, then add beef stock to cover. Bring to a simmer, then turn heat to low and partially cover the pot with a lid. Cook until tender and cooking liquid is thickened, approximately 1½ hours. Add additional stock as needed to keep moist.

° Once beef is tender, season to taste with salt and pepper and serve with potatoes and a glass of Big Bend Brewing Company 22 Porter.

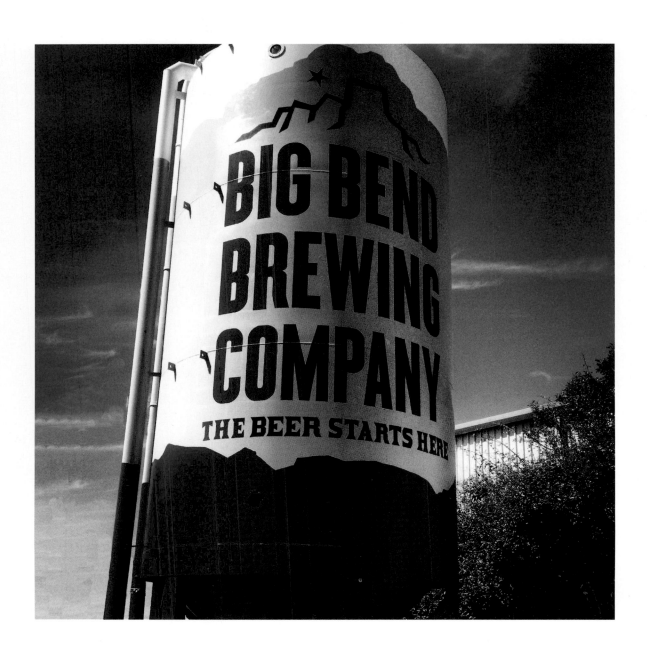

Reata's Tenderloin Tamales with Pecan Mash and Sun-Dried Tomato Cream

Courtesy of the Reata, as reprinted with permission from Reata: Legendary Texas Cuisine *by Mike Micallef*

> *They say everything's bigger in Texas. Well, it takes two husks to wrap around the five ounces of filling we stuff these tamales with. They're so good, we sell more than eight thousand of them every year at Fort Worth's Main Street Arts Festival.*
> *Yield 15–20 servings*

Masa Filling:
2½ cups masa
3 cups fresh corn (about 6 ears, off the cob)
1 cup Rich Chicken Broth
1 bunch cilantro, coarsely chopped
1 tablespoon kosher salt
1 tablespoon paprika

° Combine all the ingredients in a mixing bowl and, using an electric mixer, process until well blended. The masa mixture should be the consistency of wet mud. To test, drop a spoonful of the mixture into a glass of cold water; if it floats, you have just the right amount of lard. If it sinks, add a little more lard, 1 tablespoon at a time, mixing well after each addition. Reserve.

Rich Chicken Broth (makes about 2 quarts):
5 chicken legs and thighs
water
4 shallots, peeled
1 whole head garlic, peeled
2 carrots
1 tablespoon fresh black peppercorns
kosher salt
freshly ground black pepper

° Place the chicken in a large, heavy stockpot with a lid. Add the water, shallots, garlic, carrot and peppercorns. The liquid should just barely cover the chicken, so adjust the depth of the water if needed. Heat on medium-high and bring the mixture to a boil. As the liquid begins to heat, skim off the foam that rises to the surface and discard. When it begins to boil, lower the heat to a constant simmer. Continue skimming as needed. Cover the pot, leaving the lid slightly ajar, and continue cooking for 90 minutes.

° Remove the pot from the heat and leave the chicken in the broth for 30 minutes, until thoroughly cool. When the chicken is cool enough to handle, remove the skin and bones and discard. Shred the remaining chicken (there should be about 3 cups) and reserve in a covered container that can be reheated at serving time.

° Strain the remaining broth (there should be about 2 quarts) and return to a clean saucepan. Skim off any fat that has accumulated on the surface. Season with salt and pepper.

Tenderloin Filling:

2 pounds ground tenderloin or ground beef with at least 20 percent fat (don't go any leaner here—fat gives flavor!)
1 yellow onion, finely chopped
1 red bell pepper, finely chopped
5 jalapeño peppers, seeded and diced
4 garlic cloves, minced
2 tablespoons ground cumin
2 tablespoons kosher salt
1 tablespoon ground coriander

° Combine all the ingredients in a large bowl and mix well. Cover and refrigerate.

Tamales:

45 dried corn husks

° Soak the corn husks in hot water until pliable, usually about 1 to 2 hours. On a clean, dry work surface, place 2 corn husks end-to-end with about a 2-inch overlap in the middle. Grease your fingers well with lard or butter. Place about 2 tablespoons of the masa filling in the center of each husk, spreading the filling to within about 2 inches of the husk's edges. Next, place a generous portion, about 3 tablespoons per tamale, of the tenderloin filling in the center of the masa. Tightly roll up the husks lengthwise around the filling, then fold or tie each end.

° We like to take some of the extra soaked husks and cut them in $1/8$-inch-wide strips to use for the ties. You'll need 2 ties per tamale, one for each end.

° Place the tamales in a single layer on a steaming rack in a pot with a tight-fitting lid. You will probably need to cook these in 2 batches. Set the rack of tamales over about 1½ inches of boiling water. Cover the pot and let it steam for about 1 hour, adding water as needed to maintain the 1½ inches of liquid.

° Slice an opening in the top of each tamale. To serve, place the tamales on a platter and top with about 1 tablespoon of the Pecan Mash and at least 1 tablespoon of the Sun-Dried Tomato Cream.

Pecan Mash
(makes about 1½ cups):

In Texas, we have no fear of turning tradition on its ear. Although we love the classic Italian pesto, we've parted with tradition and created

our own unique version with pecans and cilantro. Just like its European cousin, our Pecan Mash still makes a great dipping sauce for bread. It's also excellent tossed with the Sun-Dried Tomato Cream on some al dente pasta. It wouldn't hurt a thing to throw in a leftover crushed tamale or two— you could call it Tamale Spaghetti.

¾ cup pecan pieces
2 garlic cloves, coarsely chopped
1 bunch cilantro, finely chopped
¾ cup Asiago cheese, grated
1–2 jalapeño peppers, seeded
 and diced
1–1½ cups extra virgin olive oil
kosher salt

° Combine the pecans, garlic, cilantro, cheese, jalapeños and ¼ cup of the olive oil in a food processor. Pulse repeatedly to coarsely chop the pecans. With the machine running, slowly add the remaining olive oil and process until all the oil is thoroughly incorporated. Season with salt. Cover and refrigerate.

**Sun-Dried Tomato Cream
(makes about 5 cups):**
1 tablespoon oil, for sautéing
2 garlic cloves, minced
4 tablespoons unsalted butter
½ cup rehydrated sun-dried
 tomatoes, puréed or very finely
 chopped
1 quart heavy cream
½ cup Parmesan cheese, grated
kosher salt
freshly ground black pepper

° Heat the sautéing oil in a saucepan over medium-high heat. Add the garlic and sauté for about 2 minutes, until the garlic begins to brown. Add the butter and sun-dried tomatoes and cook for 1 to 2 minutes, stirring constantly. Lower the heat and slowly add the cream. Simmer for another 15 to 20 minutes, stirring constantly, until the liquid has been reduced by about 50 percent. Add the cheese and stir well. Season with salt and pepper. Remove from heat and serve warm, or refrigerate until you're ready to reheat for future use.

The Artisan

Courtesy of Cow Dog

Complete with Tillamook cheddar cheese, stone-ground white wine Dijon mustard and authentic Cow Dog Artisan Chutney, the Artisan is an example of how Alan uses culinary creativity in topping a traditional hot dog.
Serves 6

6 Hebrew National frankfurters, butterflied
6 good hot dog buns, grilled on inside with butter
½ cup stone-ground white wine Dijon mustard
1 cup Tillamook Extra Sharp Cheddar Cheese, grated
1 cup Cow Dog Artisan Chutney

° Grill frankfurters on both sides until browned. Smear grilled buns with Dijon. Place some cheddar on both sides of bun. Place grilled frankfurter on cheese and layer chutney down the center of the frankfurter. Wrap entire dog in foil or paper and consume soon.

Cow Dog Artisan Chutney (makes about 3 cups):
5 Granny Smith apples, peeled, cored and chopped
¾ cup dried apricots, chopped
½ cup golden raisins
6 cloves garlic, chopped
2-inch cube fresh ginger, grated
1¾ cups red wine vinegar
2 cups sugar
2 teaspoons salt
½ teaspoon ground cayenne pepper

° Combine all ingredients in a heavy pot and bring to a boil over medium-low heat. Cook for 30 or more minutes or until mixture thickens and apples are transparent. Cool and store in glass or plastic in the refrigerator.

The El Pastor

Courtesy of Cow Dog

> *The El Pastor hot dogs are one of the Cow Dog's best sellers. Serves 6*

6 Hebrew National frankfurters, butterflied
1 cup canned pineapple tidbits
½ cup chopped red onion
6 good hot dog buns grilled on the inside with butter
½ cup Lime Mayonnaise
½ cup Cilantro Pesto

° Grill frankfurters on both sides until lightly browned. Grill pineapple and onions combined in a small skillet until lightly caramelized. Top grilled buns with caramelized pineapple and onion.
° Place grilled frankfurter on top of mixture and drizzle with Lime Mayonnaise and Cilantro Pesto. Wrap each dog in foil or paper and consume soon.

Lime Mayonnaise (makes 1½ cups):
juice and grated zest of 2 limes
1½ cups quality mayonnaise

° Thoroughly stir together ingredients. Store in refrigerator.

Cilantro Pesto (makes approximately 1½ cups):
2 bunches fresh cilantro
½ cup pecan pieces sautéed in 3 tablespoons butter
¼ cup good olive oil
1 tablespoon red wine vinegar
juice of 1 lime
½ teaspoon salt
¼ cup distilled water

° Combine all ingredients in food processor and purée completely. Store in refrigerator.

Reata's Classic Tortilla Soup

Courtesy of the Reata, as reprinted with permission from Reata: Legendary Texas Cuisine *by Mike Micallef*

> "Our tortilla soup has been around the restaurant since the day we opened. If you're in a hurry and you just can't wait to make the Rich Chicken Broth, you can use a grilled chicken breast or pull the meat from a rotisserie chicken and use ready-made chicken broth. Heck, if you're in that much of a pinch, your favorite tortilla chips can also be used instead of deep-frying the tortillas for the Tortilla Crisps. But honestly, once you make this all the way through, we bet you'll never do it any other way."
> —Mike Micallef

peanut oil, for frying
6 corn tortillas

° Heat the oil in a cast-iron skillet or deep fryer to approximately 350 degrees. Cut the tortillas into ¼-inch strips. Fry the strips for about 1 minute on each side until they're crispy and lightly toasted.

3 cups cooked, shredded chicken (reserved from the Rich Chicken Broth [see page 194])
6–8 cups Rich Chicken Broth
2–3 jalapeño peppers, seeded and chopped
1–2 limes, cut into generous wedges
2–3 avocados, ripe but firm, cut into ½-inch cubes

1 cup Monterey Jack cheese,
 shredded
⅓ bunch fresh cilantro, chopped

º Reheat the chicken and the broth separately until the chicken is warm and the broth is hot.
º For each serving, place approximately ½ cup of the shredded chicken in each bowl and as much broth as desired. Top the chicken with 1 teaspoon of the chopped jalapeños, the juice from at least 1 lime wedge, 1 heaping tablespoon of the cubed avocados and 2 heaping tablespoons of the shredded cheese. Finish with a generous helping of the crispy tortilla strips and a sprig of cilantro.

Wholemeal Loaf

Courtesy of Jim Glendinning

"This bread was served at my bed-and-breakfast in Alpine [the Corner House Bed & Breakfast, 1994–1999]. I learned how to make it from my mother in Scotland. This recipe yields one loaf."
—Jim Glendinning

1 heaped teaspoon Bio salt (flavor enhancement that is a healthy alternative to ordinary table salt)
1 pound flour (100 percent wholemeal, stone ground)
½ ounce fresh yeast (if not available, dried yeast)
1 heaped teaspoon brown sugar
13 ounces (just over ½ pint) water at "blood heat" (baking slang for body temperature or about 98 degrees)

° Mix salt with flour.
° Mix yeast with sugar in a small bowl with a quarter pint of water at blood heat. Leave in a warm place for 10 minutes or so to froth up. Pour yeasty liquid into the flour and gradually add the rest of the water. Mix well by hand.
° Put the mix into a 2-pint bread tin that has been greased and warmed. Put the tin in a warm place, cover with a cloth and leave for about 20 minutes to rise until the dough is within an inch of the top of the tin.
° Bake at 400 degrees for 35 to 40 minutes. Allow to cool for a few minutes and turn out onto a wire tray.

DESSERTS

Bamma's Jam Cake

Courtesy of Carla McFarland

1 cup buttermilk
1 teaspoon baking soda
½ cup butter or margarine (soft)
1 cup sugar
3 eggs
2 cups flour
1 teaspoon baking powder
2 teaspoons cinnamon
½ teaspoon ground cloves
½ teaspoon ground allspice
1 cup jam (strawberry preserves)
1 cup pecans

° Measure buttermilk in a large glass or 4-cup measuring cup and mix the baking soda in it. Set aside.
° Cream butter, add sugar and beat until fluffy. Add eggs and beat until well mixed.

° Then, mix all dry ingredients together and add alternately with buttermilk to butter and sugar mixture.
° Add jam and nuts and mix well.
° This cake can be baked in an angel food cake pan or in loaves. This recipe makes 2 large or 3 small loaves.
° Bake slow at about 300 degrees. Place a pan of water on the lower shelf of the oven while baking. Remove the pan for the last 15 minutes. An angel pan will take about 1½ hours and loaf pans about 1 hour.
° Test for doneness by inserting a toothpick into the center. If the toothpick comes out clean, it is done.

"We served this at McFarland's restaurant. This one was good because it was a customer favorite that we could make ahead of time," says Carla McFarland.

"Bamma (Bam-maw) was what we called Verna Andrews, my paternal grandmother. She swore she was five feet tall, but it was more like four feet, ten inches. She was a heck of a cook and was a schoolteacher who taught in Rising Star, Carbon and all over. My dad was her eldest child (born in 1922) of six kids.

"She always said one thing that saved her with this particular recipe was that, relatively speaking, it didn't take that much sugar and she could make her own strawberry preserves. She scrounged and made this cake and mailed it to her sons who were both fighting in World War II. Dad said it was one of his happiest days to be sitting in the cold of England and to open that cake in the mail. They didn't have FedEx in those days; this cake holds up extremely well. We joke that this cake is the reason why we won World War II."

Melt-Away Cookies

Courtesy of Carla McFarland

1 cup butter, softened (no
 substitutions)
$1/3$ cup confectioner's sugar
¾ cup cornstarch
1 cup flour
Icing

° Combine butter and sugar. Sift cornstarch and flour together. Add to creamed mixture and chill for 2 hours. ° Preheat oven to 350 degrees. Make dough into balls just a bit smaller than golf balls. Press a thumbprint into each. Place on an ungreased cookie sheet and bake 10 to 12 minutes or until barely golden. Cool on a cookie sheet. After cookies are cool, fill thumbprints with icing.

Icing:

3 ounces cream cheese (NOT low
 fat/nonfat)
1 cup confectioner's sugar
1 teaspoon vanilla
food color paste if desired

"My dad, Bob, was an engineer and a great cook, but after he retired in the '80s, he really got into cooking. He took his chemical engineering background and applied that to researching recipes and cooking. This is a recipe he futzed with and played with. He started with a recipe he found and applied the principles of chemistry to make it better. He did all kinds of cookies. Before he got ill at the end of his life, this was what he made me the last time he made me anything for my birthday."
 —Carla McFarland
Makes about 2 dozen

° Mix all ingredients together until thoroughly combined.

"As far as entrées go," Carla continues, "people tell me the things they miss the most are Steak McFarland's, Filet Oscar and Baked Potato Oscar. I'm the only person I know who ever came up with a Baked Potato Oscar (a baked potato stuffed with crab and hollandaise)," she says with a smile.

"All of our old famous ranchers used to eat at the place regularly because they were very fond of my steaks. Nobody knows steaks better than ranchers. I had Gage Holland [the confluence of the Gage and Holland families] tell me, 'Damn, girl, you're the first person in decades who can cook a damn steak right out here.'"

Carla said the secret to her steaks was hand cutting her own. "We had a locker plant here in Alpine that would age our steaks according to my specifications," she shares. "We had our secret special spray we would spray on them while we were cooking them to keep them moist.

"We were also famous for fresh shucked oysters. I used to meet the seafood truck, which ran from the Texas Gulf to El Paso, at Fort Stockton at three o'clock in the morning and get live oysters and drag them back to Alpine in a burlap bag, clacking at me from the back of my little blazer. I would feed them cornmeal and put them in a redneck oyster-storing device to keep them alive and cold until we shucked them. We would have people from the Gulf tell me our oysters tasted better, and I think it was because we fed ours cornmeal."

The Holland Hotel was built in the early 1900s. "John Holland was the original owner, and then his son Clay Holland ran it for a number of years," Carla shares. "It operated as a hotel up until 1969, very minimally in the last few years, I might add. When that owner died, it ended up vacant for a few years. Gene Hendryx bought it and saved it from being demolished. There was actually a movement afoot to tear it down. He was interested in historic preservation. He had been in the state legislature and turned it into a state office complex, but he wouldn't let anyone tear up the original walls. He put it on the market in 1985, and Mom and I slowly started turning it back into a hotel. I wouldn't have been able to afford to do it if I hadn't had some of those state and federal leases. That's why it was a slow process."

For those interested in the ghost stories accompanying the Holland Hotel, Carla confirms they had suspicious activities. "There were lots of ghosts, but I don't even know where to start," she says. "There were a number of people who died there. There's a lady who walks around on the second floor and lots of relatives of former owners. We had a lot of eccentric owners of the Holland Hotel. There would be creepy stuff when I'd get back with the oysters at four o'clock in the morning, but I was so tired I didn't care. For the most part, the ghosts were very docile around us at the restaurant."

ALAN VANNOY

Cow Dog

Alan Vannoy learned to cook from being a home chef. "I always have done that [cooked at home]," Alan shares. "My mom is a great cook, and I just love food. I grew up around good food and learning about food. My grandmother was Dutch and cooked Pennsylvania Dutch style, but my dad was a gourmet and made my mom try all sorts of stuff. So from then on, I just wanted to try things. When I'm at home and I have time, I love to cook Indian and Thai. I experiment with Italian, but if I have time, I love to cook Indian. I make my own paneer and chutneys, grind my own spices. It's a ritual. I consider preparing Indian food the most labor-intensive of foods. There is so much involved."

Prior to opening the Cow Dog food truck, Alan had some experience in the food industry, but that is not what brought him to Alpine. "I worked in an Italian restaurant in Scarsdale, New York, in the '80s; that was my first food industry job," he shares. "I grew up in Ohio and Indiana. I worked at two restaurants in Cincinnati, Ohio, as a waiter when I was going to school there. I worked for the Cincinnati Art Museum for eight years while I was getting my bachelor's at Cincinnati, then I went to Athens, Georgia, to get my master's. When I finished that, I applied for teaching and curatorial jobs. My degree is a master's in fine arts, printmaking and book arts.

"I took a job as a curator of the Museum of the Big Bend in 1994. I lasted a year; I'm not a bureaucrat, and I finally figured it out. I was thirty-one at that time, and I knew I no longer wanted to work for anyone except myself. So I started painting houses again, which made money right away. I did that for fifteen years, and then I started to get tired of it because I was having logistical problems and I always wanted to do something with food.

"I started thinking, 'Gosh, I could do a truck' and started looking for the right rig. I didn't know I'd be able to get something with an engine because I was on a strict budget and didn't want to borrow anything. I used money from a lot I sold in Marfa. I joke and call it 'the worst lot in Marfa' because nothing is built on it still to this day. I bought the 1966 Winnebago for $800 from Ballinger, Texas, after I found it on Craigslist. It said it ran, so I went out there and drove it home. A year later, Cow Dog opened on February 19, 2010."

The Cow Dog food truck offers a variety of hot dogs with traditional favorites, as well as toppings that are seasonal specials. Alan makes all of his own sauces and chutneys for a unique homemade twist on typical condiments. "I make my own pico...everything really," shares Alan. "My own BBQ sauce, my own curry, lime mayo, super secret slather, cilantro pesto,

Thai peanut sauces for the Bangkok...I use a special yellow curry paste that I always have to buy when I'm out of town because it's really good curry paste. I found the brand and then read about it in *Saveur*; it's fascinating how they smoke it and cook it. Apparently, it has lots of ingredients they make over charcoal things and package it up."

The hot dogs are served in two sizes: little or big. Topped with Cow Dog's custom pico de gallo, bacon, sharp cheddar cheese, mayo and ketchup, the Mexican is their bestseller. The Hangover comes in as a close second and is topped with bacon, sharp cheddar cheese, hot sauce, Cow Dog's own beef chili sauce and Fritos. There are other unique hot dogs such as the Wing Dog, which has wing sauce, ranch or blue cheese dressing and chopped celery, or the German, which is topped with sauerkraut, bacon, spicy brown mustard and caraway seeds.

Roaming the Alpine area, Cow Dog has been found at Plaine, the Granada, the Blues and various special events. "Sometimes I try to help organizations make money," Alan shares. "I do birthdays and weddings and graduation parties, but mostly this is it right here [at Plaine]. I've gone to Marathon and Marfa, but this is our bread and butter here at Plaine."

The food trailer is a 1966 Winnebago. "It's the first year of Winnebago's full body coach. I consider it a prototype," shares Alan. "I didn't have the horns when I opened. The logo was intact, and it's based on our dog, Bonnie Blue. She was a blue lacey, which is the state dog of Texas. We loved her dearly. Me and a buddy of mine who is a storyboard artist conspired to make the logo. I told him I wanted my dog in a bun with mustard on its back and cow horns. And that's what we did. The horn thing went from there.

"That's not the original set of horns; the first set was much smaller, but I found these horns at a garage sale and these seemed appropriate for the Cow Dog," Alan shares about the iconic set of horns that are stationed on top of the front of the truck. "The sticker thing kinda started at the Blues," he says about the various stickers that cover part of the truck. "A lot of people want to put a sticker on. The only requirement is I get to put the sticker on. If someone else puts it on, I take it off," he smiles about the whole notion. "I have to approve it and apply it."

I asked Alan about his personal favorite, and he said, "I really think the Mexican is a thing of beauty. The Artisan and the El Pastor...I'm really proud of both of those. I make the chutney and pesto lime mayo that goes with it. The newest ones are our Green Chili Cheese Dog and the Bangkok Express. A lot of times I just want a Wing Dog—it's so good."

Alan is fortunate to have several repeat customers and loyal patrons. His favorite story about one of his regulars is as follows: "When I first opened, I

was down by the Big Bend thrift store. It was a great spot, good for business and we loved it, but it had a propensity to flood in the rain. At one time, we had a lot of rain, and the Cow Dog was literally in about six inches of water. I thought I'd wait for the water to go down and go home. But then one of my favorite customers pulled up on the outside of the puddle and shouts her order to me. When I had it done, she took off her shoes and waded to the window to get her hot dog. I had only been open eight months then."

JIM GLENDINNING

Author and Owner of the Corner House Bed & Breakfast (1994–1999)

Raised on a farm in Lockerbie, Scotland, and educated at Oxford, Jim Glendinning made a career out of traveling, eating and writing. Well known for giving tours in the Big Bend country, Ireland, Mexico and beyond, Jim has traveled to 135 countries. He has also owned restaurants and boutiques and written five books. Jim came to Alpine in 1994 and established Corner House Bed & Breakfast in Alpine.

REATA RESTAURANT

The original Reata restaurant opened in Alpine in 1995. "Al bought the CF Ranch in 1993 outside of Fort Davis," shares general manager Kinsey McClure, "and I guess he got tired of eating at the same old places, so he opened his own restaurant." With partners, they opened a second location in Fort Worth, Texas, a few years later. In 2001, a massive tornado blew through Fort Worth, forcing a relocation to their current spot.

Kinsey started with Reata in May 2007 in Fort Worth and moved to Alpine in May 2011. "The pan-seared pepper-crusted tenderloin or the carne asada are our bestsellers. Or the tortilla soup," she says. Her personal favorite is the carne asada.

Juan Rodriguez became the restaurants' youngest executive chef at age twenty-eight with his promotion in 2009. "We have developed a lot of chefs," says Kinsey. "Grady Spears was with us, Tim Love, Brian Olenjack and Todd Phillips have all been part of the Reata family."

On average, Reata's Alpine location will feed anywhere from 150 to 250 patrons a day, as compared to 650 to 850 at their Fort Worth location. The Fort Worth restaurant has four stories and sprawls out over twenty thousand square feet, in comparison to the one thousand square feet of the Alpine

location. "We have only thirteen tables inside and fifteen outside," says Kinsey. "We aren't one of the largest, but I hope we are one of the favorites."

I ask her what it takes to operate a successful restaurant in a small town in the desert. She says that "consistency and a love of what you do" are the most important factors. "Reata is different than other restaurants here. I think we treat everyone that comes in like they are part of the family. You walk in our doors and you're inducted. At least that's the goal." Kinsey has repeat customers all the way from Ottawa, Canada, and Orange County, California, who come back to the Reata in Alpine year after year. "It's really special when people make a trip just to see you," she says.

Part VI

FORAGING IN THE TRANS-PECOS REGION

BY MAURINE WINKLEY

A BEGINNER'S GUIDE

When it comes to food sources, it is hard to look out over the desert landscape and imagine any juicy, wonderful food item available to eat, much less enough of it to make a good meal. And for good reason—it isn't the most easily inhabited place, which keeps civilization to a minimum, making the Trans-Pecos region one of the best areas in the world for star-gazing. It's hard to visualize all the iterations of West Texas over the last few hundred millions of years, including the swamps and dinosaurs that roamed them during the Triassic period at least 200 million years ago,[1] to more recent times when onions and melons were grown using water irrigated from shallow desert aquifers and rivers like the Rio Grande. While the geography and climate will continue to change in this area, one thing remains true: if you know what to look for, you will not go hungry.

The following section of this book takes a look at plants growing in the Trans-Pecos region that can be foraged for food and, with help from some of my foraging friends, lays out some excellent tried-and-true recipes. I'll also touch on a few of the medicinal plants that have been used for thousands of years by people living in this region. By no means is the following meant to be a comprehensive or detailed overview of the plants in the Trans-Pecos region that can be foraged for food or their medicinal or metaphysical properties, but it's a good start to finding some of the tastiest and most accessible.

Just like choosing foods based on where they come from and how they were produced, foraging takes not only having a good idea of what a plant should look like and where it should grow but also a certain respect for the

1. Christine Dell'Amore, "New Species of Ancient 'Swamp Monster' Discovered; Lived in Once-Tropical Texas," *National Geographic* (2014), news.nationalgeographic.com/news/2014/01/140131-swamp-monster-paleontology-animals-ancient-science..

land from which it is taken. There are a few key points every forager should know; these are derived from my own experiences along with excellent foraging resources Wild Edible Texas[2] and Foraging Texas:[3]

- Don't take more than you need.
- Only harvest from plants that are in abundance in an area. If there are only a few plants, they probably need all they've got to propagate and nourish native wildlife
- Make clean cuts on any plants.
- Don't forage where it is off-limits.
- Bring some old plastic baggies, scissors or a sharp knife, a glove or two, some tongs and a big bottle of water.
- When foraging, it is really important to know the plant you are looking to consume—leaves, fruit, fruiting season—and make sure you won't be easily swayed by hunger into picking something that "looks close enough" to the plant for which you are searching. This gets especially tricky with mushrooms. Let's just all agree that unless you are a mycologist, or with one, mushrooms are a no-no.

One of my favorite stories of foraging in the Trans-Pecos region comes from Gary Paul Nabhan in his book *Desert Terroir: Exploring the Unique Flavors and Sundry Places of the Borderlands*. He describes at length a forager's dream meal, including catfish caught from the Rio Grande seasoned with wild Mexican oregano and chile pequin peppers for spice, along with queso asadero[4] made with goat's milk curdled using night shade berries that grow along the Rio Grande. His description gives you an idea of the variety of items that can be foraged for a meal and are currently used on a regular basis in communities where commonly found staples from the supermarket are not available.

The following are some of my favorite plants that can be foraged to make an assortment of desert delicacies.

2. "Foraging Tips," Wild Edible Texas, wildedibletexas.wordpress.com/foraging-tip (accessed April 20, 2014).
3. "Foraging Ethics," Foraging Texas: Merriwether's Guide to Edible Wild Plants of Texas and the Southwest, www.foragingtexas.com/2008/08/foraging-ethics.html (accessed April 25, 2014).
4. Gary Paul Nabhan, *Desert Terroir: Exploring the Unique Flavors and Sundry Places of the Borderlands* (Austin: University of Texas Press, 2012), 35–51.

CHILE PEQUINS

Birds love these little peppers, and where you find several of them flying around, you will be more likely to find the chile pequin bush. Look for these in riparian areas and under the shade of other bushes and trees. They don't like full, direct sun. The chilies are best found in the summer and fall but can be harvested well into the winter, depending on how cold it has been.

In Scoville heat units, fresh chile pequins measure 30,000 to 50,000, which falls just under dried chipotles and fresh habaneros.[5] So although they are the size of a black bean, they pack a burst of heat. They are the hottest when they are young and green and tend to become milder as they redden.

5. Jan Timbrook, "The Natural History of Chile Peppers," Santa Barbara Museum of Natural History, www.sbnature.org/research/anthro/chchile.htm (accessed April 20, 2014).

Chile Pequin Egg Breakfast

Courtesy of Maurine Winkley

1 tablespoon milk
$1/8$ teaspoon cornstarch
2 eggs
1 teaspoon butter
1–2 chile pequins, finely chopped
2 shakes salt

° In a small bowl, whisk the milk and cornstarch together. Add the eggs and whisk the mixture together until the clumps from the cornstarch disappear. In a small cast-iron or sauté pan over medium-low heat, add the butter and the chile pequins. Cook for 2 minutes and then move the butter/pequin mixture around in the pan to cover the bottom. Add your eggs and salt. Cook the eggs until they no longer show any translucence. Immediately remove from heat and enjoy.

My ninety-four-year-old grandmother Maurine Thomason was the first to introduce me to the chile pequin. One of her tried-and-true breakfasts involves chile pequins and the fluffiest, tastiest scrambled eggs you will ever put in your mouth. Serves one or two depending on how hungry you are and if you have any sides. I recommend a few tortillas and some mild salsa (the pequins pack enough punch).

Pequin Pepper Sauce

Courtesy of Maurine Winkley

2 handfuls chile pequins
pinch wild oregano (optional)
1 cup white vinegar

° No chopping or blending needed. Pick a container (one with a cork is preferable, but it could be an old pepper sauce jar) and wash it thoroughly (especially if it was used previously). Make sure your peppers are clean as well. Place the peppers and oregano in the container. Heat up the vinegar until it starts to steam and then remove from heat and pour through a funnel over the peppers in the container. Wait a day or two to start using the sauce. Once you run out of vinegar, don't hesitate to heat up some more vinegar and pour it over the peppers from the first batch of sauce.

If you are going to pick pequins, you may as well pick a lot, as they're small and travel well. One of my favorite ways to use them is to make a vinegar sauce so you can enjoy their pungent spice on everything you eat. Seriously, this pepper sauce goes well on everything savory: pizza, burgers, fish and chips, add some to the Chile Pequin Egg Breakfast recipe (see page 220), tacos, an avocado with some salt and feta, pasta and a pot of beans.

HONEY MESQUITE BEAN PODS

The mesquite tree is one of the Trans-Pecos plants that fascinates me the most. Honey mesquite trees are known to be one of the biggest hassles for Texas farmers and ranchers because they spread like wildfire and are tough to get rid of. And if you've ever seen *Lonesome Dove* (or have just been poked by one of the thorns), you know that they are not reluctant to cause severe pain and swelling if broken off in the skin. Even the pods, if not processed properly, can cause sickness and deadly results. But for a tree widely accepted as very offensive, it has many great uses.

Honey mesquite trees are typically found in arroyos and creeks. The leaves and pods provide an important source of food for livestock,[6] and the wood is excellent for barbecuing. The honey mesquite beans can also be dried and ground into a meal or flour for a gluten-free or low-gluten option to make tortillas and breads. It is also high in protein[7] and lower on the Glycemic Index[8] than other flours like wheat flour.[9]

If you are going to wild harvest the pods, it is very important to avoid pods that have fallen to the ground or that appear to have been attacked by insects or are moldy. They very likely contain a fungus that can be poisonous if consumed. Healthy pods, though, are easy to spot. Sometimes mold cannot be seen, however; thus, it is really important to dry the pods before grinding them down.[10]

6. Michael Powell, Peggy Pickle and Jake Pickle, *Trees & Shrubs of the Trans-Pecos and Adjacent Areas* (Austin: University of Texas Press, 1998), 179.
7. "Mesquite Flour," Live Superfoods, livesuperfoods.com/live-superfoods-mesquite-powder.html (accessed April 28, 2014).
8. "Mesquite Cakes," University of Sydney, www.glycemicindex.com/foodSearch.php?num=2598&ak=detail (accessed May 1, 2014).
9. "White Bread, Wheat Flour," University of Sydney, www.glycemicindex.com/foodSearch.php?num=414&ak=detail (accessed May 1, 2014).
10. "Mesquite Harvesting & Processing," Desert Harvesters, www.desertharvesters.org/mesquite-in-the-kitchen/harvesting-processing (accessed May 5, 2014).

Healthy pods should taste good (so go ahead and taste a pod on the tree from which you are harvesting). On that note, try the pods from a few different trees. You may be surprised that the flavor varies significantly from tree to tree. The pods you pick should look ripe and be easily pulled from the branch. If there is any moistness in the pods collected, dry them out in the sun for a few days or stick them in the oven at 150 degrees for thirty minutes to an hour. They should then be stored in airtight containers. A small flour grinder or, for more of a workout, a mortar and pestle can be used to grind the beans into a flour or meal.

DesertHarvesters.org is an excellent resource when it comes to more in-depth information about harvesting and consuming mesquite bean pods and will give you a good breakdown of the yields of pods to flour. It also offers milling services for your mesquite pods in the Tucson area.

Mesquite flour is considered a superfood by many and is best added to a smoothie. It retains the best flavor raw. Once cooked, the taste can become strong, and thus, it is best mixed with another flour in tortillas or other baked food.

Mesquite Tortillas

Courtesy of Maurine Winkley

This recipe is adapted from a Tucsonivores.wordpress.com[11] recipe, with additional olive oil substituted for bacon drippings.
Yields 10–12 tortillas

1½ cups wheat flour
½ cup mesquite flour
1 teaspoon salt
2 tablespoons olive oil
1 tablespoon plus 1 teaspoon
 bacon drippings (or olive oil)
¾ cup water

° Mix dry ingredients in a medium to large bowl. Add the olive oil and bacon drippings and mix. Slowly add in the water. Knead the dough for 3 to 4 minutes. It will form a large ball.
° Cover the bowl and let it sit for 30 minutes, then make 10 to 12 balls. Heat up a cast-iron skillet on medium-low heat.
° Roll out each ball into a thin circle about ⅛ inch thick. Place tortilla in an ungreased skillet and watch it begin to bubble. Flip after about 30 seconds. Continue flipping back and forth at 30-second intervals until each side of the tortilla has some brown spots.
° Repeat with the remaining balls.
° Be ready to eat them while they are hot or cool them down and store them in an airtight container.

11. "Mesquite Flour Tortillas," Tusconivores, October 1, 2007, tucsonivores.wordpress.com/2007/10/01/mesquite-flour-tortillas.

Cherry, Almond, Mesquite Smoothie

Courtesy of Maurine Winkley

1 cup frozen sweet black cherries
¾–1 cup almond milk (boxed or
 fresh)
1 tablespoon mesquite flour
1 tablespoon cacao
1 dash cinnamon
1–2 tablespoons honey

° Place all items into a blender,
blend until smooth and enjoy. If
you are going to use fresh fruit (not
frozen), it is best to throw a few ice
cubes into the blender.

This is a great post-workout or meal replacement smoothie. And the combo is just a suggestion; you could throw in blueberries, blackberries, raspberries or whatever other combination of fruit you desire.

AGARITA BERRIES

Agarita berries, also known as the currant of Texas and chaparral berry, grow on bushes that can be anywhere from three to eight feet tall and are found in rocky limestone areas in West Texas.[12] They are pretty easily distinguished by their holly-like leaves, and when the bushes are blooming in late winter to early spring, they produce bright yellow flowers and fruit shortly thereafter. When looking for agarita, the sweet scent of the flowers is hard to miss. The agarita berry is bright red and commonly foraged by birds and deer. The berries and the young leaves can be consumed by animals and humans, but the berry is the most delicious part of the plant. The berries can be eaten straight off the plant and are little tart bursts of flavor.

To harvest the agarita berry, place a wide bowl under the bush and push berries off the branches with a large spoon or spatula or lightly shake the plant to release them. The green-gray leaves are stiff and pointy, making them uncomfortable to pick by hand.

Other Uses of the Agarita Plant:

- Wood (after bark is removed) and roots make yellow dye that was widely used by Native Americans.[13]
- A concoction made from the roots has been used to treat toothaches and heal sores.[14]

12. "Agarita, Agarito, Algerita, Agritos, Currant-of-Texas, Wild Currant, Chaparral Berry," Texas A&M University, aggie-horticulture.tamu.edu/ornamentals/nativeshrubs/mahoniatrifol.htm (accessed April 20, 2014).

13. Forrest Mims, "Spiny Agarita Used for Medicine, Jelly," My SA, March 30, 2014, www.mysanantonio.com/life/life_columnists/forrest_mims/article/Spiny-agarita-used-for-medicine-jelly-5355387.php.

14. "Agarita," Uvalde Texas A&M AgriLife Research and Extension Center, uvalde.tamu.edu/herbarium/trees-shrubs-common-name-index/agarita (accessed April 20, 2014).

Agarita Berry Pie

Courtesy of Tex Toler, inspired by Ezell Toler

I hadn't heard of agarita berry pie until talking with former Marfa Tourism director and longtime West Texas resident Terry "Tex" Toler, who told me the story of his mom, Ezell Toler, who passed away in 2012. Tex told me that "in her biggo cookbook, she swapped out the same cup amounts of rhubarb for agarita berries in her pie recipe. But she also has a note there about not adding as much sugar as would be for rhubarb, since rhubarb requires so much to counter its 'bite,' and also the agaritas retain a little more tang instead of being 'choose any berry and with enough sugar they all taste the same' kind of philosophy." He himself is a fan of picking them straight off the bush and eating them. "They're wild tasting, just like adding the ripe tuna [prickly pear] juice to a margarita. Now I'm getting antsy to try her recipe, but I never really learned how to bake well, much less make a flaky pie crust like she and other moms seem to do!" I told Tex we would give the flaky pie crust a shot with the following rhubarb pie recipe (with the rhubarb subbed with agarita berries).

Pie Crust:
1¼ cups all-purpose flour
¼ teaspoon salt
½ cup butter, chilled and cut up
¼ cup water

° Combine flour and salt in a large bowl. Cut butter into mixture. It should look chunky. Slowly add the water, tablespoon by tablespoon, until the mixture forms a ball. Wrap the ball in plastic wrap and place in the refrigerator for a minimum of 4 hours or overnight.
° Roll dough out on a floured cutting board or on wax paper so that it fits a 9-inch pie plate. Place the dough in the pie plate and press into plate and edges.

²/₃ cup sugar (that's ²/₃ cup less than my normal rhubarb pie calls for)
6 tablespoons all-purpose flour
4 cups agarita berries
1 tablespoon butter

° Preheat oven to 450 degrees. Mix sugar and flour and sprinkle ⅛ of it over pie dough. Scoop the agarita berries into the pie pan and sprinkle with the remaining sugar and flour mixture. Place cut butter on top and cover with the top piecrust. Bake pie on the lowest rack in the oven. Cook for 15 minutes and then reduce the temperature to 350 degrees. Keep baking for an additional 40 to 45 minutes.

TEX TOLER

"I was born in Houston—born a flatlander. My dad moved us out to Tomball when I was nine and started an airport out there; it became Hooks Airport. He died in a plane crash in 1975. We would travel around in an airplane, but I always preferred to be in a car; I liked to see the country change. I grew up in the age of watching cowboys, and I wanted to be a cowboy.

"Mom told me that when I was six months old, Dad took us to Big Bend, and they drove up to the Chisos lodge and my nose started bleeding. She could tell I was absolutely, completely fascinated by the rocks and cactus and views. Even as a baby, I was looking around at everything. We went back out there again when I was a little kid. Ever since then, I wanted to get west. I worked all my life to get west with the rocks and cactus and where it looked like Texas from what I had seen in the movies.

"I wouldn't call myself a cowboy, but out west, I was a ranch hand and got to work with cattle and goats and fencing. It's always been a fascination, and it's always been my favorite place. That's where I met so many of my longtime friends—in Alpine, Marfa, Sanderson. I was fortunate enough to be the tourism director in Marfa and helped grease the wheels for several projects.

"About the Agarita Berry Pie recipe: I went out to visit my best friend of forty-two years, who lived in Pandale. I went to his ranch when we were freshmen in college, and I went to help them during roundup with their Angora goats. His mom was picking agarita berries. We were picking them off the bushes and eating them. She told us some people make pies out of them. I got a stick and hit the bush and knocked a bunch of them down. I took a big ol' sack of them back to Mom, and she made a pie. We didn't have agarita where I grew up in Tomball.

"If you put a ruler on the map, I've never strayed more than a handful of miles drawn from Houston to Marfa. I moved for different job opportunities but always came back west. I still have a 105-year-old adobe in Sanderson and get to Marfa and Alpine every chance I get to see my friends and love camping and hiking in Big Bend. It's my love.

"When I bring people to Big Bend for their first time, I'll tell them, 'I know you've been to Yosemite and the Grand Canyon. These might not be as big as mountains go, but it's going to change your life.' I've never taken anyone out there that didn't go, 'Wow, now I see what you're talking about.' It still holds that magic for so many people. And I'm happy to be an enabler, a Big Bend pusher. I still help promote the Big Bend Film Commission and get to West Texas as often as I can."

Agarita Berry Jelly

Courtesy of Maurine Winkley

This jelly is sweet but definitely contains some of the tartness of the agarita berry. Just like Ezell Toler's pie philosophy about preserving the flavor of the berries in the pie, my philosophy on jelly and pretty much all baked and/or dessert items is the same: less is more. You don't have to feel as guilty about eating it, so you can focus more on the pleasure, and your blood sugar won't spike out of control. Tiffany and I actually learned how to make jelly together, and our mentors, the Jelly Queens, taught us the beauty of using a little alcohol in the jelly. You use less sugar, and if using a complementary alcohol, the flavor is even more apparent. Thus, you get to treasure the flavor of what you picked from the earth that much more.

This recipe will make 22 to 23 4-ounce (or 10 to 11 8-ounce) jars. Feel free to cut the recipe down, but you will need to be careful with the pectin. If doing this, use the specific quantities from the pectin packet. I've always liked using Pomona Pectin, as it is derived from citrus fruit and is preservative free. If you don't have a Sprouts or Whole Foods around, you can easily order it online at www.pomonapectin.com. One more note before you get started: it is really important to follow the directions closely to make safe, shelf-stable jelly that won't need to be refrigerated until it's opened.

1 gallon agarita berries (if you don't have enough berries, throw in some figs, cherries, loquats and/or any other nice, ripe, juicy fruit you have available)

¾ cup lemon juice

8 cups sugar

2½ cups white wine

5½ cups water

9 teaspoons pectin plus 9 teaspoons calcium water (a box of Pomona Pectin will come with both and instructions)

2–3 tablespoons coconut nectar (or agave syrup)

24 4-ounce jars or 12 8-ounce jars and lids (Ball jars are a great option, as are other jars with clean, threaded, unused lids)

° Wash the agarita berries; remove any extra plant matter you may have picked up in the harvesting process. If you are adding other fruits, wash and cut into big pieces (especially if using a loquat). Place agarita berries,

lemon juice and sugar in a bowl. Mix and press lightly to macerate. Set aside for a minimum of 2 hours (or overnight preferably in the fridge). The longer it sits, the more juices will come out.

° Bring wine, water and fruit mixture to boil over high heat, then turn heat off. Remove fruit and strain the liquid mixture, keeping all liquid reserved. I like to mash the fruit up a little bit and strain the remaining juices back into the pot. Side note: As soon as fruit pulp is added back into the liquid mixture, it is considered a jam, so try to keep out any pulp/seeds if you do decide to mash the fruit a bit and extract more juice if your intention is to make a true jelly (which is clear liquid only and no fruit chunks). Set your bowl of fruit pulp aside and put the fruit juices back into the syrup over medium heat. Let juice simmer for 5 or so minutes.

° While the juice is simmering, prepare your jars and lids for filling. Turn the oven on to 250 degrees. Wash the jars and lids in hot soapy water, rinse thoroughly and place the jars upright in an oven pan. You can go ahead and place the jars in the oven immediately. They should be dry by the time you are ready to "hot fill" them with the jelly. Dry the lids and place them on a cookie sheet. It is OK if they are a little wet. You will want to stick them in the oven about 5 minutes before you are ready to fill the jars.

° The following steps are to be used when using Pomona Pectin. If using another type of pectin, please skip the next two paragraphs and follow the manufacturer's instructions. We can meet back up at taking the jars out of the oven.

° The time when you get your jars ready is also a good time to get your calcium water and pectin ready. In a small, dry bowl, put 9 teaspoons of the pectin. In another small bowl, take the calcium powder and mix with water to make 9 teaspoons worth of calcium water. In another bowl, place 2 to 3 tablespoons of coconut nectar or agave syrup.

° The next step in the process is where the magic happens. Bring the jelly juice back up to a boil. You will have to pay close attention to the jelly, as it will boil quickly. As the jelly "crawls" up the side, take it off the heat to let it crawl back down the pot and then put it back on. Once it begins to crawl back up the side again, put the pectin powder into the bowl of coconut nectar and quickly mix them together. Take a spoonful of the hot jelly mixture and put it in the bowl with the coconut/pectin mixture. Mix quickly. Immediately after, pour the calcium water into the jelly pot, stir and turn off the heat. Then immediately add the pectin/nectar mixture, pouring it in the jelly pot while stirring. Stir

continuously for another minute. Take a spoonful of the jelly mixture, set it on a plate and stick it in the freezer. Put your washed jar lids into the oven with the jars. Take the spoon out a minute later and see if it has thickened but will still slowly slide off the spoon.

° The activities in this paragraph will ideally be done in under 5 minutes to minimize the amount of time the jelly is exposed to the air, but I will give you a way to ensure their safety post-production:

° Remove your jars from the oven. Leave oven on and lids inside. Grab a measuring cup with a pour spout. Begin scooping jelly into the measuring cup and carefully pouring the jelly into the jars. Fill up to the last 4 to 5 millimeters before the top of the jar. Fill all the jars. Take your lids out of the oven. Take a knife or skewer and look at each jar to make sure there are no bubbles at the top. If bubbles exist, pop them with the knife or skewer. Then, take a clean rag dipped into a little bleach water (or hot water if you don't have bleach) and clean off any spillage around each jar where the cap will be placed. This is really important for keeping the jelly sanitized.

° Now you are ready to cap the jelly. The lids will be hot, so you will want to grab each of them with a small, clean and dry washcloth. Screw on the lid so that it is tight but not so tight that you will have to get a pair of pliers to coax it off; I've done that many a time.

° More than likely, your jelly will be sanitary and good to go, but I always throw the jarred jelly back into the oven for 5 minutes or so. Put your timer on because leaving it in much longer will begin to turn the jelly back into liquid. Take them out of the oven, move them to an area to cool and wait 24 hours before you share them with your compadres. Oh, and a little note. If the following day your jelly is solid in the middle and a little runny on the sides of the jar, you've done well. Make sure to refrigerate it after opening. The unopened jars can be good for years, but I wouldn't let it go much further than 18 months.

° That may be the longest set of instructions in this book, but I'll tell you what, once you figure out how to properly make jelly, the food world is your oyster of jelly-making possibilities. Oh, and that fruit pulp you set aside can be cooked down to make a delicious glaze for fish, poultry or meat or thrown into the mix for a pie for some added flavor.

PRICKLY PEAR CACTUS/ NOPALES/TUNAS

Aaron Liddell

The edible cactus by far is the easiest plant to be confronted with in the desert. Its thin, elliptical pads are covered in long spines and, in the spring, are dotted with large magenta fruits called prickly pears, or *tunas*. The cactus has long been credited as a source of water in the hot and dry desert, and both its green pads (*nopales*) and bright fruits are a source of food and nutrition. The younger, greener nopales, or "nopalitos," are those that you will want to eat. They are more tender than the more mature pads. The cactus flowers dot the desert in the spring and produce the bright magenta prickly pears in the fall.

The harvesting of a cactus must be done carefully and with protection, unless you want to pull out a splinter on steroids or small hair-like, barely-visible-to-the-eye splinter from your skin. Needless to say, both the pads and the prickly pear or tuna are best harvested using tongs. I like the long, sturdy tongs used for barbecuing. To harvest the cactus pad, hold the pad with the tongs and cut at the base where it connects to the next pad using a sharp knife. The tunas should come off easily using the tongs, no knife required. If you are going to touch the prickly pear, make sure to do so using thick gloves. Ideally, you can bring them back to your kitchen for further processing before you cook them.

Before doing any cooking with the cactus, you will want to remove the spines. For the tunas, burning the spines over an open flame (lighter or gas stove) is a good way to remove most the spines; then use a knife to cut off the outer layer of skin to make sure you get all of them. Also, the tuna is like a beet; it bleeds magenta and easily stains, so heed caution when cooking with them. For the cactus pads, use a sharp knife to remove the spines.

Prickly Pear Simple Syrup

Courtesy of Mirt Foster

To prolong shelf life, add a little vodka or tequila. Store in a closed glass container in the refrigerator for up to one month.

12 prickly pears
2 cups sugar
2 cups water
juice of ½ lime

° Using tongs, rinse prickly pears in a large pot of water and refill to cover the fruit. Allow water to come to a full boil, then turn down and simmer 15 minutes. This will soften the small cactus needles enough to peel the fruit, preserving its gorgeous magenta color.

° After you have peeled the fruit, discard the skin, cut fruit into large pieces and then process, seeds and all, in a blender until puréed. Strain the fruit mix through a fine cheesecloth-lined colander to filter out the pulp and seeds, then set aside.

° In a large saucepan, combine sugar and water. Cook, stirring constantly, over medium-high heat until sugar dissolves. Add prickly pear liquid, reduce heat to low and simmer 2 more minutes, stirring frequently. Turn off heat and add lime juice to maintain color.

West Texas Prickly Pink Limeade

Courtesy of Mirt Foster

Sit back, relax and watch the tumbleweeds.
Makes 1 12-ounce drink.

6 ounces ready-made limeade
2 ounces Prickly Pear Simple
 Syrup (see recipe on page 233)
2 ounces lemon-lime soda
2 ounces vodka (Deep Eddy,
 Dripping Springs or Tito's
 Handmade)
1 tablespoon Candied Jalapeños
lime slice, for garnish

° In a tall glass or mason jar, combine limeade, syrup, soda and vodka. Add 3 or 4 Candied Jalapeño slices and ice. Serve with a lime slice.

Candied Jalapeño Slices in Simple Syrup:
½ cup water
1 cup sugar
1 12-ounce jar mild sliced jalapeños

° Combine water and sugar in a saucepan; bring to a boil. Reduce heat and simmer until sugar is dissolved and mixture is clear. Remove from heat and stir in undrained jar of jalapeños. Store in closed container in refrigerator for up to 1 week.

West Texas Prickly Pink Limeade for a Crowd

Courtesy of Mirt Foster

8 cups (64 ounces) ready-made limeade
2½ cups (20 ounces) Prickly Pear Simple Syrup (see page 233)
3 cups or 1 24-ounce lemon-lime soda
2½ cups (20 ounces) vodka
½ cup Candied Jalapeño Slices (see page 234)
lime slices, for garnish

Sit back, relax and watch the tumbleweeds with others. Makes 1 gallon of delicious limeade.

° Combine all ingredients in a glass pitcher. Float lime slices with ice and serve.

MIRT FOSTER'S BIG BEND STORY

If home is where the heart is, then certainly a piece of mine got left on a West Texas train platform many years ago. In 1968, my parents, my siblings and I boarded the Amtrak passenger train headed from Houston to Los Angeles for a family vacation. It made a stop in the tiny remote town of Alpine. Little did I know that decades later, this little dusty corner of the world would become a favorite destination for many enchanting road trips.

Art Walk, an annual winter festival, draws a lively mix of locals, cowboys and day-trippers together under the same bright Texas stars to walk, talk, dance and generally celebrate the night away. It was here that I stumbled across a delightful concoction made from the fruit of the prickly pear cactus. The dark, sweet drink tasted like a combination of strawberry, watermelon and pink bubblegum, and the surprising color—a brilliant, fluorescent magenta, both beautiful and bizarre—made a lasting impression. I went home determined to make some. Who would have guessed what was inside those unassuming thorny fruits?

Prickly Pear Jelly

Courtesy of Maurine Winkley

Prickly pear, like the agarita berry, can make a bright, delicious jelly. Please follow the recipe for Agarita Berry Jelly (see page 229) with the following exceptions for prickly pear jelly.

° The white wine can also be substituted with the same amount of your favorite light beer (I recommend Shiner's Prickly Pear beer if you can find it) or champagne.

° Prickly pears will need to be cut into quarters before macerating with the sugar and lemon juice combination.

° If the combination becomes very pulpy after it's boiled with the water and alcohol combo, you may want to put a piece of cheesecloth in your wire strainer to block any extra pulp.

Nopalitos Deliciosos

Courtesy of Mirt Foster

1 sweet yellow onion, medium-size, chopped
1 15-ounce can diced tomatoes, undrained
1 15-ounce can tomato sauce
½ cup of your favorite mild Tex-Mex-style salsa from a jar
½ cup water
3 tablespoons olive oil
1 tablespoon garlic powder
2 teaspoons cumin, ground
1 tablespoon sugar
salt and pepper, to taste
2 pounds fresh nopalitos (can be substituted with a 30-ounce can of nopalitos), chopped
¼ cup cilantro, chopped
juice of ½ lime

This recipe pays homage to the wild edibles found in the northern Chihuahuan Desert. Nopalitos are the young pads of the prickly pear cactus. They taste like a cross between green beans and okra.

° In a large skillet or pot add onions, diced tomatoes, tomato sauce, salsa, water, olive oil, garlic powder, cumin, sugar, salt and pepper and cook 20 minutes on low to medium heat.
° Fold in the nopalitos, cilantro and lime juice to combine. Cover with lid and simmer 10 minutes. Serve hot. Any leftovers are perfect the next day in an omelet or mixed into hash browns.

FORAGING FOR MEDICINALS

The medicinal uses of desert plants are vast; I've included a few of my favorite desert plants and their uses.

CREOSOTE SALVE

I absolutely love the medicinal smell the plant produces, especially after a nice summer rain. Even just driving with the windows down, you will always know when you're entering an area with an abundance of the creosote bush, as the medicinal smell is pungent. Part of this has to do with the fact that the plant releases a toxin, spread with rain, that makes it hard for other plants to grow around it, so where there is one creosote, there tend to be many more.[15]

The creosote bush can grow anywhere from four to six feet tall and is found in desert areas of the Southwest. The leaves are small and waxy and can be green with a hint of yellow. During the spring, the bushes produce small white flowers and fuzzy seed capsules. Creosote plants have been used for a multitude of homeopathic purposes and are widely known as a fever reducer, sore healer, arthritis reliever, anti-diarrheal and diuretic, among other, more contentious claims, such as cancer fighter.[16] My experience with them extends to making salves and using them on burns and mosquito bites.

15. "Medicinal Plants of the Southwest: *Larrea tridentate*," New Mexico State University, medplant. nmsu.edu/creosote.html (accessed April 30, 2014).
16. Ibid.

Creosote Salve

Courtesy of Maurine Winkley

Creosote Oil:

° Creosote Oil can be made by simply cutting a few sprigs of the plant (preferably after a rain when the resin has come up to the surface of the leaf), covering with olive oil in a jar and placing it in a cool, dark cabinet for a few months. If you need to make it quickly, it can be heated up in olive oil for 30 minutes on the stove to extract the essential oils.

This soothing and antiseptic salve can be made using a variety of oils and additional essential oils, but the following is my personal favorite combination.

Ideally, as little heat as possible is used to preserve all the healing properties of the plant.

4 parts coconut oil
1 part beeswax
Creosote Oil
lavender oil

° Melt the coconut oil and beeswax in a double boiler and remove from heat. Once cooled down a little bit but not solidified, add about a tablespoon of the Creosote Oil and 20 to 30 drops of the lavender oil into the mixture. Mix together and pour the mixture into little metal tins or small jars, such as jelly sample jars.

WILD TEXAS OREGANO

I bring up wild oregano because it has so many amazing properties. Not only does it serve as a fragrant herb for cooking, but it has also been used to make oils and tinctures that can be ingested or applied topically. It has strong antiviral and antifungal properties. One of my favorite uses includes using a few drops of the tincture in a little bit of water as a mouthwash. I also like to drink it as an immune booster either by mixing a little with water when I'm feeling under the weather or making a Medicine Man shot (created by JuiceLand in Austin, Texas) by mixing it in a concoction of turmeric, apple cider vinegar, garlic, habanero, jalapeño, lemon, ginger, cilantro and beet.

If you decide to use wild oregano, it most commonly grows on rocky slopes as far west as the Trans-Pecos. It loses its leaves in the winter but will quickly replenish them with a little rain and warmer temperatures.[17] Wild oregano is drought resistant and may actually be more potent both in flavor and medicinal purposes than its European cousin because of the "antioxidant-rich phenols" it releases to protect its leaves during periods of extreme drought.[18]

17. Ernest Small, *North American Cornucopia: Top 100 Indigenous Food Plants* (Boca Raton, FL: CRC Press, 2014), 457.
18. Nabhan, *Desert Terroir*, 9.

Wild Texas Oregano Tincture

Courtesy of Maurine Winkley

1–2 handfuls wild oregano
fifth of vodka (750 mL)

For immune boosting, mix half a dropper full with water or put 4 to 5 drops in a concoction such as the JuiceLand Medicine Man shot mentioned on page 240. For mouthwash, put 3 drops in your mouth followed by a sip of water, swish, feel the burn and spit back out. Mix a few drops with coconut oil and put on your feet to combat athlete's foot.

° Wash the wild oregano leaves. Place the leaves in a large mason jar. Pour the fifth of vodka into the jar, place a lid on it and put in a cool, dark place for at least a month. Shake the jar every 1 to 2 weeks. Strain the tincture.
° I recommend using a small metal strainer along with a doubled-over piece of cheesecloth. Pour the tincture into smaller jars or tincture bottles (typically found at health food stores).

OCOTILLO FLOWERS

The ocotillo plant looks like a type of cactus, but it's not. It is definitely one of the most prominent plants of the Pecos region. It stands tall, typically eight to ten feet, and unless it has rained, it is mostly seen as a brownish gray spindly plant that has thin tall stalks that are covered in spines. It is seen in the areas of the desert under five thousand feet.[19] Within forty-eight hours of a good rainstorm, the plant begins to grow small green leaves all over its stalks.[20] In the spring, bright red flowers pop out of the end of the stalks, and it is absolutely beautiful to see the sea of floating red flowers towering above the desert floor.

The ocotillo stalks can be seen in much of the early adobe construction in the area, as they were used as roofing material and are frequently used for fencing. Its spiny stalks are a natural deterrent for animals and people. As with many desert plants, the Native American communities that lived in

19. Cynthia Athina Kemp Scherer, *The Alchemy of the Desert: A Comprehensive Guide to Desert Flower Essences for Professional and Self-Help Use* (Tucson, AZ: Desert Alchemy Editions, 1997), 562.
20. "Medicinal Plants of the Southwest: *Fouquieria splendens*," New Mexico State University, medplant. nmsu.edu/ocotillo.shtm (accessed April 30, 2014).

the region for thousands of years used different parts of the plant to treat a variety of ailments from hemorrhoids to swollen muscles.[21]

A great juice recipe I discovered using the ocotillo flowers comes from the website Savor the Southwest.[22] The recipe calls for a few handfuls of open ocotillo flowers left in a bowl of water overnight. In the morning, you will find a nice lightly sweet floral juice.

MAURINE WINKLEY'S ACKNOWLEDGEMENTS

I'm not an expert in foraging by any means, but I've always been an explorer and lover of the desert, plants and their uses and, most recently, of the vast Trans-Pecos region of Texas. Tiffany Harelik and I grew up down the street from each other in Austin, and although we were separated for fourteen years, we are now best friends and great adventurers. We share a multitude of interests, from horseback riding, beer drinking, cooking, hiking and exploring to trailer food and jelly making. I am so proud of all her endeavors to share people's stories and am honored to get to be part of this cookbook. I also have to pay tribute to my good friend Kari Gaukler, whom I met in a permaculture class I was taking a few years ago and who was light years ahead of me in her quest to identify and understand our native Texas vegetation. Much of our time as friends has been spent exploring and experimenting with all that grows without artificial attention, and thus, much of my passion for plants has been fueled by her energy and knowledge. Currently, I am the CFO of JuiceLand and enjoy getting out to West Texas as often as possible.

21. Ibid.
22. Savor Blog Partners, "Edible Flowers of Spring: Ocotillo Tea," Savor the Southwest, April 22, 2014, savorthesouthwest.wordpress.com/tag/ocotillo-tea.

TRANS-PECOS SAUCES

Marci Roberts's Pesto

Courtesy of Marci Roberts

This probably goes against every professional chef's protocol for pesto. I just came up with this after being unsatisfied with using a food processor and a pestle and mortar. I never researched. I just kept experimenting until I got the flavor I was looking for. I don't measure. I just go by the look and taste, so I have a general idea of quantities. But you may find that you like more of one ingredient, so go for it! This recipe makes 2–4 servings depending on how much pesto you like on your pasta. James, my boyfriend, likes to drown his; I like mine on the light side.

The first and most important requirement is to grow your own basil. I have galvanized stock tanks in front of the French Company Grocer where I grow food. Basil is in one of them for my pesto. I take the most tender leaves, wash and dry them, then lay them out on a big wood cutting board. I start off with a half grocery bag of basil. I take a big pizza cutter and start going back and forth and back and forth and back and forth and back—you get the idea—until you get little chunks, but they are still chunks. They should never be pulverized. I like the flavor you get from the larger chunks.

Then I pour pine nuts—start with a cup or so—on the same cutting board and chop the pine nuts until you get the size of chunks you like. Now you can probably do this in a food processor, but I still like the chunks I get with the knife. Then I can control exactly when I want to stop. And it is a great meditation.

I grate some Parmesan cheese, more coarse than fine. Start off with more than a cup.

I found if you keep each ingredient chunky, each flavor is more distinguishable. You get a pure burst of basil, then Parmesan, then garlic, pine nut—yum.

Chop some garlic cloves, get some fine olive oil, some ground Himalayan salt and combine all of these ingredients until you get the ratio that pleases you. It is different for everyone, so be prepared to do a lot of tasting. I look at the pesto visually and see if I like the ratio of the different colors. I try not to use a ton of olive oil, but it is really hard!

It is so good I like to eat it all by itself, but certainly on pasta. I don't eat wheat, and Ancient Harvest Quinoa pasta is my favorite. If I have some special friends over, it is always a treat to prepare this for them. I can only prepare it as the basil grows for me. Last year, I had issues and had no basil crop at all, so I am looking forward to my pesto I haven't had for a couple of years!

TRANS-PECOS SAUCES | 245

Mole Sauce

Courtesy of Boyd Elder

"A good mole sauce is made with spicy red chile sauce and comino, oregano, a little dash of anise and chocolate—sweet and bitter to your taste."
—*Boyd Elder*

red chili sauce
ground cumin
dried oregano
anise
olive oil
Coca-Cola
salt
pepper
*chocolate

° Mix all ingredients together and let simmer slowly on low for 30 to 45 minutes, stirring constantly so that it doesn't stick to the pan. You don't want it too thin or too thick. If you're using the mole with chicken, use some of the stock from boiling the chicken in the sauce too.

° Note: For the red chili sauce, I use Bueno chili sauce or I make it at home. Bueno is not seasoned at all, so I season it with cumin and oregano. Be careful not to add too much oregano because it will taste more like spaghetti sauce.

° *You can add 3 to 4 different chocolates according to your taste. Sweet and bitter chocolate gives it two different flavors, so if you want it sweeter, add more sweet chocolate. If not, do equal amounts.

Chihuahuan Desert Hot Toddy

Courtesy of Marfa Table

4 oranges or grapefruits
4 lemons
4 limes
1 tablespoon whole cloves
2 cinnamon sticks
3 quarts water
18 ounces agave nectar
sotol
lime or lemon wedges

° Quarter citrus and boil with spices in 3 quarts water for 45 minutes or until rinds are soft and malleable.
° Strain liquid through a sieve into a large bowl.
° Retain cinnamon sticks and add back into liquid.
° Using two large spoons or a juice squeezer, squish cooked fruit to extract the remaining juice. Return to cooking pot and stir in agave nectar.
° Mix one part sotol with two parts hot toddy mix. Serve with wedge of fresh lime or lemon.

"Sotol and agave live close to one another in the high desert and are pleased to be paired with the citrus from farmlands for this cocktail that will not only begin or end a chilly evening with a bang but will also cure the common cold when consumed in extravagant quantity. The citrus mix will hold in the refrigerator for several days and can be reheated or used in cold mixology. It is delicious with vodka, rum or bourbon."
—Bridgett Weiss
Serves 15–20

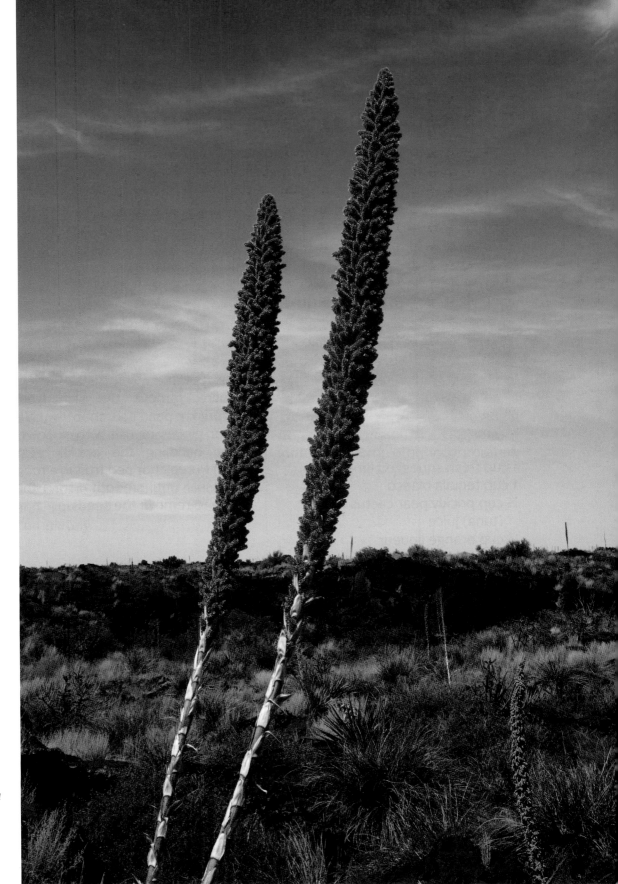

OVERVIEW OF BIG BEND NATIONAL PARK

Big Bend was the twenty-seventh national park in the United States and the first national park in Texas when it was founded in 1944. Close to one hundred dinosaur species and almost one hundred plant species have been discovered in the area. One of the most famous fossils found here was an eighteen-foot-long specimen from an enormous pterosaur that is one of the world's largest flying creatures, *Quetzalcoatlus northropi*. Within park boundaries, you can drive sections of the Comanche Trail, take a dip in the hot springs or hike along any of the designated trails. Various stores throughout the park offer educational opportunities and gifts/supplies.

Big Bend Bucket List: Big Bend Park

- Soak in the Hot Springs
- Hike the Santa Elena Canyon Trail
- Hike the Lost Mine Trail
- Hike the Window View Trail
- Hike the South Rim

YOU CAN DO IT HERE IN THE BIG BEND

BY BETH NOBLES, FORMERLY OF TEXAS MOUNTAIN TRAILS

S pend all morning on horseback and then watch a full lunch emerge from the saddlebags—roast chicken, black bean salad and corn bread.

Indulge in real Texas barbecue, coleslaw and peach cobbler and visit with the smoke master as you dine.

Kick back on the porch and watch a meteor shower, local brew in hand.

For all the adventure that's possible in the Big Bend—and *all* adventures are possible here—it goes hand in hand with good eating. Hop on a horse. Hike a trail. Paddle down the Rio Grande. And know that waiting for you is a great meal made by the fine folks of the Big Bend.

We have the rare gift of untouched land, breathtaking vistas, sheer river canyons and pristine dark night skies. We are miles from the noise of the city. We still see cowboys riding to town on horseback for lunch. We visit places that were stopping-over spots for the Comanche and Apache and buffalo soldiers. This may be one of the best, last genuine places worth visiting. And so much of what's real and original about this place is still here, waiting for all our travelers.

When J.O. Langford arrived in the Big Bend by wagon in 1909 to establish the Hot Springs (now in the national park), one of his first breakfasts included hot biscuits, fried bacon and coffee. You can order that breakfast in just about every local café today, more than one hundred years later.

It still takes a pioneer's spirit to live in the mountains of Far West Texas, where creativity and improvisation are as important to cooking as they are to every other part of life. A nimble mind and enterprising spirit are required to

live in such a large land so far from the city. Families drive up to three hours to shop in an amply stocked city grocery store, and when faced with shortages, they just "make do," which leads to surprising creations in the kitchen. You also see that creativity in the cafés and restaurants of the Big Bend.

Consider the Marfalafel, the creation of Marfa's food truck the Food Shark. Plump falafel balls, cucumbers, tomatoes and hummus sit on a Texas flour tortilla instead of pita bread. Or Alpine's Reata restaurant's signature dessert, a tamale of chocolate chunk bread pudding drizzled with dulce de leche. Our region's Mexican heritage and desert landscape are on nearly every menu. Enjoy cajeta, tres leches cake and prickly pear margaritas.

If you think we've got a wild landscape now, consider what it was like to be a traveler in the late 1920s and early 1930s, when the highways out here were still a mix of gravel and desert and most folks arrived by train. A hotel building boom began in 1927 with the Gage Hotel in Marathon, followed in 1928 with Alpine's Holland Hotel, both situated across the street from the train tracks. With these properties, the architect Henry Trost established his legacy in Far West Texas. More Trost-designed hotels followed in 1930 with Marfa's Hotel Paisano and Van Horn's Hotel El Capitan. All properties are completely (and lovingly) restored, welcoming guests in their rooms and hungry visitors in their dining rooms. Step into a lobby and pretend you're a cattleman there to make a deal. Feast on an enormous pistachio-breaded chicken-fried steak or a char-broiled rib-eye and *believe* it.

As the frontier matured, local bond elections were held to finance the paving of our highways in the 1930s, and travelers started to arrive by automobile. Most early auto travelers did what smart folks still do today: pack plenty of water and food for the journey. Roadside picnic areas were built along with the highways as "safety" rest areas for tired travelers. Some charming ones remain. Watch eagles and hawks circle overhead at the Point of Rocks on Highway 166 outside Fort Davis on the Scenic Loop and pronghorn roam in a forest of giant yuccas and cholla. Unpack a sandwich under the shade of huge cottonwoods in view of Wild Rose Pass on the way to Balmorhea State Park on Highway 17.

One special property from that period still offering rooms and meals is the 1930s Indian Lodge in Davis Mountains State Park. Built by members of the Civilian Conservation Corps as part of our nation's economic recovery, this gracious place continues to charm with original interiors and furnishings. Though new rooms have been added, the entire hotel still has the feel of its original southwestern Native American–style, multilevel pueblo village

design. Eighteen-inch adobe walls and hand-carved furniture add to the experience, as does the kitchen's efforts to use locally sourced vegetables for the Black Bear restaurant's dishes.

When enough rain blesses the Chihuahuan Desert, crops are grown along the Rio Grande and in select areas. Old issues of the *Big Bend Sentinel* from the 1930s advertise Presidio-grown onions, melons, chili and other produce in Marfa grocery stores. Today, tomato farms (under glass), pecan orchards and a goat cheese operation provide products for local restaurants.

Tiny Marfa stands unique among Far West Texas communities. Still very much a traditional Texas ranching community, it benefits from the influx of artists settling in town following the legacy of American minimalist painter Donald Judd. Artist and National Endowment for the Arts grant recipient Malinda Beeman draws a parallel between her creative work and producing goat cheese; both require an allegiance to process and careful attention to detail. Citing the scarcity of fresh produce in town, Beeman was instrumental in the development of Marfa's farmers' market. Beeman and her partner, Allan McClane, began experimenting with cheese making, and Marfa Maid Goat Cheese was born. Three years ago, the couple built a milking and cheese-production building on their property east of town. While McClane tends to the goats, Beeman produces the cheese, sometimes holding classes for the public. Their herb garden supplies fresh flavors for their products.

Marfa Maid Goat Cheese enjoys wide-ranging public support, as evidenced by its successful Kickstarter campaign for a pasteurizer and milking machine. Yet the couple admits starting a business later in life requires tenacity and a big leap of faith. As McClane states in their Kickstarter video, "To make it in Marfa, you really have to have priorities, and you better be able to stick to your guns. You better have some backbone just like the old West Texans because it isn't easy to make a living."

CAMPING AND HIKING IN THE BIG BEND

BY HEIDI TRUDELL

Heidi Trudell is a native Texan, mercenary ornithologist and blacklighting enthusiast. She is a co-blogger at BigBendNature.com and enjoys mixing travel stories with Dublin Dr Pepper.

TRAIL FOOD

Some people have innate knowledge of keeping themselves fed on the trails. Others, like myself, have relied too heavily on granola and protein bars for too long and burn out.

Trail food is an interesting challenge because you need portable nutrition that requires as little prep, gear and waste as possible. Figuring out the needs for a day hike or multiple days can be challenging. Car camping allows luxuries unheard of on multiday backpacking trips, but the ultimate challenge is finding a strategy to meet each adventure in food and wilderness that actually works for you.

For lack of better advice, and not being much of a cook myself, I can only offer what little wisdom I've gleaned from being my own guinea pig in West Texas, as well as some wise pointers from folks I've met along the way. My goal was to avoid as much prep as possible and any cleanup that involved more than a knife/fork/spoon and not live on peanut butter alone.

Do Bring

- Dried fruit
- Nuts
- Salty snacks
- Hard-boiled eggs
- Jerky
- Summer sausage
- Electrolyte tablets/
 Gatorade powder

Don't Bring

- Canned food
- Glass containers
- Easily bruised/smashed
 fruits

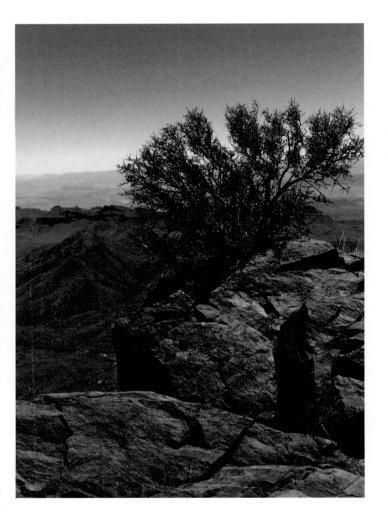

BACKPACKING
AND DAY HIKES

Backpacking is my weakest point in the grand scheme of outdoor adventuring. Hat-tip to those brave enough, strong enough and prepared enough to tackle the challenge. Day hikes require basically the same concept as food requirements for backpacking: lighter is better. Drinking enough water in the desert is the most important thing, along with lightweight, long-sleeved clothing and minimizing pack weight. Heavy foods—literally and figuratively— are a disadvantage in the backcountry, so keeping to lighter items will work to your advantage. There is no shame in measuring out your preferred portions into sandwich baggies because later you can use the empty bags to pack up trash and they cut down on bulky packaging (unless you were able to purchase your ingredients in bulk, which isn't always an option). MREs (meals ready to eat) will provide balanced nutrition but can get pricey and high maintenance, assuming you're not up to the challenge of boiling water.

If you don't mind a little extra weight, look for pouches of rice that can be heated and served with no additional water, like the ninety-second microwave options offered by Uncle Ben's. Backpackinglight.com has some excellent pointers for DIY instant rice, but it takes several hours of prep. Additionally, peanut butter can be one of the best items to sacrifice weight for, as it offers protein and versatility. You can try peanut butter banana chip sandwiches in honor of Sam Kolb, whose unique twist on the PB banana classic is actually trail friendly!

CAR CAMPING

This is where culinary adventures can get interesting. Some of the more intrepid folks may choose some of these options for non–car camping adventures, but space and weight are the primary reasons that these ideas are not suggested for anything other than car camping.

Coolers have the power to make or break a trip. Bulk ice can be overrated if you need to bring your own drinking water, but it is also overrated due to its ability to turn into a giant, heavy, sloshy mess. Ice packs, however, are useless after the second or third day, so you might as well get the same amount of life out of alternative sources. Taking reasonably thick resealable containers (think clean, empty Gatorade bottles) that are sixteen to twenty ounces and filling them two-thirds full with water before freezing them will provide you with cool drinking water that will keep perishables cold until hopefully you can eat them. Obviously, you should bring as much water as you can, frozen or not. If you have a ready supply of drinking water but don't want to bring ice packs, consider freezing single-serving packs of fruit. Usually you can find four- to six-packs of peaches, mandarin oranges, mixed fruit, etc., generally in four-ounce plastic containers with plastic seals. Chilled fruit is incredibly refreshing after a hike, but you definitely want to put it in baggies when freezing just in case there are any issues with expansion. This is especially true of foil-sealed packets, which are easier to puncture than plastic. Some protein smoothie–type drinks may be freezable in their existing containers, but texture change and expansion are more problematic, and these should be tested on a case-by-case basis. The smaller the serving size, the shorter the time they will remain frozen.

Somewhere between coolers and fruit/veggie issues is the combination of baby food pouches. Store them in the fridge before you leave (use caution trying to freeze them) or keep them at ambient temperature. Baby food is perfect for travel. Not even kidding. Skip the glass and plastic jars/tubs; go for the pouches.

There is everything from acorn squash to fruit smoothie combinations; ignore the smiling baby on the label, these are pocket-sized bursts of sugars that put candy bars to shame. There are so many flavors in the average grocery store that you can probably eat two a day as snacks for a week without repeating flavors.

Space can still be a challenge with car travel, and smashing things is often as problematic as the banana that you shouldn't have put in the bottom of your day pack. Chips are delicious and salty and a really impractical choice when trying to save on space and maintain proper 3D qualities, so grab the Pringles and...eat them before you leave. That empty tube? You might as well grab two or three containers of Pringles because you can fit an entire pack of Ritz crackers or Saltines in there! Crackers are arguably among the most versatile camping foods (peanut butter and banana chip crackers, anyone?), and I crushed far too many crackers before my impulse Pringles purchase became an obvious candidate for repurposing. Also, Goldfish and animal crackers travel well in a Pringles tube.

Ultimately, travel foods need to factor in more things than this blurb can ever hope to address, but go forth with your foods and try new things on the trails! Established trail food wisdom can be found all over the Internet, but experimentation brings a novel satisfaction. Enjoy!

Natural Fly Spray

Courtesy of Z Bar Farm in Marathon

Z Bar Farm in Marathon, Texas, is mainly a goat farm. Sally Roberts is the cheese maker and shared this recipe for a natural fly spray that she uses on her farm. It's useful for both humans and animals to create a shield against the buzzing of the flies in summertime in Big Bend country.

1 cup apple cider vinegar
1 cup peanut oil
1 cup water
10 drops citronella essential oil
5 drops tea tree oil
4 drops lavender essential oil
 (optional)

° Mix all ingredients in a spray bottle.

WILDLIFE AND HUNTING IN BIG BEND COUNTRY

Aaron Liddell

The Big Bend region is known for its impressive wildlife. But if it weren't for landowners and ranchers implementing certain parameters, area wildlife would be sparse. Intensive watering, feeding and predator control measures are taken in order to protect the wildlife that hunters and outdoorsmen have enjoyed for years. I interviewed four men for this section of the book to give you local insight on wildlife and hunting in this area: Randall Liddell is the foreman of Calamity Creek Ranch in Fort Davis; Lyn "Shack" Shackelford owns and maintains the Dead Horse Mountain Ranch close to Big Bend National Park; Andy Allen has done predator management professionally for over twenty years and serves the entire Big Bend region; and Craig Trumbower is a well-respected advocational herpetologist and author who has researched the area since the 1970s.

Aaron Liddell

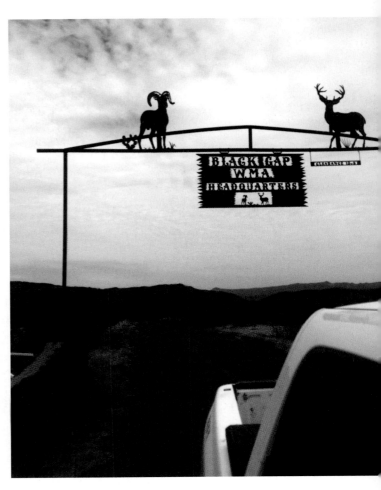

MULE DEER

By Randy Liddell

We are in what is called an MLDP, which is an extended season that runs from November to the first or second week in January. On a regular season you are allowed [to kill] one mule deer, but on the MLDP, how many deer you can hunt is a matter of how many permits you have. The amount of permits you are granted is regulated by the deer population, which is counted by annual surveys. I do most of those here [at Calamity Creek]. For a daylight survey, you start in July/August and you count deer (you might see two doe, one buck, etc., per day). Night surveys are done on a predesignated route. You run the same route every year at night with spotlights. You try to count the deer whether they are white-tail, mule deer, bucks, does or fawns. We don't do helicopter surveys here as much because the spotlight surveys serve the same purpose. I work with Texas Parks and Wildlife on the counting. Then the permits are issued to us by Texas Parks and Wildlife according to what we find in the surveys. With the MLDP, you have to have a Texas

Aaron Liddell

hunting license, but you don't use your license to tag the deer; you have a special permit to tag the deer with.

We don't have any paid hunters here. We use the MLDP as a management program to cull the deer we don't want to be breeding (which allows you to harvest deer over a longer period of time that aren't good for your program).

In our area, a lot of people hunt for meat, no doubt about it. But mule deer are game animals, so many people are hunting them for their horns. The deer are scored for their horns, and the quality of horns will vary from year to year based on rain and food availability. In our breeding program, we cull the mature deer that are six and a half or seven years old. This is at the end of their lifespan and usually when their teeth start to go.

We feed the deer mainly cottonseed and alfalfa bales. Here we have 300 to 350 deer on the property today [May 2014]. The drought reduced the population significantly.

By Lyn "Shack" Shackelford

Back when it was raining, we had some that were 200-class deer. Last year, we killed two in the high 170s and one in the 190 range on the Boone and Crockett scale. We just need Mother Nature to help. My last survey showed I had a little over two hundred deer in the count.

I've been doing this for twenty years. One story about mule deer pops into mind. I sent one of my hunters off on his own. He had been coming with me for several years. Come noontime, he said he'd shot a big twelve-point buck but it didn't go down. He had found a blood trail but couldn't find the buck. I was taking up a greenhorn that afternoon. We went to where he said he shot that deer, but we didn't see any blood. We went about five miles away from where he said he shot it and saw a twelve-point grazing. We Indian stalked him and crawled on our bellies up to him. This hunter had never shot before, so I was going to put him up pretty close to help ensure success. One shot got him down, and he rolled right up to us. He had one broken leg with a bullet hole through him, so I knew it was the deer the other guy lost. When we went home to clean it, I asked the other hunter if it was the same deer he "killed," and we were able to joke about it.

Aaron Liddell

We do annual mule deer hunts on a MLDP. On average, I get about fourteen to fifteen tags a year now. At the beginning, I didn't. To go back, the ranch never had fences, water wells, houses, etc. I put twenty-eight miles of pipeline in, thirty water troughs and then the deer started showing up. That's when we got on the MLDP—when it started four years ago.

MOUNTAIN LIONS

By Lyn "Shack" Shackelford

I'll tell you why we kill cats: they are a majestic awesome creature, but if you're going to be in the deer business, you have to keep the cats under control. A lion will kill one deer a week, and that's fifty-two a year. I'm killing ten deer a year, so if the lions are doing their one a week, we have to balance out the system. There's no way in hell you'll ever kill all the lions, but to keep the balance going, you have to keep their population down because they are a competition against you as a hunter. In my thirty years at the ranch, I've only seen two in the wild while I was driving around. You just don't see them.

That said, I've seen a two-hundred-pound mountain lion carrying a two-hundred-pound calf jumping bluffs as tall as me that I couldn't crawl up. Mountain lions have a healthy population because of the park next to me and Black Gap. It's a constant battle, and we don't want them decreasing the deer population.

By Randy Liddell

The mountain lion population is under control. The drought affected so many animals that in this area, the mountain lion population is a little bit down from previous years because they don't have as much to eat. Last year, we had a lot of twins with deer and are building the deer population back up. The lion population will increase as the deer are coming back.

A female, when she has her kittens, could have one to four. Four is the most I've ever seen. She'll usually keep them in the area she has them for two to three weeks. When they grow, she'll move them around a little bit but will stay in the area for three to four months in the same den. The kittens will stay with the mom; the female kittens will stay one to two years with the mom, but in that time the males will be kicked out. They will travel with the female and eat on her kills. If there is a female that has two kitten and both female, they will hunt together for up to two years. The males will get a territory that is dependent on the population of other mountain lions. Depending on how many toms are in the area, they will get a circle which can be up to a fifty-mile circle or bigger. They will come every two weeks and are constantly on the move.

The toms are always hunting. They are either hunting females to breed or hunting for food. They are predictable because they will come back through the same area. They travel the same routes. Most mountain lions have trails that are set trails and set ways of traveling because of the type of animal they are. They are basically looking for the same advantages for hunting; they know the lookout points on mountains and all the bluffs in a canyon. So if you know the habits of mountain lions, you can predict where they will come through and you can predict when they might be back.

Man is their only predator, and they eat anything; they are opportunists. I have found deer kills, antelope kills. I've found where they've killed coons, fox, other lions, birds and hawks.

Are they a threat to people? They can be. A mountain lion, if it's an immature mountain lion if it gets kicked off the mother or if the mother gets killed and the immature lion is trying to fend for itself, it will lose its fear because of hunger. That's why we see reports of children or girls/young women being attacked because they are smaller.

How big do they get? Around here, the biggest lion you might hit is 200 pounds; that would be a big, big cat. Most of the toms in this area are 160 to 180 pounds. They look like they weigh a lot more.

Why kill the lions? When you hunt mountain lions, you're basically trying to manage them like you would deer or anything else so their population doesn't get out of control, and also you are trying to protect the deer population. For a

conservative approach, if you say a mountain lion kills every other week, that's twenty-five deer a year. They will kill one to two times a week, so they can decimate a population of deer if they get overpopulated and will eat everything up. They compete with bobcats and coyotes. Bobcats will leave an area when lions come in; if not, they get eaten. Lions are at the top of the chain.

There's no limit on cats, and there's no bounty. There are paid hunters that are predator hunters that work on these ranches to try to keep the mountain lions, bobcats and coyotes under control.

If you see a lion in the wild, the best thing to do is to *not* run and to throw rocks at it. I'll tell you a story about my granddaughter Jacy. Jacy, Susan and Becky were on a trail by the main house. I was by the guesthouse. I started making a cat sound, and they took off running all the way to the house. I told Jacy, "Don't ever run because that triggers a mechanism for them to chase you if you run. Don't move. Try to hit it in the head with a rock. You don't want to run." A month or two later, Jacy and her friend were back in the rocks and had my dog with them. They crawled down in this little place in the canyon and saw a mountain lion. The dog never did see it, but she said, "Grampy, you'd be proud; we never did run." That's why you hear of cyclists and hikers getting attacked: because they are moving. That's part of the problem. The main thing that makes animals dangerous is when they are hungry or trapped, they lose their fear.

COYOTES

By Randy Liddell

Coyotes are as bad as mountain lions in terms of how hard they are on the fawn population. They prey on antelope and deer fawn. The coyotes are denned up until the first of May, when they have their pups. It's the same time the antelope have their fawn. So the coyotes start to feed on the antelope. Then in June and July, you start getting deer fawn, so their little ones are coming up at the same time the others are having their little ones. Deer and antelope have no scent for their first few weeks of life, so they can hide from predators. All the grazers are the same way; it's just God's way of helping them get started. Once they get to a certain size, they can try to outrun the coyotes.

Coyotes hunt in groups, but not always. The coyotes that have a litter with four- to five-month-old pups start traveling with the parents and hunting with the parents. Then you also see groups that hunt together. They have lots of strategies. One is to separate a fawn or young deer/antelope from

the main group or bunch. The deer separate to have their fawns so it's not as noticeable. Then they come together in a herd. The coyotes like to separate a fawn from a group and run it to wear them out until they are easy prey.

They have other tactics too when they work in a unit. One time I saw a group of five coyotes crossing a big, flat area, not trying to hide. They ran between a group of ten to twelve antelope and then one buck off to the side. While they ran, right in the middle of the split, one of the coyotes lay down, and the rest kept going. After the coyotes made it past the last antelope, the buck that was singled out started to make its way back to the herd and came across the coyote that had been lying down. The coyote almost caught the antelope. That is the smartest I've seen them behave.

The coyote population is never really in jeopardy. They are incredibly resilient, and they move so much. If you wiped out all the coyotes in one area, it wouldn't be long before others would move in from other territories. I've heard you can figure there are at least a pair of coyotes every two miles.

By Andy Allen

An antelope wont jump a fence line; he goes under the fence. Most of the fences in our area aren't antelope fences yet, but some of the landowners are taking the bottom wires off their fences to help the antelope have an escape from predators like the coyotes. The coyotes will run an antelope up against a fence they can't get under and follow them until they are exhausted or until they bleed out.

"A pack can be three to seven coyotes and is usually a family unit hunting together. They'll usually have one or two of last year's puppies with them. They can have three to ten babies a year depending on how the food base is. Kills are seasonal. If it's winter, they will make a couple kills a week. In the summer, they are competing with the buzzards, and that's a hard question, but maybe three to four kills a week.

SNAKES

By Craig Trumbower

The Chihuahuan Desert, this part of West Texas, is home to many very unique species of reptiles. It's of interest to a lot of herpetologists and naturalists.

The gray-banded kingsnake is one of the harmless ones. It's very colorful and variable with populations all over the place. The area is also home to mottled rock rattlesnakes, which are of interest to a lot of people. Western coachwhips (often referred to as red racers) offer a vibrant color. Specimens can be bright flamingo pink when seen in the daytime, crossing highways. These snakes can grow to be six feet or larger. Known to eat other snakes, the western coachwhip or kingsnake can receive a venomous bite from another snake, survive the bite and ingest the snake without harming itself.

If you are among the few who get bitten by a snake, go to the emergency room immediately. It's very rare to get bitten. There are very few fatalities a year from wild bites. The appropriate thing to do is go directly to the emergency room. If you can kill the snake and bring it safely with you to the ER, it will be used to be identified to help you. It's rare to die from a rattlesnake bite. Big Bend Regional Medical Center starts the patient with four vials of anti-venom, costing $2,000 to $3,000 per vial. Patients can get as many as thirty vials and are then sent to Midland for further treatment.

There are six species of rattlesnakes found out here: western diamondback rattlesnakes; Mohave rattlesnakes (these are the most dangerous because they are highly neurotoxic); black tail rattlesnakes; mottled rock rattlesnakes; prairie rattlesnakes; and rarely seen there are also desert massasauga rattlesnakes. Besides rattlesnakes, Trans-Pecos copperheads are also venomous snakes in the area. We don't have coral snakes here; they live farther east about one hundred miles. Water moccasins are also east of here; there are none in Brewster, Jeff Davis or Presidio County.

By Randy Liddell

When you're in a drought, the snakes are not as noticeable. When it starts getting rainy and we have more moisture, the snakes are able to move more. If it's dry and they get away from their den and get hot, it kills them. A snake can last two to three months without water if they are denned up in semi-hibernation. So the more moisture you have, the more snakes are going to be moving because they are not as affected by not being able to find something to drink and there are usually more small animals. They don't move around when it's dry.

We have four kinds of rattlesnakes here, lots of rat snakes, garter snakes and whip snakes. Most of them like to eat rodents. Along the creek, you can get lots of frogs, so rattlesnakes, copperheads and certain other snakes can be found along the creeks.

Red racers can play dead. They will turn over on their back and play dead if they get in a situation where they can't get away. They are not poisonous, but they can bite you good. They have a lot of teeth about an eighth of an inch long.

By Lyn "Shack" Shackelford

I have a snake story for you. I was digging plants one day, sending a load to California. I was on a tractor loading them in a trailer with my dad. I set a Spanish dagger on the trailer, and something caught my eye. Dad was bear hugging a yucca trying to move it, and I saw a rattlesnake was curled around the plant long ways. Dad had his arms right below that snake. Dad's hard of hearing. I told him, "Get your ass off the trailer. Get away." He was looking at me like, "Don't talk to me that way." I grabbed his arm and jerked him off the trailer, and he fell, but I caught him. I grabbed a piece of pipe and went to whacking on the cactus. Dad was looking at me like I was crazy, but I killed it [the snake]. That was one of the scariest ones I've ever had.

BEARS

By Lyn "Shack" Shackelford

Bears are protected in Texas, meaning we do not kill them. I would say over the last twenty-five years, I've seen hundreds of bears on my property. My biggest problem with bears has been when they mess up my water troughs and houses and facilities. They get into the floats on the water systems and chew on them. Then the water drains all the tanks, and the wildlife and cattle don't have any water.

In 1993, my brothers and I drove down to the ranch on Christmas holidays after opening presents. We drove up to the house; everyone was drinking and having a good time. When we walked into the house, it looked like someone had ransacked it. The fridge was wide open, beds were turned over, stuff was all over the place. My sister-in-law started hollering; a bear had jumped out the back window of the house and started running up the house. We called Parks and Wildlife, and they came and trapped it. This [incident] was at my dad's house, but it [the bear] made the circle and went up to my house six miles away.

DESERT BIGHORN SHEEP AND AOUDADS

By Andy Allen

How we created the problem for the desert bighorn sheep: With the introduction of domestic livestock before 1900, we created a food base that caused a predator explosion with mountain lions, wolves, coyotes and black bears. It hasn't stopped today. The big food base, which was domestic sheep and goats, disappeared in the '80s in a five-year period. When one ranch fell, they all started to fall. Then nonresident landowners began buying land for deer. Most of them did not want anyone killing anything (i.e., predator control) on their land, and ten years later, they didn't have deer anymore. Then they realized they had so many deer because they had domestic livestock. In the meantime, the aoudad population exploded. We always had a few, and over a twenty-year period, the aoudad herds went from a few scattered herds to herds with over two hundred in them. There is not a creature in the North American continent more adaptable than the aoudad.

So the lions got another food base to move on to: the aoudad. With restoration efforts for the bighorn sheep and mule deer, we still have this predator issue. You have Big Bend National Park, which allows no management whatsoever in it. A lot of our state parks are the same way. And a lot of these extremely vulnerable areas are near the park, along with all of northern Mexico. So you have huge breeding grounds for the predators close to the areas we are trying to preserve, so the predators just keep coming.

Aoudads are hunted for sport. They are treated as an invasive exotic, which they are, but they didn't ask for it. With the bighorn sheep, groups are working real hard to make a successful program. The program has come a long ways, further than I ever thought it would. It's a combination of Texas Bighorn Society, Texas Parks and Wildlife and a hell of a lot of volunteers and private landowners. They have nothing but the best interests of the sheep in mind. Parks and Wildlife has extremely dedicated employees on its side. You can see the groups working together to put together a really strong program.

Bighorns are native to this area. Disease and overhunting reduced the population down to 3. There were 3 desert bighorn left in the state of Texas when the preservation effort started in 1959. They had breeding pens, and they ended up trading different wildlife to different states to start the breeding stock. They had a breeding pen at Black Gap for a while and Chilicote Ranch near Valentine for a while. I don't think their numbers here in Black Gap were ever very large, but there were always a few. The farther west, the larger the numbers got. The Sierra Diablos have larger herds. The last herd estimate was approximately

1,500 in the state. They have done a fantastic job, and the volunteers that work on these projects are unbelievable—that that many people would come together and work that hard on what's supposed to be their vacation.

I spend time with different Parks and Wildlife personnel on the sheep, and their dedication is second to none, I promise you. They do an aerial survey each year on the private land side that potentially have desert bighorn sheep, and based on what they see out of the helicopter, the private landowner will or will not be issued a permit for hunting. On the state side, they do a walking survey to do counts, and they'll decide what permit will be issued on state lands. Sometimes Black Gap will get a permit. Those are the ones that go on the public draw. So anyone can pay $10 every year for their chance to do a desert sheep hunt. I know two brothers that got lucky; one year one won one, and two years later, his brother won one. Twenty per year are generally issued, and it costs anywhere from $60,000 to $90,000 to shoot a bighorn sheep.

"In my opinion, the bighorn sheep are probably the neatest animal out here because of the nostalgia of them. I went my whole life growing up hearing about

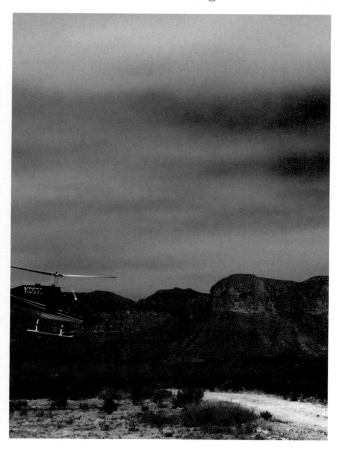

them but never seeing them. In 1993, they did a big release at Black Gap. In 1994, I saw my first wild bighorn sheep on the Bear Canyon Ranch. It was a game changer for me. I had never seen anything like it before; king of the mountain is the best way to describe them. You think they are these big, tough animals, and actually they are not. If it weren't for people like the Bighorn Society helping them, they wouldn't make it.

Randy's Feral Hog Sausage

Courtesy of Randall Liddell

Yields about 4 pounds

3 pounds pork (feral hog)
12 ounces hickory smoked bacon
 (as fatty as possible)
3 teaspoons dry sage
3 teaspoons salt
3 teaspoons ground black pepper
1½ tablespoons brown sugar
1 teaspoon crushed red pepper
2 pinches ground cloves
2 tablespoons cayenne

° Combine all ingredients and form into links. Grill until thoroughly cooked or freeze until ready to eat.
° Note: If you want to make venison sausage, use 2 pounds of venison instead of 3 pounds of pork and add 3 teaspoons of garlic salt.

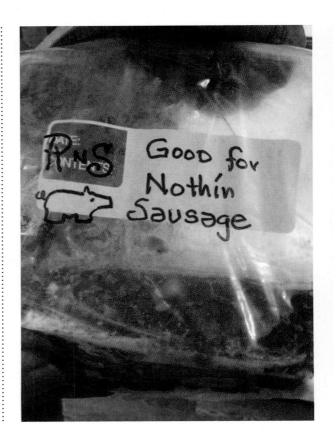

Shack's Quail Dumplings

Courtesy of Lyndell Shackelford

"We were at the ranch feeding hunters one day. One of the hunters mentioned wanting chicken and dumplings. I didn't have chicken. I told them if they wanted white meat, we were going to have to cut some quail. We got about fifteen quail and breasted them out. We ended up getting some dove, too, so it was dove/quail dumplings that day."
—Lyn Shackelford

quail
onions
1 can sliced mushrooms
white wine
celery
carrots
make your preferred biscuit dough (raw)
chicken broth
seasonings to taste: salt, pepper, garlic, Tony Chachere's Creole seasoning

° Stir fry the quail a little bit with onions, a can of sliced mushrooms and white wine (we drank all the red). I don't fully cook it, but it's cooked a little before we put it in the pot.

° You can put celery and carrots or vegetables of your choice in with the meat and onions, but at that time, we didn't have that much, so we made do with what we had. I've put red potatoes in before.

° Make your preferred biscuit dough for dumplings. We made biscuits right out of the Clabber Girl baking powder can; there's a recipe on the back that we used. Cut dough in small dumpling shapes, approximately 2 tablespoons each.

° In a Dutch oven, heat chicken broth to high heat, just before boiling. Add partially cooked meat and vegetables and raw dumplings and cook until all ingredients have fully cooked through but are still tender. Add seasonings to taste.

ARROWHEAD HUNTING

By Randall Liddell

We have found arrowheads, matates and cave paintings here on the ranch. Those stay here. My boss has a big collection up at their house. It's fun to get out and walk around, especially in an area where you know you'll find it. We'd make a day of it to get out—just as a hobby.

Tips for finding arrowheads: there are different areas and different places, but one thing I've learned is that camps have to be around some kind of water, or where water was one hundred years ago. So dry creeks, spots where their campsites would be without floods washing them away, these are good spots to look. Usually where you find an old homestead built around the 1900s, that same spot was almost always used as an Indian camp too because they'd pick the spot for the same reasons: high and dry, safe, with water and game available.

Sotol mounds are another good area for finding arrowheads. These are spots where the Indians would come bake the

sotol and turn it into a candy. They would come together in groups, dig a big hole and put a fire in it with the sotol on top, then more fire on top. It was like sugarcane, like a treat to them. You'll find a pile of rocks the size of your fist, and the mound might be two feet across or ten feet across, depending on how many times they used the pits.

By Lyn "Shack" Shackelford

If you want to find arrowheads, go first thing in the morning as the sun is rising. Look on the ground in the direction of the sunrise so you can see them shining. Early morning until about ten o'clock in the morning is best.

If you're in a cave, shovel some of the dirt onto a sifter and sift about an inch of the dirt off through a screen that's about two inches by two inches. Sift and see what falls out.

To initially find a campsite, look for lots of greasewood (creosote) and prickly pear where it's real thick. Indians used to eat the pear apples, so if you find a big thicket of prickly pear, ninety-nine times out of one hundred it's an Indian camp. Real thick, heavy creosote will be growing out of it because it's healthy land where the Indians burned and got their food recycled. It's more fertile.

Down on the river in my county, I'll find a place that's real thick in prickly pear, right in the middle of where they used to burn fires, and I'll find some there. Also by postholes, dirt tanks or where there's been excavation of any kind.

INDEX

recipes

breakfast

desserts

drinks

main courses

ABOUT THE AUTHOR

Tiffany Harelik (rhymes with garlic) has been writing about iconic food cultures since 2009. Her first series, *Trailer Food Diaries Cookbooks*, featured several titles focused on entrepreneurial chefs in Texas and Oregon. A Scorpio with a master's in health psychology, Tiffany is an avid outdoorswoman who is also rumored to make the best fried chicken south of the Mason-Dixon. Look for her other projects at tiffanyharelik.com.